Zuffi, Stefano,
 1961-

Gospel Figures in Art

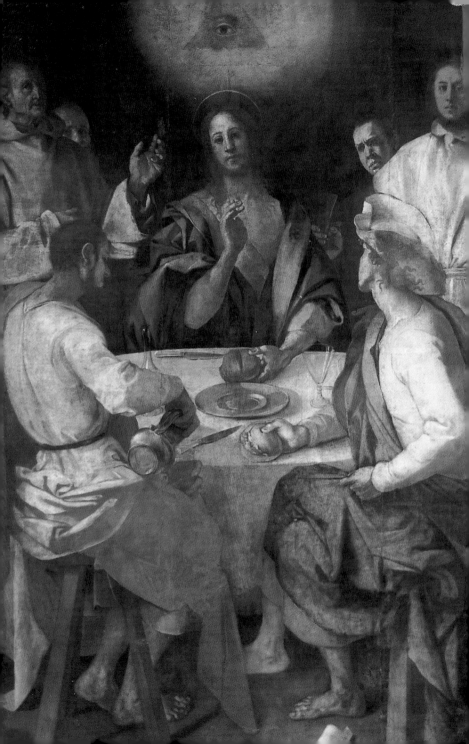

Stefano Zuffi

Gospel Figures in Art

Translated by Thomas Michael Hartmann

The J. Paul Getty Museum
Los Angeles

Italian edition ©2002 Mondadori Electa S.p.A., Milan.
All rights reserved.
www.electaweb.it

Original art director: Giorgio Seppi
Original editorial coordinator: Tatjana Pauli
Original graphic design: Dario Tagliabue
Original layout: Sergio Castagna, Men at Work, Verona
Original cover design: Anna Piccarreta
Original photo research: Elisa Bagnoni and Carlo Ingicco

First published in the United States of America in 2003 by

Getty Publications
1200 Getty Center Drive, Suite 500
Los Angeles, California 90049-1682
www.getty.edu

English translation ©2003 The J. Paul Getty Trust

Christopher Hudson, *Publisher*
Mark Greenberg, *Editor in Chief*
Thomas Michael Hartmann, *Translator*
Alexandra Bonfante-Warren, *Copy Editor*
Hespenheide Design, *Designer and Typesetter*
Printed in Italy

Page 2:
Jacopo Pontormo, *The Supper at Emmaus*, 1525.
Florence, Galleria degli Uffizi.

On the facing page:
Hans Baldung Grien, *The Rest on the Flight into Egypt*,
1515. Vienna, Akademie der bildenden Künste.

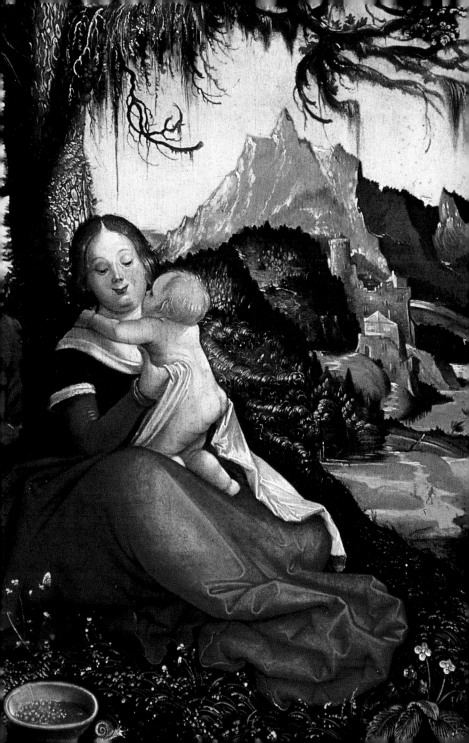

Contents

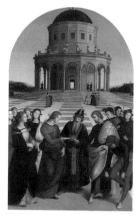
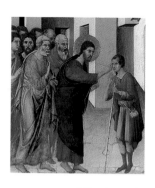

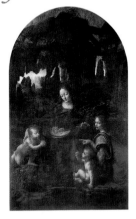
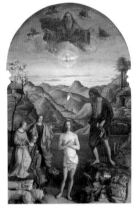
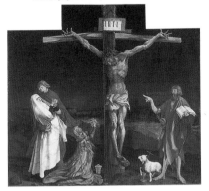
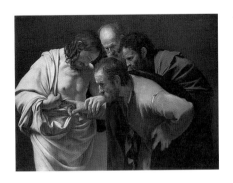

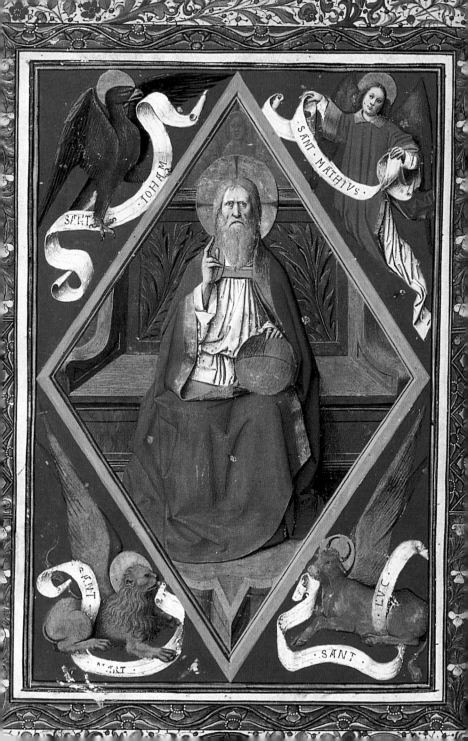

THE EVANGELISTS AND THEIR SYMBOLS

◀ Enguerrand Quarton, *God
in Majesty*, an illuminated
page from the missal by Jean
des Martins, 1465–66. Paris,
Bibliothèque nationale

▶ Carlo Dolci, *Saint
Matthew and the Angel*
(detail), ca. 1670. Los
Angeles, J. Paul Getty
Museum

*In the sixth century, Bishop Eusebius of Caesarea compiled
the so-called canons, that is, synoptic tables for comparing
the Gospels. These canons reveal the agreement between the
various versions.*

The Canonical Gospels

The Greek word for "gospel," *euangelion,* means "good news."
In the earliest Christian writings, the evangelists are those who
spread the good news, and so, in a sense, all disciples are evange-
lists. In the New Testament, the term "gospel" refers to the mes-
sage itself, not the book that contains it. Nevertheless, as early as
the first century the word had come to mean each of the four
books that narrate the life and teaching of Jesus. These books
were written by four trustworthy disciples. John and Matthew
belonged to the Twelve Apostles, Mark was a direct disciple of
Peter, and Luke was one of the first converts from the Greek cul-
tural sphere. The Gospels of Matthew, Mark, and Luke are
called the "synoptic" Gospels, because their narratives are from
the same point of view. John, however, stands alone. The
Vulgate—the Latin Bible that Saint Jerome revised in the late
fourth century—gave a definitive structure to the body of the
Holy Scriptures. The Gospels should be considered as comple-
menting one another, in that they were written within the same
period (the first century) and are based upon the same sources.

▶▶ Mozarabic School,
*Tables of the Eusebian
Canons,* tenth century.
Madrid, Biblioteca Nacional

▶ School of Oviedo, *Tables
of the Eusebian Canons,*
ninth century. *Left,* on a blue
background; *right,* on the
natural color of the parch-
ment. Cava dei Tirreni,
Biblioteca della Badia

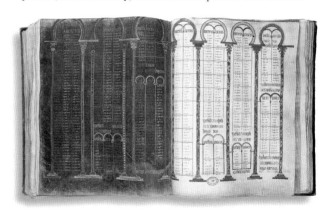

Following the sequence of the sacred texts, thin horizontal lines group the chapters of each Gospel by subject.

Luke's symbol is the ox.

John's is the eagle.

The small, decorated columns between the Gospels recall the ambulatory of a Romanesque cloister.

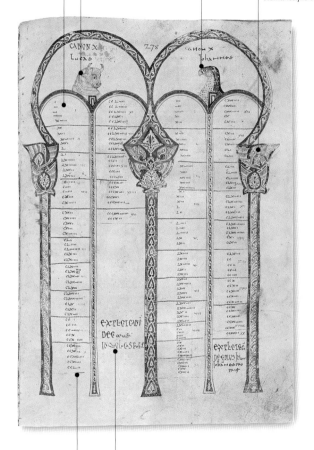

There is little symmetry between these two indexes. Luke is the third of the "synoptic" evangelists, who exhibit many similarities in their approaches and in the way they ordered the scenes they narrated. John's Gospel, however, is distinctly different in tone, main theme, and choice of episodes.

The conclusion of the text (explicit) is visually emphasized at the end of the chapter sequence.

In their canonical sequence, the Gospels are those of Matthew, Mark, Luke, and John. Their respective symbols are a winged man, a winged lion, a winged ox, and an eagle.

The Evangelists

The "four living creatures" that circle the throne of the Most High in Revelation (4:7–8) and that became the symbols of the evangelists originated from the four-sided creatures (tetramorphs) described by the prophet Ezekiel:

> They had the form of men, but each had four faces, and each of them had four wings. Their legs were straight, and the soles of their feet were like the sole of a calf's foot; and they sparkled like burnished bronze. Under their wings on their four sides they had human hands. . . . As for the likeness of their faces, each had the face of a man in front; the four had the face of a lion on the right side, the four had the face of an ox on the left side, and the four had the face of an eagle at the back (1:5–10).

In the late second century, Saint Ireneus of Lyons first connected the tetramorphs with the Gospels. He pointed out that the lion symbolizes the idea of royalty; the ox, sacrifice; the man, incarnation; and the eagle, the Spirit that sustains the Church. It was Saint Jerome, however, in the late fourth century, who associated the "animals" with the evangelists. The Gospel of Matthew begins with the Incarnation; therefore his symbol is the angel. Mark's begins with the figure of the Baptist—"the voice of one crying in the wilderness" (1:3)—who was solitary and as powerful as a lion's roar. Luke stressed the theme of sacrifice, so the ox was his symbol. Finally, John achieved spiritual heights in his Gospel that resemble an eagle's flight.

▶ Fernando Gallego, *Christ Blessing*, ca. 1495. Madrid, Museo del Prado

▼ *Plaque with Agnus Dei on a Cross between Emblems of the Four Evangelists*, probably ninth century. New York, The Metropolitan Museum of Art

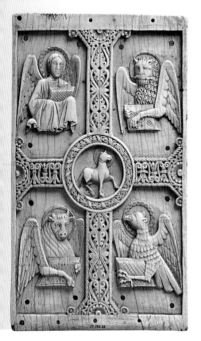

On Jesus' right (the area reserved for the good) is an allegorical figure representing the Church or the Christian faith. The figure serenely bears the standard symbolizing the Resurrection, the chalice, and the host.

The raised right hand with index and middle fingers together is the typical gesture of benediction.

John's symbol is the eagle.

Matthew's is the angel.

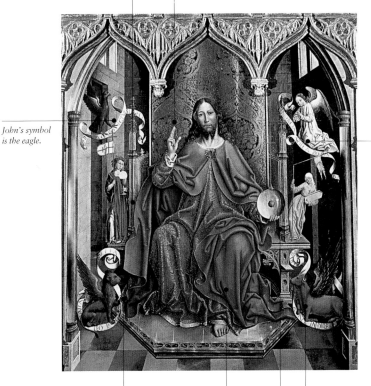

Mark's symbol is the lion.

Luke's is the ox.

As Imperator mundi *(emperor of the world)*, Jesus sits enthroned in a perfectly frontal position. He wears a sumptuous regal cloak and holds a globe, a symbol of dominion over the world. His bare foot, however, recalls the Savior's humanity and humility.

On Jesus' left (the place reserved for the wicked), note that an allegorical figure representing Synagogue, or the Law of Moses, can be seen. The figure holds the Tablets of the Law, but her posture is unstable and her staff is broken.

John, the youngest, is strongly differentiated from the other three evangelists, not only by his appearance but also because he does not rest his book on the same plane as those of Matthew, Mark, and Luke.

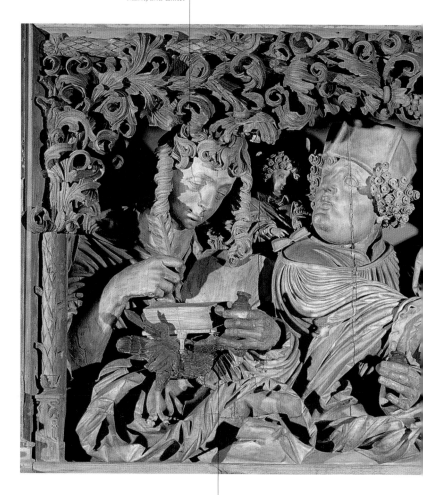

▲ Master HL, *Altar of the Coronation of the Virgin*, predella with the four evangelists, 1523–26. Breisach, Cathedral of Saint Stephen

John's symbol, the eagle, supports his Gospel. Lecterns throughout Europe were typically sculpted in the shape of an eagle, whether they were made of marble, bronze, or wood.

A tiny, winged lion stands beside Mark. Unlike John, the three synoptic evangelists wear the same hat in order to emphasize the similarity of their approach.

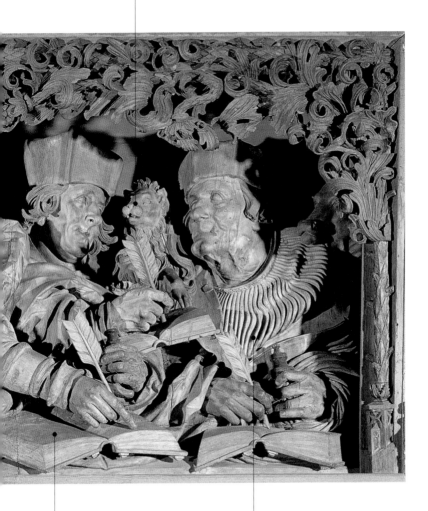

The desk at which the three synoptic evangelists are working is somewhat untidy, as if their respective Gospels were interchangeable.

Luke, who is recognizable because of the ox, is depicted, unusually, as an elderly man.

Matthew, the only one of the Twelve Apostles who had a clerical job (he was a tax collector), was "called" by Christ while he was at work. His symbol is an angel.

Matthew

The traditional attribution of the four Gospels to the four evangelists goes back to Saint Ireneus of Lyons (about A.D. 180). The case of Matthew is perhaps the most controversial; according to scholars, the author of the text collected, between A.D. 65 and 100, a series of notes and details directly from one of Christ's disciples—probably Matthew himself—and integrated these with accurate transcriptions and original paraphrases of episodes in the Gospel of Mark, which is the oldest of the four and perhaps the only one actually written by one of the apostles. In any case, the Gospel of Matthew features the most references to the historical and social facts of the period and also the closest to Jewish thought. Written by a Jew who converted to Christianity, and who made accurate references to Old Testament prophecies and to the author's place and time, it was addressed to the Jewish people in order to demonstrate that Jesus was Israel's

▶ Caravaggio, *Saint Matthew and the Angel*, 1602. Rome, San Luigi dei Francesi

▼ Guido Reni, *The Four Evangelists: Saint Matthew*, 1620–21. Greenville, South Carolina, Bob Jones University

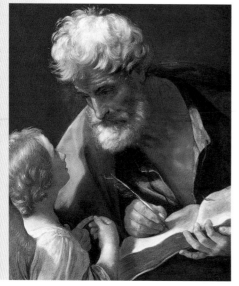

long-awaited Messiah. There are more descriptive details and natural and urban "settings" in Matthew's text than in the work of the other evangelists, and this has made it a particularly privileged source for religious art, especially the illustrations of the miracles and parables. According to *The Golden Legend*, Matthew's symbol is in human form because the first evangelist insisted on Jesus' humanity and began his narrative precisely with the Incarnation of Jesus.

His eyes fixed on the angel,
Matthew looks as if he is
taking dictation.

The angel's gesture indicates
that he is explaining the Gospel
with specific arguments.

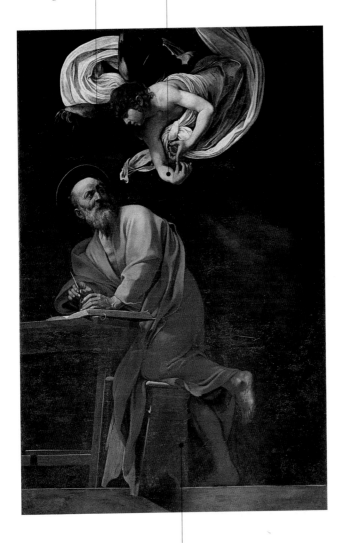

The stool and table that Matthew uses are
markedly rustic. They seem to resemble the
modest furnishings of an office rather than a
scholar's desk. The reference is to Matthew's
previous employment as a tax collector.

Mark

Mark's symbol is the winged lion. His Gospel, which was composed in Rome around A.D. 60, based on Peter's direct testimony and memories, is the oldest of the four canonical Gospels.

Mark may make a cameo appearance in his own Gospel. The commentators, in fact, tend to identify the almost nude young man who runs away during Christ's arrest as the evangelist himself (14:51). Born and raised in Jerusalem, Mark was a Jewish convert to Christianity who was very close to Peter. Mark was the apostle's disciple for a long while and also acted as his interpreter (he knew Latin perfectly) and secretary. In this latter role, Mark scrupulously gathered the testimony of Peter— "prince of the apostles"—and based his Gospel upon it. He also showed that he was personally acquainted with other figures from Christ's life on earth. For example, Mark vividly described the miraculously healed blind man Bartimaeus in a simple, chronologically straightforward narrative. It may be that the Gospel of Mark has come down to us missing some parts, since it begins with the preaching of the Baptist (completely ignoring Christ's childhood) and concludes abruptly with the pious women standing amazed at the empty tomb. In the history of art, the Gospel of Mark has been the principal source primarily for the episodes of the Passion, which it narrates in a detailed manner.

▶ Master of the Ulm High Altar, *Saint Mark*, detail from a panel in the monastery of Maulbronn, 1442. Stuttgart, Staatsgalerie

▼ Vittore Carpaccio, *The Lion of Saint Mark*, 1516. Venice, Palazzo Ducale

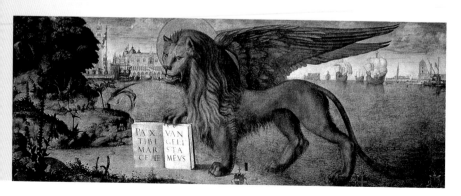

The furnishings of Mark's studio resemble those of a scholarly humanist ecclesiastic. The inks of various colors refer to the customary appearance of the Gospels used in the liturgy, with their chapter openers and main verses highlighted with red ink.

The miter, the typical head covering of bishops, is highly unusual for Mark. However, Mark is held to have been Peter's secretary. As the principal collaborator of the first pope, he is thus believed to have been worthy of a bishop's rank.

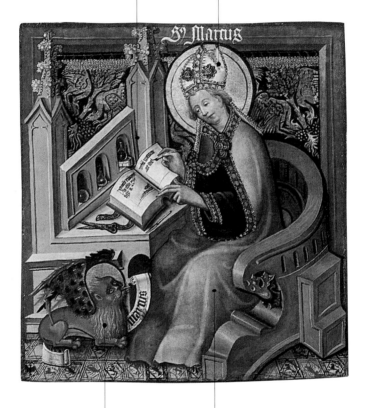

Northern European artists often portrayed lions in an approximate way, since they had few opportunities to see a live lion or to observe Classical sculptures of the animal closely.

Mark's symbol is the lion. This choice is connected with an ancient legend, according to which newborn lion cubs lay for three days as if dead until their father's breath brings them back to life. In his Gospel, Mark wrote at significant length about Jesus' Crucifixion and Resurrection.

According to an ancient tradition, Luke is the patron saint of artists and was himself a painter, a sculptor, or both. His Gospel is full of episodes that lend themselves to figurative expression. The winged ox is his symbol.

Luke

Luke is the author of the third Gospel and of the natural continuation of all the Gospels, the Acts of the Apostles. Both books, dedicated to a certain Theophilus, were addressed to the communities of Gentiles and of Christians who had already converted, not to the Jews. This is why these texts lack the many biblical references in the Gospel of Matthew. Luke, a disciple and friend of Paul, was not Jewish; he may have been from Antioch, but in any case, culturally, he belonged to the Greek world. According to some commentators, he may have known Mary personally, which would explain his detailed narrative of Jesus' conception and childhood.

His method was pragmatic: he never claimed to have written the Gospel by means of mystical inspiration, but rather maintained that he had attempted to sort out the many legends and opinions surrounding the figure of Jesus. To do this, he systematically collected the testimonies of eyewitnesses and the recollections of reliable people. He, too, relied on the Gospel of Mark as his primary source, or at least as the axis around which his narrative is organized. We owe to Luke some of the most poetic and lovable scenes, long explored by artists over the centuries: the stories of Mary, many "minor" figures (characters and parables), and episodes occurring after the Resurrection, such as the Road to Emmaus and the Ascension.

▶ Master of the Augustinian Altarpiece, *Saint Luke Painting the Madonna*, ca. 1490. Nuremberg, Germanisches Nationalmuseum

▼ Simone Martini, *Saint Luke*, ca. 1330. Los Angeles, J. Paul Getty Museum

S·LVC S CVLT

Northern European painters preferred a realistic domestic setting—emphasized here by the hearth—for their Madonnas.

In typical northern European style, Luke is shown painting on a panel. It is interesting to note that he is in a different room than the Madonna, separated from her by a threshold, almost as if he wished to study the perspectival effect.

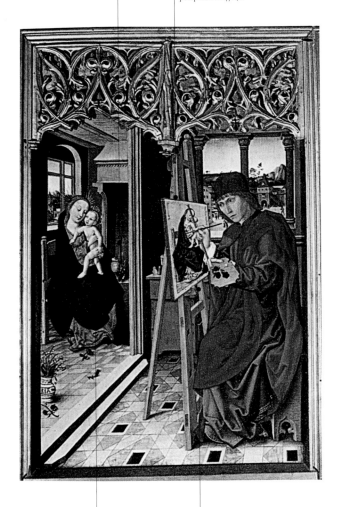

The Madonna sits calmly on a simple chair, a sign of her humility.

The tools and technique of a painter are shown in minute detail. Votive images of Luke were often created for an audience of professional artists, since they were commissioned by their confraternities to celebrate their patron saint.

The eagle symbolizes John's Gospel, which stands apart from the other three because it records what Jesus "said" more than what he "did." As a result, his Gospel has given rise to fewer art-historical episodes.

John

John, the son of a well-to-do fisherman, Zebedee, was a fisherman himself. He was James's brother and Jesus' cousin on his mother's side. John emerges as a prominent figure among the Twelve Apostles, so much so that he is considered Christ's "beloved disciple." He is one of the principal New Testament authors: besides his Gospel, three letters and Revelation—the last book of the Bible—are attributed to him.

Regarding the works' treatment in art, although Revelation is a fiery succession of visual images (in fact, there is a repetition of "I, John, saw . . ."), John's Gospel is a work of soaring mysticism from its opening words. This approach is incompatible with anecdotal or descriptive details; for example, not one parable is recounted. After his prologue, John's Gospel presents Jesus already as an adult, fully immersed in his public activity. The evangelist then explores themes such as the tangible physicality of Jesus, who is explicitly presented as a man of flesh and blood; the incredulity of many of the Jews; and Christ and his disciples' mission of universal salvation.

It should also be mentioned here that John, who was present in many key moments of Jesus' life, is the saint most often portrayed in art. When he is not depicted as an evangelist (accompanied by an eagle), he can be identified by the presence of a chalice from which a serpent rises. This attribute recalls his dispute in Ephesus with a priest of the goddess Diana. When the priest dared John to drink from a poisoned cup, the apostle blessed it, and the poison rose from the chalice in the shape of a snake.

▶ Hans Burgkmair the Elder, *Saint John on Patmos*, 1518. Munich, Alte Pinakothek

▼ Hans Memling, *Saint John the Evangelist*, a side panel of the *Donne Triptych*, ca. 1478. London, National Gallery

This painting evokes an exotic natural setting, with palm trees and unusual animals. The parrot, however, can also be seen as a symbol: its call "ara, ara" has been thought to sound like "ave, ave," the archangel Gabriel's greeting to Mary.

God appears to John when he is alone on the island of Patmos and reveals the Apocalypse (Book of Revelation) to him.

John was quite old when Revelation was written. Nevertheless, according to iconographic convention and in order to make him recognizable, the evangelist is always portrayed as a young man.

This symbolic eagle has a tiny halo that sets it apart from the many other animals in the painting. According to Saint Jerome, John's Gospel "flies" spiritually higher than the others—"it rises above the angels' sphere and goes directly to God."

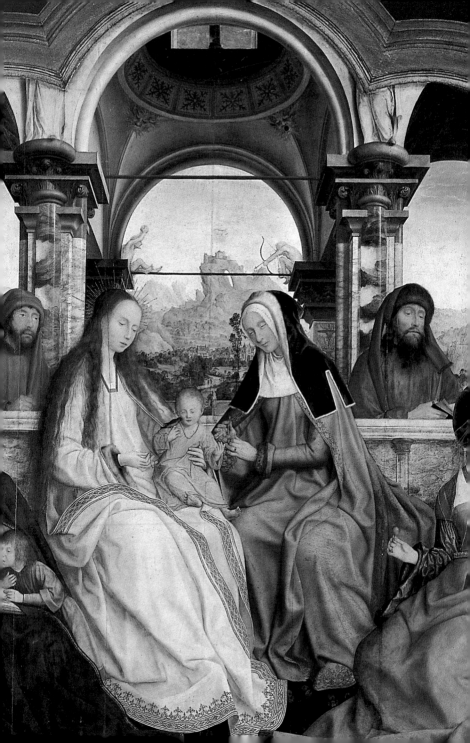

JESUS' FAMILY

◄ Quentin Massys, *The Family of Jesus* (detail), from the central panel of the *Confraternity of Saint Anne of Louvain Triptych*, 1509. Brussels, Musées royaux des beaux-arts

► Raphael, *The Marriage of the Virgin* (detail), 1504. Milan, Pinacoteca di Brera

Among the various images relating to Jesus' origins, the depiction of the genealogical tree of Saint Joseph's family stands apart. Following Jewish custom, descent is on the father's side.

The Tree of Jesse

The question of Jesus' lineage is complex. Matthew calculated forty generations of ancestors, but David is counted twice, as both the link between the descendants of Abraham and the beginning of the royal line. The addition of Joachim (or, in some cases, of Jesus himself), makes forty-two generations in all, which can be divided into three groups: fourteen generations from Abraham to David; fourteen kings from David to Josiah; and fourteen ancestors of Christ, from Jechoniah to Joseph.

The phrase "tree of Jesse" comes from Isaiah's prophecy, which tells how a "branch shall grow out of his roots" (11:1). Jesse was another name for Isai, David's father, who lived in Bethlehem. However, according to the genealogy in Luke, the "root" of the tree is not Jesse, but Adam, the ancestor of the entire human race. The "tree" thus becomes superimposed upon the Tree of Life (*lignum vitae*), which according to *The Golden Legend* also originated with Adam.

The difficulty arises from the fact that Joseph was not Jesus' natural father, so the genealogy must end instead with Mary.

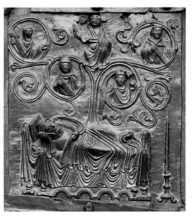

For this reason, Saint Jerome, Saint John Damascene, and other patristic writers, followed by Jacobus de Voragine, determined that Mary, too, descended from Jesse and his son David.

The Place
Jerusalem and Palestine

The Time
Beginning in 5228 B.C.

The Figures
Adam (or Jesse, David's father) and the forty-two generations of patriarchs, kings of Israel, and ancestors of Christ

The Sources
The Prologue of the Gospel of Matthew, the Gospel of Luke, and *The Golden Legend* ("The Birth of the Blessed Virgin Mary"); the subject refers to a prophecy by Isaiah

Variants
The Ancestors of Christ; the Family Tree of Christ

Diffusion of the Image
In all of Europe; first, because of its vertical format, in French and German Gothic stained-glass windows; later, especially in the late fifteenth century, because of the spread of the cult of the Immaculate Conception

▶ Second Master of S. Zeno, *The Tree of Jesse*, tenth–eleventh century bronze door. Verona, Basilica of Saint Zeno

Joachim, Mary's father, is in a position of veneration before his daughter.

God the Father stretches out his arms in welcome, the same gesture that will be repeated at the Assumption. Mary's stance here became typical of the Immaculate Conception.

Anne, the Madonna's mother, wears the characteristic costume of an elderly woman.

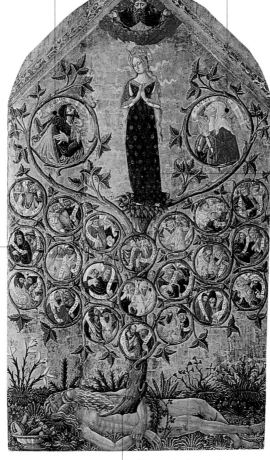

Although Mary is portrayed with her hands together in prayer, she also wears a crown and a rich, embroidered gown, which identify her as a princess of royal blood.

Pairs of biblical figures are portrayed in the tree's shoots. These are the Madonna's ancestors, who can be identified by the names within the scroll.

In this example, the root of Mary's genealogical tree is not Jesse but Adam.

▲ Matteo da Gualdo, *Genealogical Tree of the Line of David (The Tree of Jesse)*, ca. 1497. Gualdo Tadino, Museo Civico

All the characters curiously climbing the tree bear royal attributes, such as scepters, crowns, or fur-lined clothing.

In this example, Mary holds the child Jesus in her arms to show his direct descent from King David.

King David, son of Jesse, and so near the base of the tree, is easily recognizable because of the lyre he holds.

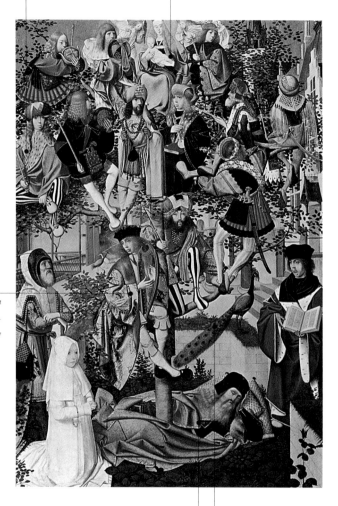

The progenitor Jesse is shown sleeping; he is peacefully stretched out in hortus conclusus, the enclosed garden that symbolizes the Virgin.

The peacock should not be interpreted here as a negative symbol of pride, but rather as an exotic bird that lived only in the gardens of kings. It has been added here to bring magnificence to the scene.

▲ Geertgen tot Sint Jans, *The Tree of Jesse*, ca. 1480–90. Amsterdam, Rijksmuseum

While Saint Anne is very popular in the Roman Catholic and Orthodox traditions (although opposed by Luther), veneration of Saint Joachim has fluctuated dramatically in the West.

Joachim and Anne

Episodes preceding Mary's birth do not appear in the canonical Gospels. The fable-like apocryphal narratives trace Old Testament models (an elderly couple who believe themselves barren conceive a child after a forty-day penance and an announcement from an angel). These stories are full of vivid descriptive, scenic, even psychological details, the kind that inspire the imaginations of artists.

Joachim and Anne, an exemplary couple who have been married for more than twenty years, are childless. Because of their inability to help the "chosen people" multiply—this was considered a curse from God—the offering that Joachim brings to the temple of Jerusalem for the dedication ceremony is spurned. Humiliated, Joachim does not dare return home to Nazareth, but remains in the desert with shepherds to fast and atone for forty days. An angel, however, declares that his offering has reached the throne of God and that his prayers will soon be answered: his wife, Anne, will bear a daughter. The angel also comforts Anne, who weeps at her husband's absence, and tells her to go to Jerusalem's Golden Gate to meet him. After their moving reunion, Anne conceives Mary.

The Place
Nazareth (Joachim's native city) and Jerusalem and its outskirts

The Time
About 16 B.C.

The Figures
Joachim, an elderly priest, and his wife, Anne; an angel who brings tidings to both

The Sources
The Protevangelium of James, retold in *The Golden Legend*

Variants
Titles of individual scenes: Joachim's Offering Refused (or the Refusal of Joachim's Offering); Joachim in the Desert (or Joachim among the Shepherds); the Annunciation to Joachim; the Annunciation to Anne; the Meeting at the Golden Gate

Diffusion of the Image
The scene that recurs most frequently in art is the Meeting at the Golden Gate, which spread throughout northern Europe in the fifteenth century.

Giotto, *Stories of Joachim* ◄ *and Anne: The Meeting of Joachim and Anne at the Golden Gate* (detail), 1304–6. Padua, Scrovegni Chapel

The temple is portrayed
as an extravagant
Renaissance pavilion
that is open on all sides.

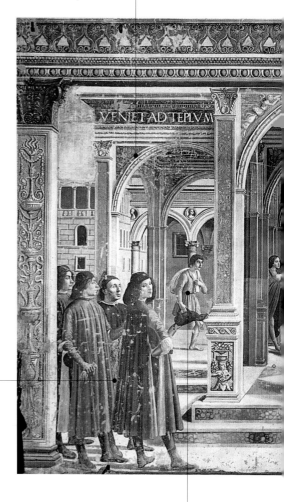

Ghirlandaio portrays a number of his
Florentine contemporaries in a row. The
cycle at Santa Maria Novella represents
one of the most extensive and complex
pictorial undertakings of late-fifteenth-
century Florence.

Some of the faithful piously approach the temple
bearing offerings. Their youthful appearance is in
contrast with Joachim's advanced age.

▲ Domenico Ghirlandaio, *Joachim Expelled from the Temple* (detail), from
the Tornabuoni Chapel frescoes, 1495. Florence, Santa Maria Novella

At the center of the composition is the altar, where the priest receives animals and offerings that the faithful bring for the sacrifice.

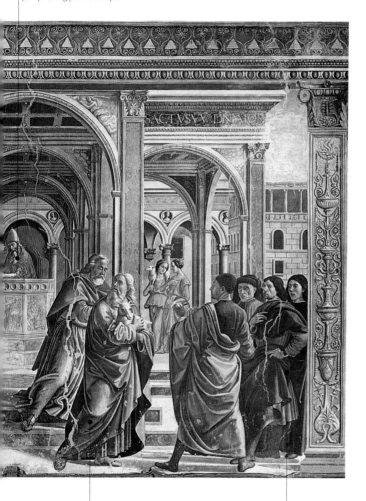

Joachim, his long white beard emphasizing his advanced age and scrupulous attention to religious practices, is expelled from the temple and, as a result, from the community as well. He is considered unworthy to bring offerings to the altar because of his childlessness.

Several people are stunned as they observe the scene. According to an apocryphal tradition, Joachim was deeply ashamed at being thrown out of the temple.

The angel tells Joachim to return to Jerusalem. His prayers have been answered, and his wife, Anne, by now thought to be sterile, will bear a child who will be called Mary.

This barren, rocky landscape represents the "desert" where Joachim retreated out of shame at being cast out of the temple.

Joachim, who is awake, reacts fearfully to the angel's appearance. Therefore, what he is experiencing is a vision, not a dream, as in those works of art that follow the version from the Gospel of the Pseudo-Matthew.

The dog is a charming allusion to the shepherds that Joachim stayed with during the period of his solitude and penance.

▲ Quentin Massys, *The Annunciation to Joachim* (detail), from the *Confraternity of Saint Anne of Louvain Triptych*, 1509. Brussels, Musées royaux des beaux-arts

We recognize in the background the scene of the angel appearing to Joachim and urging him to return to Jerusalem.

The angel suggests that Anne begin walking toward the Golden Gate to meet Joachim.

This figure may be Judith, the servant with whom Anne quarrels bitterly in the Protevangelium of James.

Anne prays, joining her pleas to laments at her husband's prolonged absence.

The book on the reading desk refers to Anne's teaching. A reading desk is often included in depictions of the Annunciation, which this episode prefigures.

▲ Bernardino Luini, *Annunciation to Saint Anne*, 1516–21. Milan, Pinacoteca di Brera

This scene takes place beneath the arch of Jerusalem's Golden Gate, which has been rendered here as a Classical structure that is richly decorated with statues.

Anne and Joachim are explicitly shown as an elderly married couple.

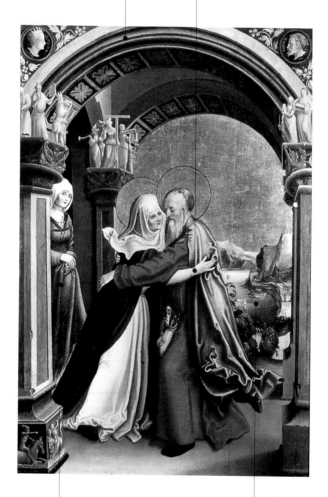

A woman observing the scene emphasizes the "public" importance of the meeting and embrace between Joachim and Anne.

The background realistically depicts a typical Swiss landscape of alpine lakes surrounded by mountains.

▲ Manuel Deutsch Niklaus, *The Meeting between Joachim and Anne at the Golden Gate*, 1520. Bern, Kunstmuseum

It was not until December 8, 1854, that Pope Pius IX proclaimed the dogma of the Immaculate Conception of Mary, in line with the ancient tradition that holds Mary to be conceived "without stain."

The Immaculate Conception

The figure of the Virgin, triumphant over sin, and even pre-served intact from original sin, is one of the most widespread and popular Marian images. In Western art, this image has given rise to a series of iconographic and devotional conventions (colors, attitude, and general structure) worthy of Byzantine icons.

The Franciscans raised the question of the Immaculate Con-ception of Mary in the second half of the fifteenth century. The widespread diffusion of the embrace of Joachim and Anne at the Golden Gate should be considered in light of these friars' initiatives at that time. The debate was espe-cially lively in Milan; one of Leonardo da Vinci's masterpieces, *Virgin of the Rocks*, originated in response to it.

In Revelation, John described a "woman clothed with the sun, with the moon under her feet, and on her head a crown of twelve stars" (12:1–17). This figure has been identified with the Church as much as with Mary. The image of Mary in Heaven standing on a crescent moon was already widespread in the Renaissance, partly due to German engravings, and became even more popular in the seventeenth century, even-tually becoming the "official" paradigm of the Immaculate Conception.

The Place
Jerusalem and Nazareth, although in art the image is often placed in an indefinite stretch of sky

The Time
About 16 B.C.

The Figures
The Immaculate Concep-tion has been depicted the same way since the seven-teenth century: the adult Mary in flight in the sky on a crescent moon where a serpent lurks.

The Sources
This interpretation is traditionally based on a passage from Genesis; numerous biblical verses; the Magnificat, a prayer in the Gospel of Saint Luke; and a scene from Revelation.

Variants
Immaculate Mary; Mary Immaculate

Diffusion of the Image
Throughout the Catholic world during the Baroque period, especially in Italy and Spain

Francisco de Zurbarán, ◄
The Immaculate Conception,
1530–35. Sigüenza, Museo Diocesano

The Book of Revelation is the source for the crown of twelve stars around the Virgin's head. In the symbolic interpretation of Mary as an allegory of the Church, the stars stand for the Apostles.

Her spotless white dress expresses Mary's absolute purity. In a symbolic reading of this image based on Revelation, the splendor that clothes the Madonna is light emanating from Christ himself.

The lilies that the angels carry reaffirm the virtue of Mary's perfect purity.

The serpent and apple represent the relentless snares of evil and recall Eve's sin, the original "stain" from which Mary is miraculously exempt.

The globe symbolizes the world, which is besieged by the serpent but protected by Mary. The crescent moon under Mary's feet signifies that she (and thus, allegorically, the Church) is above the mutability of destinies and situations.

▲ Giovanni Battista Tiepolo, *The Immaculate Conception*, 1734–36. Vicenza, Museo Civico

This episode has provided for enchanting and realistic portrayals of birthing rooms and of the activities of midwives, friends, and neighbors. It is the only exclusively "female" New Testament scene.

The Birth of Mary

The birth of Mary (or Miriam, her name in Hebrew) was completely normal. The divine and supernatural elements of Mary's nature and conception occurred before Anne gave birth. Even her mother's very sweet words and attentions, abundantly reported in the Protevangelium of James, basically fall within an intense, loving relationship between a mother and her firstborn daughter. Precisely because of this earthy, human quality, depictions of it from the late Middle Ages to the High Renaissance represent precious records of history and costume, with many details of interior decoration and apparel. The down-to-earth figure of Anne, who is never mentioned in the Gospels, was very popular in

Germany, including among the more humble social classes. This is why she was harshly attacked by Martin Luther, who sought to "chase images" from the hearts of the faithful in order to return to the simple, sincere purity of the Scriptures.

The Place
Nazareth

The Time
About 15 B.C.

The Figures
The newborn Mary, her mother, Anne, and various women who help the new mother and the baby girl

The Sources
The Protevangelium of James, retold in *The Golden Legend*

Variants
The Nativity of Mary

Diffusion of the Image
Throughout Europe; frequently commissioned for convents in the fourteenth and fifteenth centuries. Appears less often beginning in the sixteenth century. The Birth of Mary is, together with the Annunciation and the Assumption, one of the three great Marian feasts and is celebrated on September 8.

Gaudenzio Ferrari, ◀
The Birth of the Virgin,
ca. 1545. Milan, Pinacoteca di Brera

These two women could be Ismeria, Anne's sister, and Ismeria's daughter Elizabeth, Mary's older cousin, who will become the mother of John the Baptist. Her hand on her stomach, in fact, recalls Elizabeth's gesture in scenes of the Visitation.

Anne, still exhausted and pale from giving birth, delicately takes the newborn Mary into her arms.

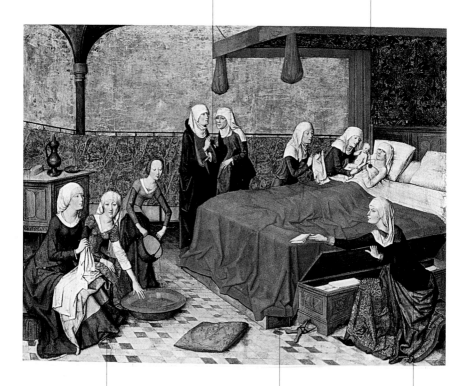

Three women prepare a basin and towels for the newborn's first bath.

Anne's pattens at the foot of the bed are a realistic detail, although they can also have a symbolic meaning related to Mary's birth. They recall the sandals that Moses took off as he stood before the burning bush that miraculously burned without being consumed. The bush has been interpreted by Christian exegetics as a symbol of Mary's virginity, which "generates light without decaying."

Another woman holds out a small, folded towel. In all, there are ten women in this scene and no men at all.

▲ Master of the Life of Mary, *The Nativity of the Virgin*, ca. 1460. Munich, Alte Pinakothek

*According to the apocryphal sources, which provide a wealth
of fabulous details, Mary spent the first three years of her life
in her parents' home, where she had a small room that had
been prepared just for her.*

The Education of the Virgin

Due to her father's vow that she would have an exemplary religious education and be consecrated to God, Mary spent most of her childhood at the temple of Jerusalem. Although there are almost no scenes of the child Mary in medieval art, they multiplied between the Renaissance and Baroque periods, corresponding to the growth of the cult of Saint Anne. Mary quickly learned from her mother to read and sew; the book and sewing basket became attributes of the Madonna, often appearing in scenes of the Annunciation. According to the Protevangelium of James, it was Mary's skill at embroidery that caused her to be chosen from among her classmates to make a precious curtain of fine material for the temple.

The Place
Nazareth

The Time
The first three years of
Mary's life

The Figures
The child Mary and her
mother, Anne; Joachim
appears only rarely

The Sources
The Protevangelium of
James and the Gospel of
Pseudo-Matthew (or the
Book of the Infancy of
the Blessed Mary and the
Savior), retold in *The
Golden Legend*

Variants
The Child Mary; Mary in
the House of Nazareth

Diffusion of the Image
Throughout Europe, but
especially common in
Spain and the colonial
Baroque; the duomo in
Milan is dedicated to
the child Mary

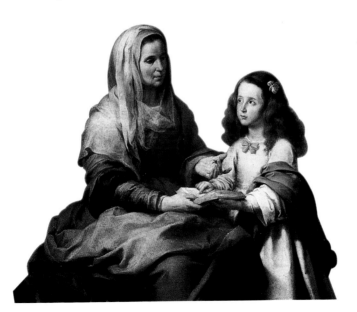

Bartolomé Esteban Murillo, ◄
The Education of the Virgin,
1650. Madrid,
Museo del Prado

The angels, like Mary, hold a book, although theirs is in shadow, as if alluding to the inscrutability of destinies. A vague presentiment of the Madonna's future suffering emanates from the seriousness of these celestial creatures' expressions.

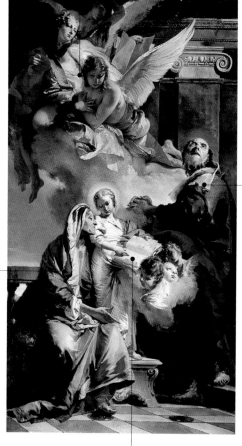

Joachim, typically portrayed as a model of piety, turns toward Heaven in an attitude of prayer and thanksgiving.

Usually, in art, Anne is teaching Mary to read or sew. Here the roles seem reversed: the elderly mother follows Mary's finger on the book attentively, as if she barely knows how to read.

The child Mary confidently indicates a point in the book, on which light is shining. The color of her dress and cloak are in keeping with the traditional iconography of the Immaculate Conception.

▲ Giovanni Battista Tiepolo, *The Education of the Virgin*, 1732. Venice, Church of Santa Maria della Fava

The phrase "presentation in the temple" can be used for either Mary or Jesus. The child Mary entering the temple is the subject of several fascinating Venetian Renaissance canvases.

The Presentation of Mary in the Temple

According to the apocryphal sources and medieval tradition, Mary lived in the temple from age three to age fourteen. Nevertheless, only her entrance into the temple (the "presentation") and her final departure after her marriage to Saint Joseph are usually portrayed in art. The description of her leaving her parents to enter the temple's "boarding school" is quite detailed. Although a tiny three-year-old, Mary behaved like a small, but emotionally mature woman, who climbed the temple's fifteen steps with assurance and without looking back. This evoked the admiring amazement of the high priest.

The Place
Jerusalem

The Time
About 12 B.C. (according to the apocryphal sources, Mary would be three years old, although in art she is generally represented as a little older)

The Figures
Mary and her parents; the high priest

The Sources
The Protevangelium of James, retold in *The Golden Legend*

Variants
Mary in the Temple

Diffusion of the Image
This episode is usually included in cycles of paintings dedicated to Mary or specifically commissioned by Marian confraternities.

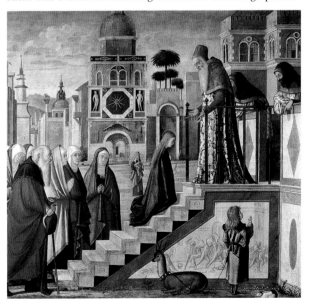

Vittore Carpaccio, ◄
The Presentation of Mary in the Temple, 1502–8. Milan, Pinacoteca di Brera

The Presentation of Mary in the Temple

At the edge of the canvas we see a gentleman distributing alms. This refers to the activity of the work's patrons—the directors of the Scuola della Carità—but also to Mary's most characteristic virtue. According to apocryphal sources, during her stay in the temple she went so far as to fast in order to give food to the poor.

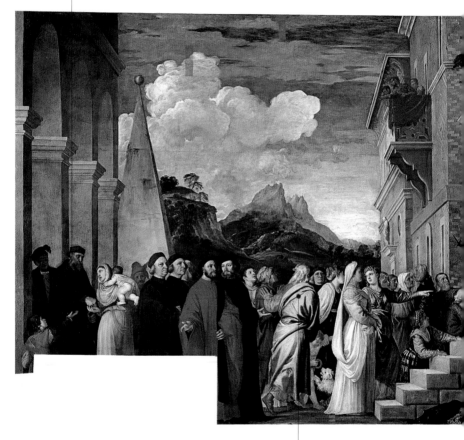

Anne and Joachim, now old, are among the crowd that witnesses the scene. They comfort each other as they watch the child climb the steps without looking back to wave goodbye.

▲ Titian, *The Presentation of Mary in the Temple*, 1534–38. Venice, Gallerie dell'Accademia

Encircled by a halo of light, Mary climbs the stairs gracefully. The little girl's light step can be attributed to Christian apocrypha that tell how Mary danced when she reached the top.

The high priest welcomes the child Mary at the top of the temple stairs. He is astonished at the three-year-old child's assurance as she climbs the stairs without ever looking back and without any help despite her tender age.

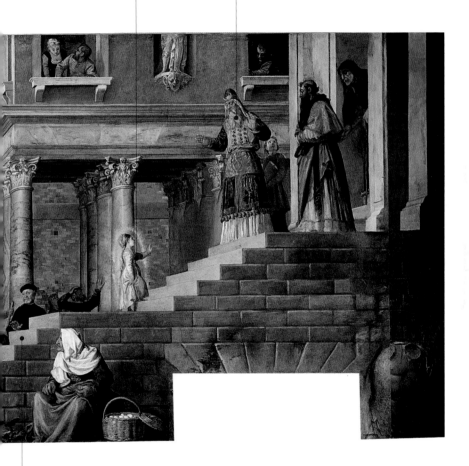

The temple steps number fifteen, as do the so-called Gradual Psalms, which pilgrims recited as they ascended to the temple.

At the base of the stairs, next to the handrail, Anne and Joachim watch with some sadness as their daughter climbs the stairs.

The temple is portrayed as a circular construction with slender trabeated columns. It is surrounded by a wide podium and balustrade.

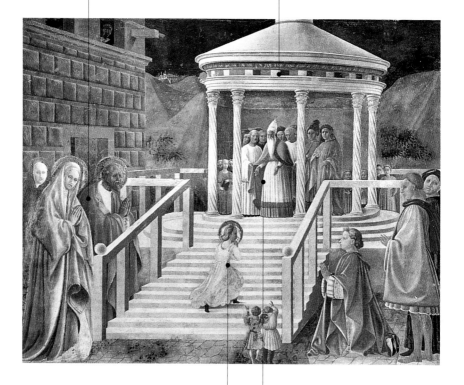

Dressed in white, Mary climbs the fifteen stairs of the temple without ever looking back. Following The Golden Legend, Uccello painted Mary as a three-year-old child.

The high priest waits for Mary at the top of the stairs, pleased with the assurance and grace with which the child ascends the steps.

▲ Paolo Uccello, *The Presentation of Mary in the Temple*, 1435–40. Prato, Duomo, Chapel of Our Lady of the Assumption

Her long flowing hair, which is frequently one of Mary's attributes even as an adult, is a reference to virginity. Even today in many countries of the world, this hairstyle is reserved for young women who have not yet married.

Even though she is intent on her weaving, Mary manages to read a prayer book at the same time.

Mary's main activities in the temple were spinning and weaving: work and prayer—almost a prefiguration of the monastic rule.

Mary's companions work at spinning and embroidering, while Mary weaves on a large loom. They are working on the rich hangings for the temple, a task assigned specifically to Mary.

▲ Church of San Primo Painter, *The Virgin at the Loom*, 1504. Kamnik, Slovenia, Church of San Primo

In the case of the marriage between Mary and Joseph, once
again the most famous and complete sequence of scenes is
Giotto's cycle in the Scrovegni Chapel in Padua.

The Marriage of the Virgin

The Place
Jerusalem

The Time
About a year before Jesus
is born

The Figures
Mary, Joseph, the high
priest (identified in the
Protevangelium of James
as Zechariah, the future
father of John the
Baptist), other suitors
for Mary's hand, and
her virgin companions

The Sources
The Protevangelium
of James, retold in
The Golden Legend

Variants
The Wedding of Mary
and Joseph

Diffusion of the Image
In Marian cycles; during
the Italian Renaissance,
the episode was depicted
in wide-open perspectives
and architectural settings

The account of the episodes leading to the marriage of Mary is
one of the most celebrated cases of an entirely spurious tradi-
tion, contaminated by legendary wonders, and yet able to take
root deeply in Christian tradition and art.

When she turned fourteen, Mary, like her classmates of the
same age, should have left the temple of Jerusalem to return to
her parents' house and take a husband. She maintained, how-
ever, that she was destined for a religious life, not marriage.
The high priest organized a test in order to discern the divine
will. He called for the unmarried men who were descendants
of David (or, according to another tradition, the representa-
tives of each of the twelve tribes of Israel) to place rods around
the altar. The elderly widower Joseph hesitated even to leave
his stick by the altar, due to his advanced age and because he
already had children. He did, however, and it was on his
branch that flowers blossomed and a white dove came to rest.
Thus Joseph was Mary's chosen husband. It should be noted,
however, that neither the Protevangelium of James nor *The
Golden Legend* speak of "marriage," but only of "betrothal."
Joseph merely pledges to take the Virgin Mary under his pro-
tection until they celebrate their nuptials and is dismayed
when he learns that she is expecting a child.

▶ Fra Angelico, *The Marriage
of the Virgin*, 1434–35.
Florence, Galleria degli Uffizi

Joseph is shown here as an elderly scholar (he holds a book that is bound in the fourteenth-century manner, in a bag), but fearful. According to the apocryphal sources, he resisted taking Mary as his wife despite the flowering of his branch. Only the high priest's threats finally convinced him.

Joseph's branch was the smallest, but it was the one that flowered. According to another tradition, a white dove flew out from within it.

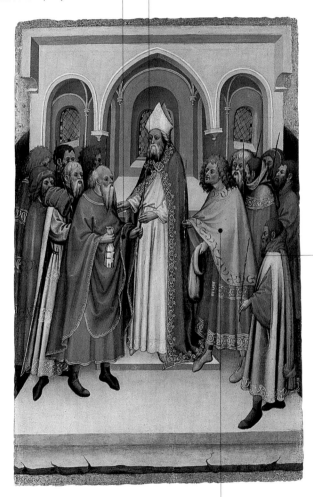

Their dry branches and surprised and disappointed expressions identify Mary's other suitors.

There should actually be twelve suitors, one for each tribe of Israel.

▲ Stefan Lochner, *The Marriage of the Virgin (The Flowering of Joseph's Branch)*, ca. 1440. Private collection

At the marriage cere-
mony, Joseph holds
up the branch that
miraculously sprouted
a green shoot.

Although the word always used is
"marriage," the ceremony described
in the apocryphal gospels and
shown here is rather a betrothal, a
prenuptial agreement solemnly
blessed by the priest, who here
wears papal vestments.

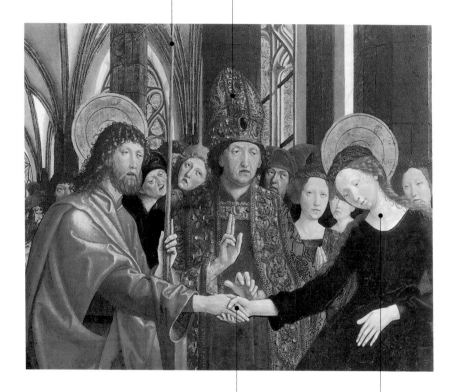

Mary and Joseph grasp each other's
right hand as a sign of their covenant
and betrothal. In paintings where
their union is considered an actual
marriage, they exchange rings.

Mary accepts the will of the
Lord with a sweet, submissive
gesture that is quite similar to
her expression in representations
of the Annunciation.

▲ Michael Pacher, *The Marriage of the Virgin*, a panel from the main altar from
the Salzburg parish church, ca. 1495–98. Vienna, Österreichische Galerie

Meticulously described in various apocryphal sources, Joseph plays a special role in Jesus' childhood and turns out to be one of the most interesting figures in the history of sacred art.

Joseph

With a very few medieval exceptions, Saint Joseph acquired a significant cult only due to the efforts of fifteenth-century preachers such as Vincent Ferrer and Bernardino of Siena. His cult reached an impressive crescendo of devotion thanks to the Carmelites and Saint Teresa of Avila: Pius IX proclaimed him patron saint of the universal Church; Pius XII superimposed the religious feast of Saint Joseph the Worker onto the secular holiday of the first of May. Following sources that are either unreliable or muddled, the history of art offers a wide range of figurative interpretations, although in general Joseph appears as a very old man, more a grandfather than a father. According to the Protevangelium of James, Joseph was a widower, with an unspecified number of children from previous marriages. This would explain the mysterious presence of Jesus' "brothers," mentioned in the canonical Gospels. An attentive reading of the four Gospels, however, reveals a very different image of Joseph: a young father who faces difficult trials to protect his family and who then keeps his son by him for a long time, in order to teach him the carpenter's trade. Jesus' time in his father's workshop is confirmed by his use of many metaphors and comparisons that refer directly to carpentry. Jesus' affection for Joseph is movingly confirmed by his suggestion that we address God with the words "Our Father."

The Place
Nazareth and Jerusalem

The Time
Sources disagree about Joseph's age; according to the Protevangelium of James, Joseph was already old at the time of his marriage; he probably died before Jesus' public ministry

The Figures
Joseph is associated with Mary and the Christ child.

The Sources
Beyond the brief mentions in the Gospels of Matthew and Luke and the Protevangelium of James, Joseph is the main character in the *History of Joseph the Carpenter*, a remarkable Greek text of the fifth or sixth century.

Diffusion of the Image
Before the Gothic period, Joseph always appears with other members of the Holy Family; from the Renaissance on, he takes on an independent spiritual intensity.

Giovanni Battista ◀ Caracciolo, *Saint Joseph and the Child Jesus*, ca. 1622. Venice, private collection

Both popular devotion and art gradually rehabilitated the figure of Joseph. From the Counter-Reformation on, Jesus' elderly earthly father becomes a model of virtue because of his silent hard work and continual self-denial.

When Jesus was born, a symbolic light was lit in Joseph's house. In this painting, the child holding a candle may be Jesus or else an angel appearing to Joseph in a vision.

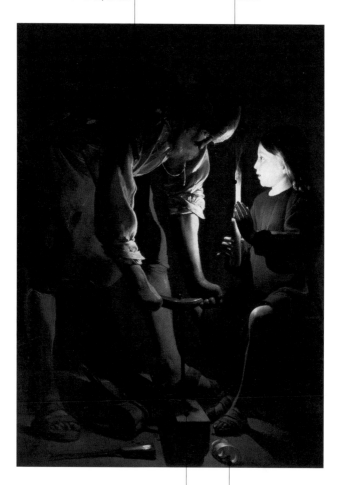

Joseph the carpenter is drilling through a wooden beam with a huge drill. This probably alludes to the nail holes that were made in the cross when Jesus was crucified.

In part because of the circulation of images like this one, Joseph was proclaimed the patron saint of workers.

▲ Georges de La Tour, *Saint Joseph the Carpenter*, ca. 1640. Paris, Musée du Louvre

The garland of flowers and the lilies that the angels bear emphasize Joseph's sainthood and his entry into Heaven.

Mary kneels in prayer at her dying husband's bedside.

▲ Giovanni Battista Lucini, *The Death of Saint Joseph*, ca. 1674. Private collection

In one of the apocryphal texts, Jesus describes Joseph's death: "He turned his face to me, and made signs for me not to leave him. Thereafter I put my hand upon his breast. . . . His eyes dissolved in tears, and at the same time he groaned after a strange manner."

Joseph's expression is unmistakable: he is afraid of death and is experiencing pain. Because of his simple, touching humanity, Joseph also became the patron saint of the dying.

THE BIRTH AND CHILDHOOD OF JESUS

◄ Martin Schongauer,
*Madonna and Child in a
Window*, ca. 1485–90.
Los Angeles, J. Paul Getty
Museum

► Leonardo da Vinci,
Virgin of the Rocks (detail),
1483–86. Paris,
Musée du Louvre

God sent the archangel Gabriel to announce to Mary that she would give birth to a son conceived by the Holy Spirit. At first frightened and troubled, Mary bowed to God's will.

The Annunciation

The Annunciation is one of the subjects that best lends itself to a richly detailed, realistic setting. An episode of the highest mysticism and poetry, the Annunciation is one of the most fascinating motifs of the entire Gospel of Luke, the only canonical Gospel that narrates it. There have been a variety of artistic interpretations of this scene, the pivotal moment of Christian history. The sensibilities of painters and sculptors have explored by turn Mary's psychological reactions, the fascinating nature of the angel, the will of God, the decoration of the setting, the scene's effect on other characters, and many descriptive details. The visual arc of Annunciations over the centuries provides an opportunity to discover profound ideas. An unusual Byzantine iconography based on the Protevangelium of James sets the Annunciation by a well where Mary had gone to draw water with a pitcher.

The Place
Nazareth

The Time
March 25, exactly nine months before the birth of Jesus

The Figures
Mary and the archangel Gabriel; God the Father, the dove that symbolizes the Holy Spirit, and—rarely—the newborn Jesus may also appear

The Sources
The Gospel of Luke and the Protevangelium of James, retold in *The Golden Legend*

Variants
In those paintings where Mary appears alone (such as the celebrated example by Antonello da Messina), she is called the Madonna of the Annunciation.

Diffusion of the Image
Extremely wide, both in cycles of paintings dedicated to Mary and as single scenes; its ready division into two parts made it popular for the hinged panels of triptychs and for altars with wings

▶ Nicolas Poussin,
The Annunciation, 1657.
London, National Gallery

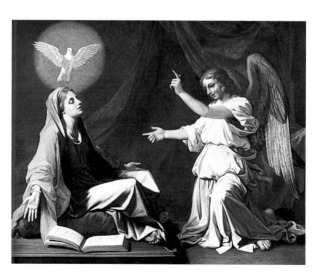

In the most common Byzantine iconography, based on the account of the Annunciation in the apocryphal Protevangelium of James, which is quite different from the Western version, the angel appears to Mary just outside the door of her home.

The pitcher that Mary was taking to draw water became a symbol of the Madonna, who at the moment of the Annunciation prepares herself to be the "container" of Jesus.

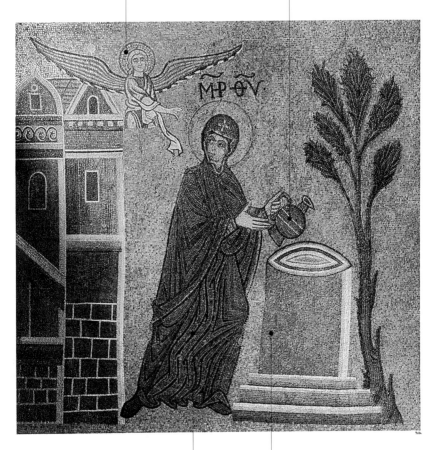

Mary has gone out to draw water from the well. Hearing the angel's words of greeting, she looks around, frightened. At first, she does not know where the voice is coming from.

Water plays a powerful symbolic role in the Scriptures, as exemplified by Jesus' words to the Samaritan woman at Jacob's well: those who drink the living waters of the Christian teachings will never suffer spiritual thirst again.

▲ *Stories from the New Testament: The Annunciation to Mary,* twelfth-century mosaic. Venice, Basilica of San Marco

The Annunciation

Before illuminating Mary, the ray of light—an emanation of the Holy Spirit in the form of a dove—crosses the painting diagonally. It passes through the Garden of Eden, reaffirming the meaning of Jesus' redemption of sins.

The angel's pose of prayer and piety is identical to Mary's. Both bow before the manifestation of each other's divinity. The magnificent iridescent wings refer to the iconography of angels in the Old Testament.

Mary has placed the small book she was reading on her knee and assumes the humble posture of her reply: "Behold, I am the handmaid of the Lord."

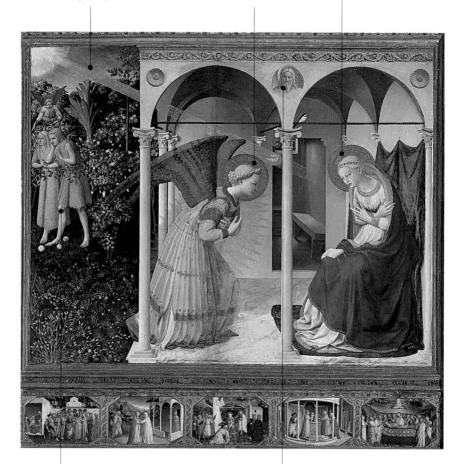

Adam and Eve's expulsion from Eden is a fundamental precedent for the Incarnation of Jesus, who, with his death on the cross, will atone for their original sin.

The figure of God the Father appears in the form of a decorative bas-relief in the middle of the Renaissance portico. The extreme modesty of the room in the background reflects Mary's humility.

▲ Fra Angelico, *The Annunciation*, ca. 1430–32. Madrid, Museo del Prado

Mary is frightened by the arrival of the angel, who suddenly interrupts a sleepy spring afternoon. She jumps to her feet, clutches a column, and raises her hand in a defensive gesture.

In this example, the announcing angel is relatively small and is dynamically shown in flight. The lily, a symbol of pure, virginal love, is often shown held by the angel in images of the Annunciation.

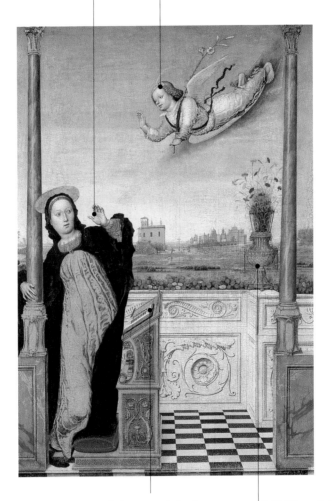

In the greater majority of Annunciations, the angel surprises Mary as she is reading a small book of prayers, which here rests on an extremely refined carved reading desk.

In Christian symbolism, red carnations are associated with the Passion, because the shape of their seeds recalls the nails with which Christ was nailed to the cross.

▲ Carlo di Giovanni Braccesco (attributed), *The Annunciation*, ca. 1480. Paris, Musée du Louvre

The perfect orderliness of Mary's room alludes to both the Madonna's virtue and the clarity of God's divine plan.

Mary is shown at the moment of conturbatio, *her perturbation, even a gesture of fright, caused by the angel's arrival and by his words.*

In this dynamic interpretation, God the Father, his hands joined, almost seems to be diving from Heaven toward Mary.

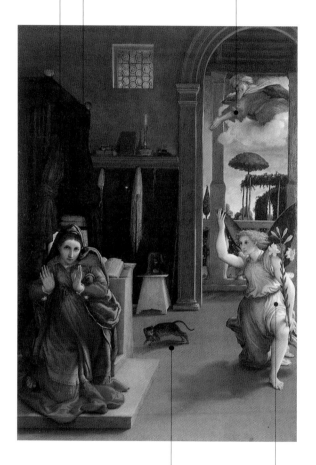

The cat with arched back that is running away is a realistic detail, but also an obvious reference to evil, which flees before the revelation of divine power. During the Middle Ages and the Renaissance, cats were charged with negative symbolism associated with witches and the devil.

Gabriel, holding the lily, addresses Mary with a peremptory gesture (the Hebrew etymology of the name Gabriel is "God is my strength"). Nevertheless, he also kneels before the mystery of the Incarnation.

▲ Lorenzo Lotto, *The Annunciation*, 1527. Recanati, Pinacoteca Comunale

The archangel Gabriel, lily in hand, kneels piously before Mary and makes the blessing gesture with his right hand. This was the preferred iconography of central Italian painters during the Renaissance.

The garden enclosed by a picket fence and divided tidily into flower beds is an image of the hortus conclusus, or enclosed garden, one of Mary's attributes. It is a symbol of Heaven and of virginal purity.

The dove of the Holy Spirit descends toward Mary, urged by a gesture from God the Father, who appears at the upper left.

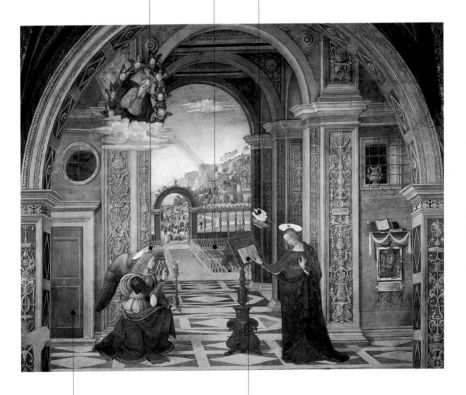

The closed door and the arch that leads into the garden perhaps refer to the ritual description of Mary as the "gate of Heaven."

Mary, as usual, interrupts her reading. In this case, the book is on a high lectern like those used in the choirs of monastic churches, which forces Mary to remain standing. The Virgin bows her head as a sign of pious submission.

▲ Pinturicchio, *The Annunciation*, 1501. Spello, Church of Santa Maria Maggiore, Baglioni Chapel

The figure sending the Holy Spirit resembles Jesus. Since God the Father typically sends the Holy Spirit, this image emphasizes the fundamental identity of God the Father and Christ.

The archangel holds a lily and kneels before Mary outside the Virgin's room. His greeting reaches her over the threshold. The word of God allows communication between the Divinity and the human world.

The Madonna bows her head and places a hand on her chest, a traditional gesture of submission.

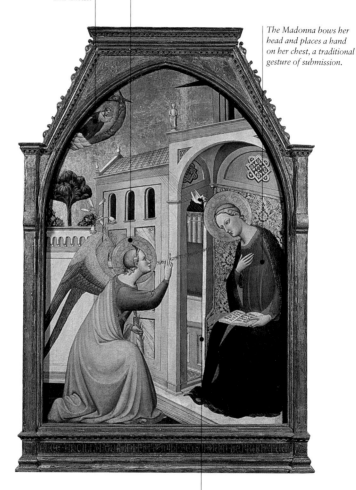

▲ Master of Saint Verdiana, *The Annunciation*, 1410. Los Angeles, J. Paul Getty Museum

Many Annunciations depict the interior of Mary's room. The apocryphal gospels insist on the fact that Mary had a room to herself in her home ever since her early childhood.

The choice of locating the Annunciation inside a large church recalls the symbolism that identifies Mary with the Church. Many details can be read allegorically, such as the three identical windows in the background that allude to the Trinity. Mary has been inserted into the middle window.

God the Father is portrayed in a stained-glass window in the background, while the ray of light with the Holy Spirit enters from the left, above the angel.

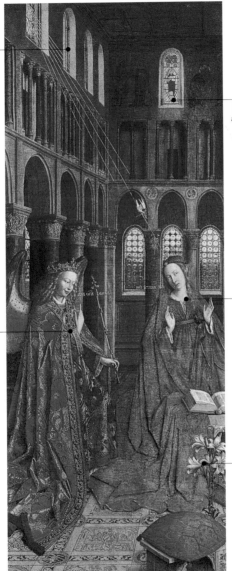

Mary's attitude is one of pious acceptance. She replies to the angel's greeting of "Hail, Mary, full of grace" (Ave gratia plena) with the words "Behold, I am the handmaid of the Lord" (Ecce ancilla Domini). Since the words are addressed to the angel, the letters read right to left.

The archangel Gabriel, sumptuously dressed in embroidered vestments, bears the staff of the gatekeepers who were charged with protecting the churches. This attribute appears frequently in northern European images.

In this version, the lilies are shown in a vase.

The historiated pavement displays recognizable biblical scenes in which God's power is manifest: David beheading Goliath, and Samson toppling the columns.

▲ Jan van Eyck, *The Annunciation*, ca. 1425–30. Washington, D.C., National Gallery of Art

Directly related to the Annunciation and Mary's conception, the episode of Mary's visit to Elizabeth always evokes a sense of tenderness and intimacy.

The Visitation

The Place
The house of Elizabeth and Zechariah on a hill near Nazareth

The Time
A few days after the Annunciation

The Figures
Mary, Elizabeth, and occasionally their husbands, Joseph and Zechariah

The Sources
The Gospel of Luke

Variants
The Meeting between Mary and Elizabeth

Diffusion of the Image
Widespread throughout the Christian world (East and West) between the fourteenth and sixteenth centuries, this episode has undergone several interesting interpretations, especially in late-Gothic German art and Renaissance Tuscan art.

Luke amply described the Annunciation and the Visitation. The "miracle" at the Visitation is interior, jealously guarded by two women in what appears to be a normal visit between two relatives who are both pregnant. At the Annunciation, the archangel Gabriel told the Virgin that her elderly relative Elizabeth was also expecting a son, but Mary's mother, Anne, too, had conceived when she was considered too old to do so. Prompted by the angel, Mary set out for the hill country outside Nazareth and the house of Zechariah and Elizabeth. According to the apocryphal tradition, Mary and Elizabeth were first cousins: Mary's mother, Anne, had a sister named Ismeria, who was Elizabeth's mother. Mary's cousin had long kept her pregnancy a secret but now was in her sixth month. When Mary arrived, Elizabeth felt the child leap in her womb and exclaimed, "Blessed are you among women, and blessed is the fruit of your womb!" (1:42). Mary responded with the prayer known as the Magnificat.

She would stay with Elizabeth for about three months, until John the Baptist was born.

▶ Jacopo Pontormo, *The Visitation*, ca. 1528–29. Carmignano, Church of San Michele

The cousins' reciprocal gestures, with their hands on each other's stomachs, highlights their pregnancies.

Zechariah and Elizabeth's luxurious house is on a hill. The path going up faithfully reflects Luke's narrative.

Mary's unbound hair is a typical sign of her virginity. The contrast with Elizabeth's veil also underscores the difference between the two pregnancies: Mary's is exclusively the work of God; Elizabeth's, although miraculous, was still human in nature.

A man appears at the door to the house. Perhaps this is Zechariah, the priest who was struck temporarily mute because he did not immediately believe an angel's announcement of Elizabeth's pregnancy.

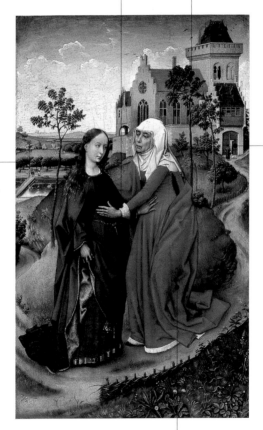

Elizabeth is older than Mary. She conceived John the Baptist when she had been considered barren for some time.

▲ Rogier van der Weyden, *The Visitation*, ca. 1426–30. Leipzig, Museum der Bildenden Künste

Behind the two main
characters, unusually,
are Mary's half sisters,
from Anne's second
and third marriages.

Mary of Salome
joins her hands
in prayer.

Mary responds to Elizabeth's gesture by
solicitously inviting her to rise. The scene
illustrates the correct attitude of the faithful,
who are immediately comforted when they
prostrate themselves before the Madonna.

Elizabeth kneels before
Mary. Generally, Tuscan
art tends to favor this
attitude of devotion on the
part of the older cousin.

▲ Domenico Ghirlandaio, *The Visitation*, 1491. Paris, Musée du Louvre

Piero della Francesca's moving masterpiece, repeatedly the object of exegetical studies because of its doctrinal implications, is the most renowned—but not the only— image of the pregnant Madonna.

The Madonna of Childbirth

Mary was, naturally, expecting at the Visitation, although according to Luke's narrative she would have been at the very beginning of her pregnancy and hardly showing. Many artists have emphasized the Madonna's pregnancy even though she was much less further along than Elizabeth, who was already in the sixth month. The Madonna of Childbirth is an entirely different scene, not a narrative episode, but a pause for intimate meditation. Here, the Madonna is reflecting on the future birth of her son and on her role as his mother. It is a very specific theme, and its popularity as a private devotion during pregnancy is easily understood. There is some debate about whether or not Mary experienced pain in childbirth. The

Scriptures seem to hold that Mary participated fully in the suffering of every birthing mother (see, for example, Revelation 12:2). The medieval tradition, however, as evidenced in *The Golden Legend*, tended to favor the idea that Jesus' birth was above the human condition, completely painless, in fact, "joyous," or even unnoticed.

The Place
Nazareth

The Time
A few months before the birth of Jesus

The Figures
Mary

The Sources
None; this is essentially an independent image that is not based on any particular Gospel, canonical, or apocryphal passages

Diffusion of the Image
This distinct, relatively uncommon image, an object of local devotion, was no longer represented after the sixteenth century.

Master of the Madonna of ◀
Childbirth, *Madonna of Childbirth and Two Votaries*, late fourteenth century. Venice, Gallerie dell'Accademia

The angels' perfectly symmetrical gestures indicate the ceremonial and mystical nature of the image.

The tabernacle-tent made of precious fabrics is similar to the one made to hold and protect the Ark of the Covenant.

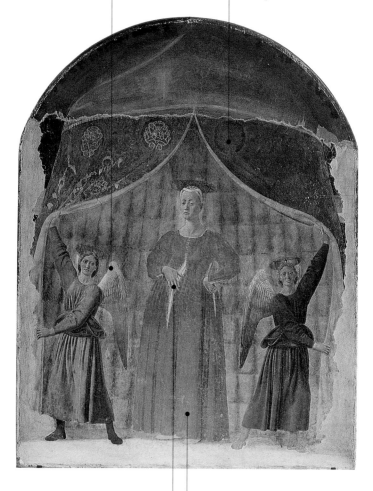

With her right hand, Mary opens her dress, emphasizing her stomach and her advanced pregnancy.

Mary's perfect axial symmetry and the volumetric treatment of the figure allude to her role as a mystical tabernacle, keeper of the Holy of Holies. At the same time, Piero della Francesca included two realistic elements: the gesture of her left hand, which supports her lower back, and the slight arching of her back, both typical poses of pregnant women.

▲ Piero della Francesca, *The Madonna of Childbirth*, ca. 1476–83. Monterchi, Arezzo, Museo Civico

Christ blessing is depicted in the cusp of the painting.

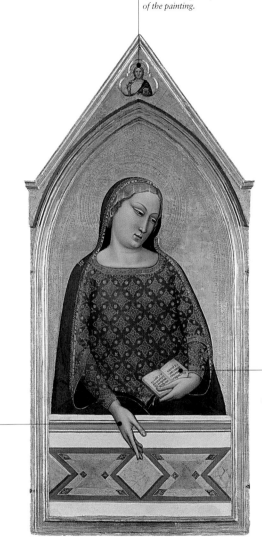

Both Mary's gesture and her gaze are directed at the faithful below. This work served as a small altar and stresses her role as intercessor and mediator between humanity and God.

The first words of the Magnificat can be read clearly in the book. Mary spoke this prayer at the Visitation, in answer to Elizabeth's greeting.

▲ Bernardo Daddi, *Madonna, Saint Thomas Aquinas, and Saint Paul* (detail), ca. 1330.
Los Angeles, J. Paul Getty Museum

The most highly anticipated and poetic feast of the liturgical year celebrates Jesus' birth in Bethlehem. Throughout the centuries, the scenery has become embellished with detailed surroundings, animals, figures, lights, and sounds.

The Nativity

The scene most accurately defined as the Nativity occurred in the dark of night, in a silence charged with expectation that was probably broken by the Madonna's contractions and then, finally, by the Christ child's first cry. The chorus of angels, the shepherds, and, lastly, the Magi would all come later.

The Gospel of Luke describes the episode succinctly. Responding to an Augustan decree, Joseph and Mary traveled from Nazareth to Bethlehem in order to be registered in the general census of the Roman Empire. When they arrived in Bethlehem, Mary went into labor, but there was no lodging to be found, so the expectant mother had to make the best of a chance shelter. Luke did not describe it, but, by speaking explicitly of a manger in which the child was placed, he implied that it may have been a stable or some sort of lean-to

The Place
Bethlehem

The Time
December 25

The Figures
Mary and the newborn child, Joseph (usually standing apart), and sometimes angels (usually musicians)

The Sources
The Gospel of Luke, the Gospel of Pseudo-Matthew, and the Protevangelium of James, retold in *The Golden Legend*

Variants
Holy Night

Diffusion of the Image
Parallels and complements the Crucifixion; this is the most important scene in Christian iconography of all times and on all continents

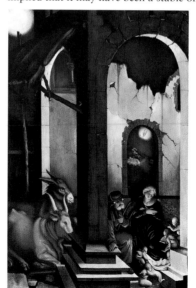

for animals. The apocryphal Gospel of Pseudo-Matthew, instead, very specifically tells of a cave and adds to the scene the ass and ox that have been part of the popular, devotional, and iconographic images of Nativity scenes ever since.

▶ Hans Baldung Grien,
The Nativity, 1520.
Munich, Alte Pinakothek

A small records office has been set up next to the village tavern, where the residents of Bethlehem can go to register in the census, ordered by Augustus, of all those living in the Roman Empire.

This rare and moving iconography shows Joseph and Mary's arrival in Bethlehem for the census at the end of December. The couple lived in Nazareth, in Galilee, but Joseph was a native of Judea and had to be counted there. Obviously, the December landscape of the Middle East is entirely different from this one, with its typically northern European features and climate, as depicted by Pieter Bruegel the Elder.

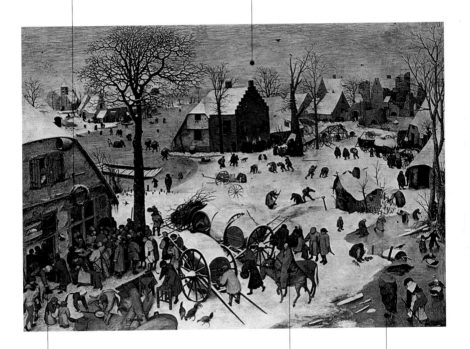

Pigs are slaughtered in the midwinter; it is a key moment in the life of peasant families. It would seem a stretch to label such a realistic scene as anti-Semitic, even though it is generally known that Jews consider the pig an unclean animal.

Mary approaches the census office riding a donkey that is led by Joseph.

Other families cross the frozen pond to register, while everyday activities continue in the village. Joseph and Mary's arrival is essentially ignored.

▲ Pieter Bruegel the Elder, *The Census at Bethlehem*, 1566. Brussels, Musées royaux des beaux-arts

The oldest shepherd listens to the angel while the youngest plays a pipe, which has become a typical instrument for Christmas music. The sheep are arranged around the edge of the cave in which the birth has taken place.

The prominent title of the panel is Nativity of the Lord, *even though the entire upper part is dedicated to the Annunciation to the Shepherds. The two angels and two shepherds have been arranged symmetrically.*

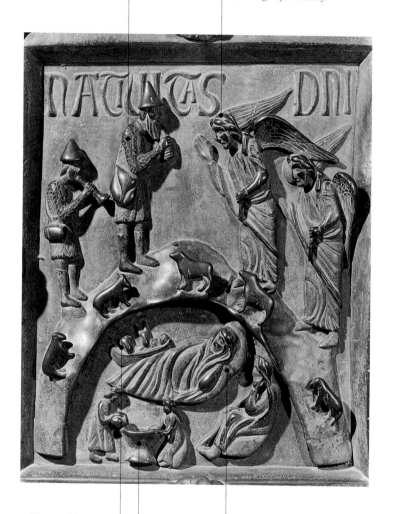

The ass and the ox warm the Child in the manger with their breath.

Two midwives prepare a bath for the Child.

Mary is shown lying down, exhausted from the effort and pain of childbirth. Joseph is also noticeably tired.

▲ Bonannus of Pisa, *The Nativity of Christ; The Annunciation to the Shepherds*, ca. 1190. Pisa, Duomo, The San Ranieri Door

The muzzles of the ox and the ass are visible in the shadows. The presence of these two animals, which has become traditional in crèches, harks back to the apocryphal gospels, which refer to two passages from the prophets Isaiah and Habakkuk.

The Annunciation to the Shepherds can be seen in the background. Correctly following the Gospel of Luke, the Dutch painter painted only one angel, who is brilliantly luminous in the dark of night.

As in all depictions of the Nativity before the Counter-Reformation, Joseph's role is markedly secondary.

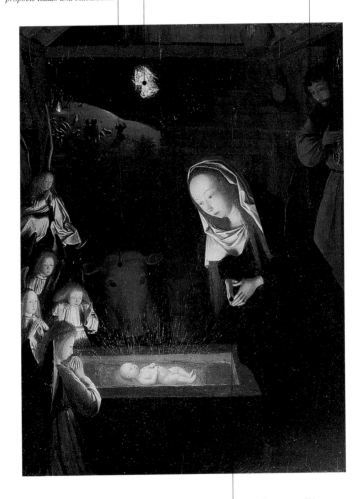

Mary, first among all human beings, is illuminated by the light shining from the Christ child. Her prayerful pose, which predominates in Western art, was a typical expression of medieval devotion.

▲ Geertgen tot Sint Jans, *The Nativity at Night*, ca. 1480–85. London, National Gallery

The Nativity is taking place under a roof in a rocky landscape, a combination of the stable and grotto traditions.

The immense star that shone above the grotto follows the Gospel of Pseudo-Matthew precisely. It is an example of the extent to which non-biblical texts influenced representations of the Nativity.

This accurate interpretation of the Gospel of Luke shows only one angel (here identified by its gatekeeper's staff) announcing the birth to the shepherds, while other angels sing hymns of glory.

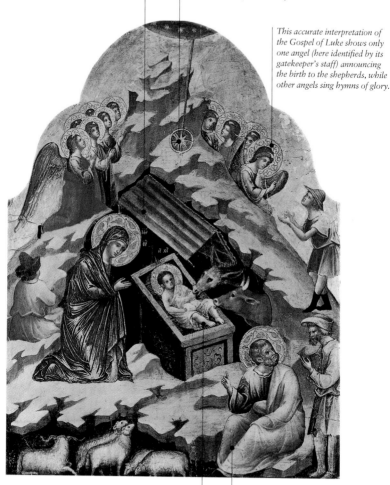

Warmed by the ox and the ass and worshiped by the Madonna, Jesus lies in a tiny, Classical sarcophagus, symbolizing the connection between Christianity and antiquity as well as that between his birth and future Passion.

Joseph shows the shepherds the Child, thus inaugurating his role as adoptive father and human interpreter of Jesus' divinity.

▲ Paolo Veneziano, *The Birth of Christ*, ca. 1355. Belgrade, Narodni muzej

Joseph opens the door of the stable to the shepherds and points to the Child.

The ox and the little ass watch over the Child, who emanates a halo of light.

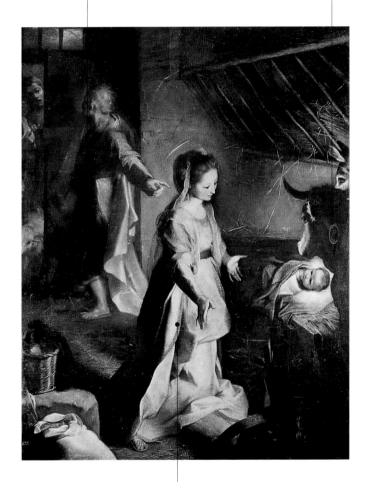

According to the norms of the Counter-Reformation, Mary is worshiping the newborn Jesus. However, Barocci's sensibility gives the scene a delicate and affectionate feeling.

▲ Federico Barocci, *The Nativity of Christ*, ca. 1590. Madrid, Museo del Prado

In a long inscription in Greek, Botticelli noted that he painted this work in 1501, during a period of political and religious turbulence provoked by the prophecies of Revelation.

Botticelli adopted the mixed iconography of the grotto and the stable, painting a cave with an awning.

The angels, with their crowns and olive branches, symbols of royalty and peace, form a harmonious ring between the world and the heavenly spheres, which are symbolized by the golden dome.

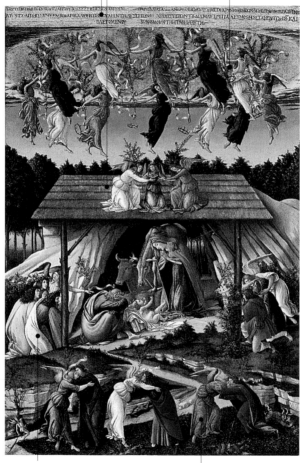

The angels point out the Christ child to the Magi and the shepherds. There are references everywhere to the olive trees of peace; Botticelli was anxious about Florence's situation after the Medici had been driven from the city.

Like the three angels on the roof, the three angels below wear the colors of the three theological virtues: white for faith, green for hope, and red for charity.

▲ Sandro Botticelli, *Mystic Nativity*, 1500. London, National Gallery

Based on apocryphal sources, this episode is one of a series of "tests" of Mary's virginity. These tests, charged with an unusual physicality, have roused the curiosity of artists and patrons alike.

The Incredulous Midwife

The detailed account of the Nativity in the Protevangelium of James includes a secondary episode that has had some diffusion in art but that is rarely recognized, despite the presence, in some cases, of very explicit inscriptions.

In order to help Mary in childbirth, Joseph went in search of a midwife, who arrived after Jesus was born. The midwife noticed that Mary was a virgin and sang a hymn in honor of the miraculous birth of the Savior of Israel. She then ran to call a friend, Salome, who absolutely refused to believe that a virgin could have had a child. Salome, at the grotto of the Nativity, anticipated Saint Thomas when she declared, "By God, unless I thrust in my finger, and search the parts, I will not believe." She extended her hand toward Mary, but immediately her hand withered and was paralyzed. At that point, Salome pleaded for forgiveness; just then, an angel appeared and advised her to take the Christ child in her arms. The repentant disbeliever carried out the loving gesture the angel had suggested and was healed.

The Place
Bethlehem

The Time
The moment of
Jesus' birth

The Figures
Mary, the Christ child,
two midwives, and
sometimes Joseph

The Sources
The Protevangelium of
James, retold in *The
Golden Legend*

Diffusion of the Image
A rare episode that is
not always correctly
identified, this is a varia-
tion on the Nativity.

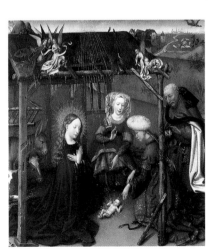

Jacques Daret, ◄
The Nativity, ca. 1433–35.
Madrid, Thyssen-Bornemisza
Collection

The Incredulous Midwife

Typical of fifteenth-century Flemish painting, the rising sun translates the complex symbolism of light in the Protevangelium of James into a perfectly realistic image.

An angel suggests to Salome how she can be healed: "Put your hands on the infant, and carry it, and you will have safety and joy."

The incredulous midwife, named Salome, wished to verify Mary's virginity, but her outstretched hand remained paralyzed. The scroll reads, "I will believe only what I have touched."

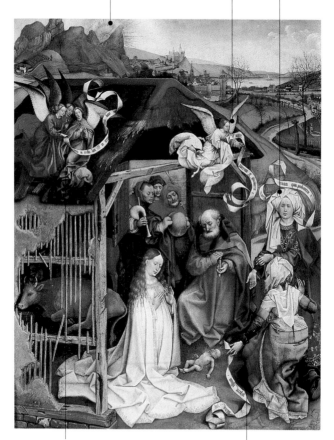

As we may infer from the presence of the shepherds and of the angels who sing the Gloria, this scene combines three different moments: the Nativity itself, the Adoration of the Shepherds, and—the principal subject—the episode of the Incredulous Midwife.

The first midwife to have hurried over exclaims in astonishment, "A virgin has given birth to a son," as we read in the scroll.

▲ Robert Campin, *The Nativity*, ca. 1425. Dijon, Musée des beaux-arts

The shepherds are figures charged with immediate human intensity as well as deep symbolic meaning. The scene that Luke narrated is full of descriptive details and solemn and passionate language.

The Adoration of the Shepherds

At the very beginning of the episode, Luke empha-sized that it happened at night. In this regard, the episodes connected to the Nativity and—at the opposite end of the Christological iconographic cycle—the Arrest of Christ com-prise exceptions in religious painting, which at least until the late sixteenth century was mainly set in daylight. An unex-pected glare of light, alarming the shepherds, signaled an angel's arrival. Luke repeatedly mentioned a single angel; only later is the "multitude of the heavenly host" (2:13) added. The angel announced a "great joy" (2:10) to the shepherds; the angels then proclaim the famous Gloria in excelsis Deo (Glory to God in the highest). They did not accompany the shepherds, but only gave them a "sign" to look for—a swaddled child lying in a manger. The shepherds set out toward Bethlehem and eventually found Mary with Joseph and the Christ child in the manger. Upon seeing the angels' announce-ment confirmed, they spread the news (and thus are the first "evange-lists"). Then they returned to their flocks, "glorifying and praising God" (2:20).

The Place
Bethlehem

The Time
The night Jesus is born

The Figures
Mary and the newborn Jesus, various shepherds, an angel who announces the "great joy" to them, and sometimes choirs of musical angels

The Sources
The Gospel of Luke

Variants
Although this episode and the Nativity are usu-ally depicted together, occasionally they can be presented separately.

Diffusion of the Image
Extremely widespread in every era and country, to the point of being con-fused with the Nativity

Hugo van der Goes, ◀
The Adoration of the Shepherds (detail), from
The Portinari Triptych, 1479.
Florence, Galleria degli Uffizi

In Luke's text, an angel appears at night to shepherds who are awake, guarding their flocks.

The angel's gesture of blessing is intended to calm the shepherds, who "were filled with fear" (2:9). The angel's smile expresses the words "I bring you good news of a great joy" (Annuntio vobis gaudium magnum, 2:10), which are used today to signal a pope's election.

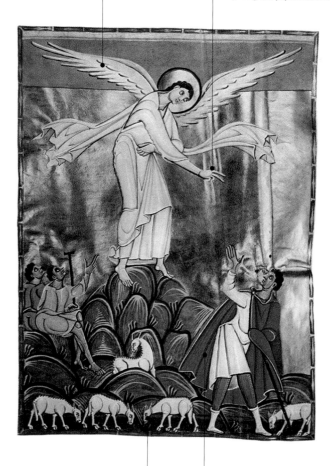

Images and metaphors linked to shepherding, sheep, and lambs are quite frequent in the Gospels.

Through the use of color, the medieval illuminator sought to translate pictorially the evangelist's words "the glory of the Lord shone around them" (2:9).

▲ Reichenau Scriptorium, *The Annunciation to the Shepherds*, from an illuminated page of Henry II's Gospel book, 1007–12. Munich, Bayerische Staatsbibliothek

A choir of angels sings "Gloria in excelsis Deo" (Glory to God in the highest).

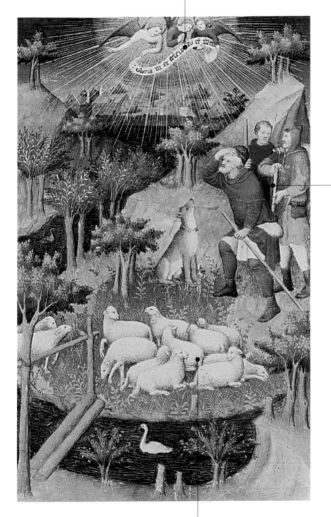

As we can see by the shepherds' attitudes, the actual Annunciation of the Nativity has already occurred. Luke, in fact, wrote that the shepherds talked among themselves and decided to walk toward Bethlehem. The exact title of this miniature, therefore, should not be The Annunciation to the Shepherds, but rather, "the shepherds make their way to Bethlehem."

▲ Boucicaut Master, *The Annunciation to the Shepherds*, a miniature from the *Boucicaut Book of Hours*, ca. 1410–15. Paris, Musée Jacquemart-André

The spotless white sheep in the meadow recall the words of the Twenty-third Psalm, in which God is praised for leading his flock to rest in green pastures.

The Adoration of the Shepherds

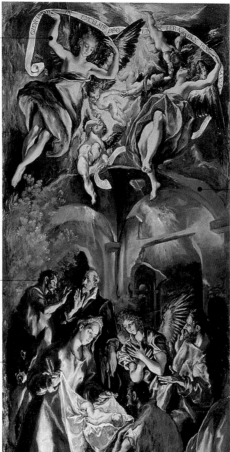

By painting angels of different ages and sizes, El Greco was alluding to the "multitude of the heavenly host" that Luke mentions (2:13). The scroll refers to their words: "Glory to God in the highest, and peace on earth to people of good will."

The dilapidated building recalls the precariousness of the shelter where Mary gave birth. It may also refer to the medieval legend that a pagan temple in the heart of Rome crumbled at the very moment Jesus was born.

Here, too, Joseph welcomes the shepherds and points toward the Christ child.

The ass, a symbol of readiness and humility, often occurs in sacred iconography, especially in the Flight into Egypt and the Entry into Jerusalem.

The lamb with its legs tied, which the shepherds brought as a gift, is the key element in this painting. It symbolizes Jesus, who is offering himself as a sacrificial victim. This image is typical of paintings after the Counter-Reformation.

▲ El Greco, *The Adoration of the Shepherds*, 1596–1600.
Bucharest, The National Museum of Romanian Art

The stream of clear water is a reference to the Bible's frequent use of water as a symbol. Here, it seems to refer primarily to the meeting of Christ and the woman of Samaria, when Jesus compares himself to a "spring of water welling up" (John 4:14).

Unlike most renderings of the Adoration of the Shepherds, this scene is not set at night. By spreading abundant and serene sunlight over the countryside, Giorgione alluded to the divine grace that descends on the world at Jesus' birth and "make[s] all things new" (Rev. 21:5).

Little angels' heads along the archway into the cave hint at the celestial choir, without impinging on the idyllic country atmosphere that reigns over this scene.

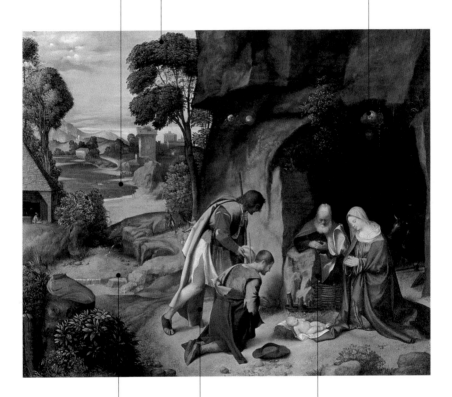

The smooth and well-lit road that winds through the countryside may stand for the Christian's path through the world.

The shepherds, who act and are dressed like pilgrims, number only two and have neither flocks nor pipes. Theirs is a shy and silent homage.

The Madonna and Joseph also kneel and pray. The gazes of the four adults converge on the Christ child, who, though not the composition's geometric center, is its focus.

▲ Giorgione, *The Adoration of the Shepherds*, ca. 1504. Washington, D.C., National Gallery of Art

Joseph, who stands with his purse attached to his belt, is ready to depart. The ass, too, has risen, unlike the ox.

With her characteristic long, flowing hair, the Virgin kneels in prayer. Placed along the diagonal between Joseph and the Christ child, she expresses explicitly the unity of the Holy Family.

There are three shepherds, like the Magi. The differences in their gestures and ages are intended to suggest a rustic yet complementary counterpoint to the kings' homage.

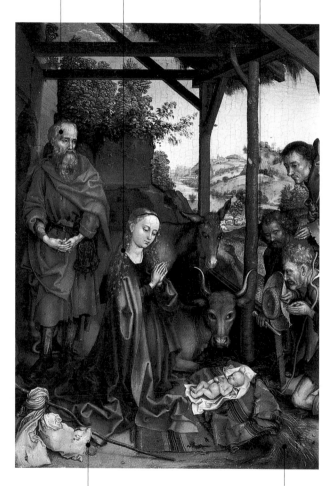

The bundles and staff in the foreground indicate the Holy Family's immediate need to flee to Egypt.

According to medieval tradition, Saint Helen brought the hay from the manger back to Rome as a relic.

▲ Martin Schongauer, *The Adoration of the Shepherds*, ca. 1472. Berlin, Gemäldegalerie

After the Counter-Reformation, images of Joseph become increasingly distinct: his delicate halo and nobler features set him apart from the shepherds' rustic humanity.

Strozzi, a painter from Genoa who was a Capuchin friar, tends to isolate the Madonna from her affectionate surroundings. As Luke writes, during the Adoration of the Shepherds "Mary kept all these things, pondering them in her heart" (2:19).

The shepherds, like the Magi, bring gifts to Bethlehem.

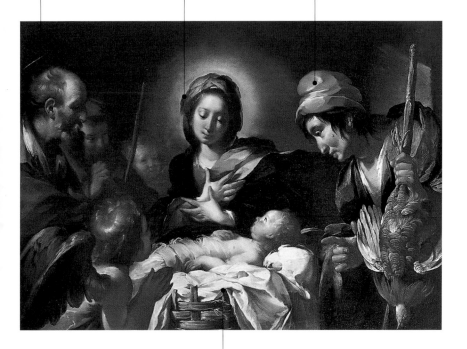

The child Jesus is not placed in a manger, but in a basket full of linen. Unusually, but very touchingly, he gazes at Mary.

▲ Bernardo Strozzi, *The Adoration of the Shepherds*, ca. 1616–18. Baltimore, Walters Art Gallery

Matthew, followed by an extremely rich medieval apocryphal literary tradition, told of the Magi and the two closely connected episodes of the Massacre of the Innocents and the Flight into Egypt.

The Journey of the Magi

The pseudoevangelical narratives originating in the East flesh out these fascinating yet elusive characters from the Gospel of Matthew. The first canonical Gospel describes how there appeared in Jerusalem "wise men from the East" (2:1). Having seen a star, they were inquiring about the newborn king of the Jews. The actual king, Herod, hurriedly called for the scribes and high priests, who told him of the prophecy that stated that Christ would be born in Bethlehem. Herod then summoned the Magi and directed them to the town, asking them to "search diligently for the child" (2:8). The wise men set off

again, following the star—which had reappeared—to the Child's "house" (Matthew mentioned neither a cave nor a stable). They bowed in worship and offered gifts of gold, frankincense, and myrrh. After a dream warned them to avoid Herod, they took another route home.

Matthew did not say how many Magi there were, nor that they were "kings" traveling with an entourage, nor whether they were of different races and ages. These elements, however, have come to be permanent fixtures of the tradition and iconography.

The Magi converge on their meeting place from different valleys. According to the Armenian apocryphal gospels (which provide the most details about the Magi), they journeyed from Persia, and the star that guided them was the light from an angel.

The Magis' retinues include scouts on the hilltops, mounted soldiers, and buglers.

In this case, the Magi are clearly distinguished by their three different ages and their royal insignia.

In the lower part of the painting are David and Isaiah with scrolls quoting prophecies of the birth of the Messiah.

▲ Master of the Saint Bartholomew Altarpiece, *The Meeting of the Three Kings with David and Isaiah*, before 1480. Los Angeles, J. Paul Getty Museum

The attention of the Magi is on a dark cave; deep within it they hope to make out the glow of the star, rendered faint and impossible to discern in the light of day.

The second Magus has clearly Middle Eastern traits, including his clothing and skin color. Giorgione's Magi represent not only the three ages of man but also the distinct races that descended from Noah's three sons.

The youngest of the three observes carefully, with the aid of scientific instruments. The traditional title of this work is The Three Philosophers; only recently has the opinion taken hold that these were the journeying Magi.

The oldest Magus holds very visible astronomical charts. According to the Armenian tradition, the Magi were the kings of Persia, India, and Arabia; Zoroastrians; and astronomers. The same source names them as Melkon (which later became Melchior), Balthasar, and Gaspar.

▲ Giorgione, *The Three Philosophers*, ca. 1505. Vienna, Kunsthistorisches Museum

This figure represents one of the sages that Herod consulted. On the basis of the prophecies, the priests and sages indicated Bethlehem for the birth.

Following the Gospel of Matthew, the medieval manuscript illuminator gave Herod an anxious and perplexed expression.

Passing through Jerusalem, the Magi come before King Herod to ask him where to find the newborn king of the Jews—Herod's own title!

Herod's throne is a folding chair decorated with lions' heads. The inclusion of these small heads of ferocious beasts beside the king injects an element of wickedness and danger to the scene.

As they render homage to the Christ child (the oldest always steps forward first), the Magi identify the star directly above Mary's head.

▲ *The Magi before Herod* and *The Adoration of the Magi*, an illuminated page from the Ingeburge Psalter of Denmark, ca. 1200. Chantilly, Musée Condé

This bas-relief is located next to the ancient presumed tomb of the Magi, which today is empty. The Holy Roman Emperor Frederick Barbarossa ordered the relics transferred from Milan to Cologne.

An angel visits the Magi in a dream and warns them of Herod's intentions.

The oldest of the Magi leads the way up a steep path.

Curiously, the Magi are sleeping sitting up, in what seems to be more of an afternoon nap than a night's slumber.

The Magi set off once more, changing their route after the angel's warning.

▲ Campionesi Masters, *The Journey and Dream of the Magi*, a detail from the *Magi Triptych*, 1350. Milan, Basilica of Sant'Eustorgio

*The precious gifts the Magi offered the Christ child were gold,
a symbol of his royalty; frankincense, a symbol of his priestly
ministry; and myrrh, a symbol of his incarnation as a mortal
man, destined to die and be buried.*

The Adoration of the Magi

The gifts at the Epiphany are three, and this suggested the
number of characters: Melkon, king of the Persians; Balthasar,
king of India; and Gaspar, king of Arabia. A connection was
made between the fact that the kings went to Bethlehem with
precious gifts, accompanied by a retinue, and diplomatic eti-
quette, which required the powerful to pay homage. Saint
Bernard, however, preferred a more down-to-earth interpreta-
tion: the gold was to relieve Mary and Joseph's poverty, the
frankincense was to perfume the air of the stable, and the
myrrh (a medicinal herb) was to nurture the health of the
child. There is no lack of clues about where the Magi origi-
nated. In medieval art, the Magi are kings with Western fea-
tures, and one of them looks younger. After the fourteenth
century the kings, believed to be descendants of Noah, were
portrayed as being of three different ages, races, and continents.

The Place
Bethlehem

The Time
Thirteen days after the
birth of Jesus (January 6);
in the Middle Ages it was
believed that the episodes
of the Baptism of Christ,
the Marriage at Cana, and
the Miracle of the Loaves
and Fishes occurred on
this same date

The Figures
The Magi with their
retinue; the Holy Family

The Sources
The Gospel of Matthew
and Syrian, Armenian,
and Arab apocryphal
traditions retold in *The
Golden Legend*

Variants
The Epiphany

Diffusion of the Image
Extremely widespread
and general, with a
particular emphasis in
fifteenth-century Florence
(the Medici family liked
to identify themselves
with the Magi)

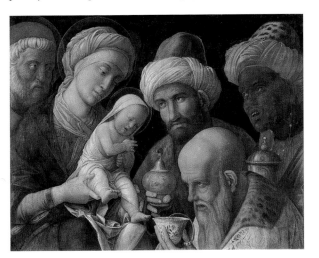

Andrea Mantegna, ◄
The Adoration of the Magi,
1495–1505. Los Angeles,
J. Paul Getty Museum

The Adoration of the Magi

Although almost invisible, the star of Bethlehem still shines from on high.

At the center of the scene is a group of figures who have nothing whatever to do with the story. They are hunters who are resting and quenching their thirst as they celebrate their capture of a hare.

The shepherds have returned to tending their flocks. The Epiphany occurs several days after their visit to the Christ child. A wolf hiding in a cave threatens the sheep, and the dog snarls, smelling danger.

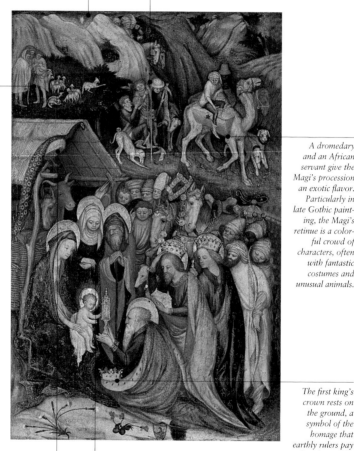

A dromedary and an African servant give the Magi's procession an exotic flavor. Particularly in late Gothic painting, the Magi's retinue is a colorful crowd of characters, often with fantastic costumes and unusual animals.

The first king's crown rests on the ground, a symbol of the homage that earthly rulers pay the Christ child.

Perched on the beam of the stable, as if in a royal garden, the peacock accentuates the scene's regality.

This elderly woman with the halo could be Anne, Mary's mother and Jesus' grandmother, or Elizabeth, Mary's cousin, who gave birth to John the Baptist six months earlier.

▲ Stefano da Verona, *The Adoration of the Magi*, 1435. Milan, Pinacoteca di Brera

In the middle ground, Joseph raises his gaze toward Heaven. The ox, the ass, and the shepherds are also moved to the back in order to provide space for the Magi and their sumptuous retinue.

The Magi bring gifts of gold, frankincense, and myrrh. In northern European painting, the containers for these gifts became progressively more precious, in effect promotional images for the masterpieces of local goldsmiths.

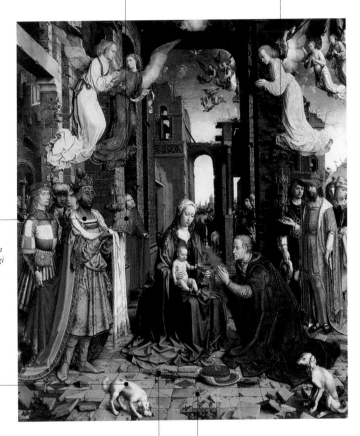

Beginning in the mid-fifteenth century, it became more common to find one of the Magi represented as a black African, a descendant of one of the sons of Noah. He is usually given the name Balthasar.

The little dog chewing on a bone, which is placed prominently in the foreground, foreshadows the Passion. A skull and bones often appear at the foot of the cross.

The scepter that rests on the ground in front of Mary and Jesus is a sign of the kings' homage to a more powerful sovereign than they.

The tiles are of high quality, but quite cracked and uneven, like the ruins of the grand buildings in the background. The floor symbolizes the decline of ancient civilization, which was restored and renewed by Christ's coming.

▲ Mabuse, *The Adoration of the Kings*, 1500–1515. London, National Gallery

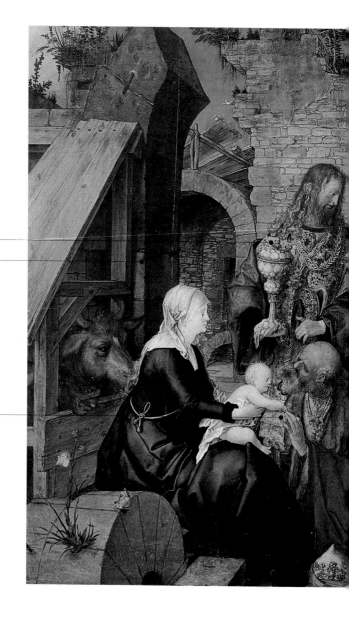

The gifts have been interpreted in a variety of ways: in the most common view, gold is considered a tribute to the regality of Jesus; frankincense is a symbol of piety, prayer, and the priesthood; and myrrh—a medicinal herb used for embalming—symbolizes the physical and corporeal humanity of Jesus, who is destined to die and be buried.

The stable leans against the massive, but crumbling structures of an ancient building. A humanist such as Dürer is insisting on Christianity's continuity with and renewal of the Classical world.

The second Magus is a self-portrait of the artist, who in his own way paid homage to the Christ child by painting this splendid work.

▲ Albrecht Dürer, *The Adoration of the Magi*, 1504. Florence, Galleria degli Uffizi

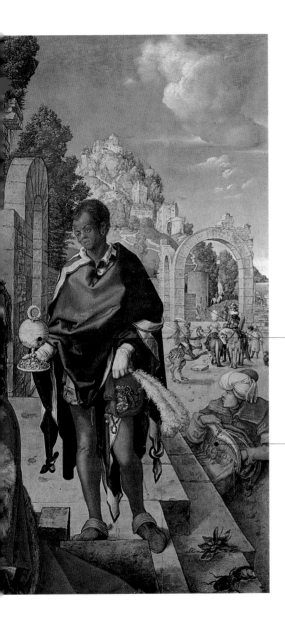

The container of myrrh has a serpent on its cover, a symbol of death and corruption.

Just one figure with a turban is enough to give an exotic touch to the Magi's retinue, which here is particularly sparse and distracted.

Only a couple of lines from Luke's Gospel recall this important event of Jesus' infancy, the most specific and irrevocable sign of his Jewish identity.

The Circumcision

A number of facts in the Gospels of Luke and Matthew intertwine.

According to Luke, eight days after his birth the Christ child was brought to the temple of an unspecified city to be circumcised and be given the name Jesus. If we follow Matthew, Mary and Joseph would have returned to their precarious situation in Bethlehem, there to receive the Magi a few days later and then flee into Egypt.

According to Jewish custom, circumcision was also the occasion to name a newborn child. This explains why the Jesuits, for whom the name of Jesus is especially important, commissioned altarpieces featuring the Circumcision.

In the Middle Ages, the Circumcision was primarily considered as the first time Jesus shed his blood. This is why the bloody aspects of this scene—or at least the small knife used for the operation—tended to be highlighted in the oldest representations. Emotions prevail in Renaissance interpretations: the priest's concentration, Mary's worry, the Child's fear.

The subject of the Circumcision, which was understood as identifying the chosen people, was hotly debated during Christianity's first centuries. Baptism's supplanting of this rite occurred only after much disagreement among the various communities.

The Place
The temple in Bethlehem, or perhaps Jerusalem

The Time
Eight days after the birth of Jesus

The Figures
The newborn Jesus and his parents; the high priest

The Sources
The Gospel of Luke

Variants
This episode is sometimes mistaken for the Presentation of Jesus in the Temple.

Diffusion of the Image
Fairly widespread during the Gothic and Renaissance periods, and into the Counter-Reformation

▶ Giotto, *The Circumcision*, 1304–6. Padua, Scrovegni Chapel

An attendant holds a book of prayers, in keeping with the ritual of the religious ceremony. The scene is symbolically set on an altar.

The architecture accurately reflects the late Gothic style of the "hall" churches of the alpine regions.

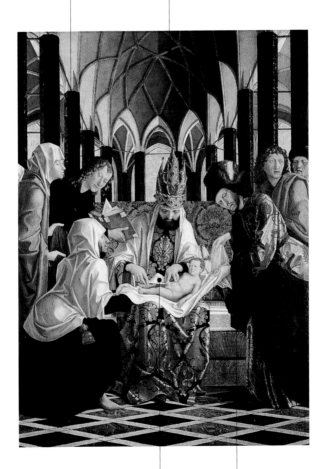

Pacher showed the precise moment of the tiny operation, with the priest cutting Jesus' foreskin.

Scenes of Jesus' childhood often prefigure the Passion. The figure holding the cloth recalls Joseph of Arimathea's gesture with the shroud at the Deposition.

▲ Michael Pacher, *The Circumcision of Christ*, a panel from the altar of Saint Wolfgang, 1479–81. Sankt Wolfgang, parish church

The Circumcision

Joseph holds a candle, a symbol of the purification that takes place with circumcision.

The altar's bas-relief portrays Moses receiving the Tablets of the Law. This subject is connected to the Circumcision because it confirms that Jesus rigorously observed the Jewish religion.

This elderly woman could be Anne, Mary's mother, or the aged prophet with a similar name at the temple.

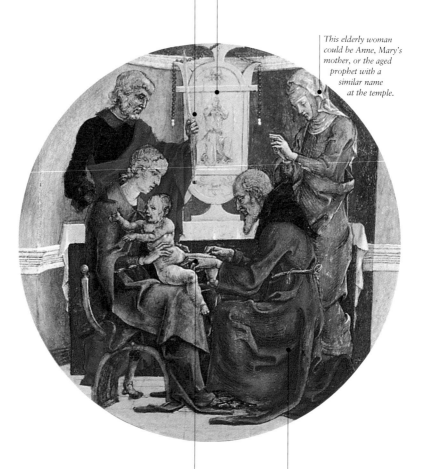

The incision is done delicately with a scalpel. In this version, it is Mary who holds Jesus in her arms.

The priest who is carrying out the tiny operation is the same Simeon mentioned in the episode of the Presentation of Jesus in the Temple.

▲ Cosmè Tura, *The Circumcision of Christ*, ca. 1470. Boston, Isabella Stewart Gardner Museum

Mary and Joseph watch prayerfully and do not participate in the ritual, which is entirely carried out by priests. In examples such as this, the painting of the Counter-Reformation tended to affirm the essential role played by the priesthood, whereas the Protestant supported a more direct participation on the part of the faithful.

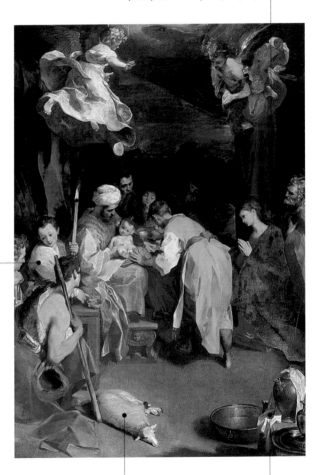

A young attendant holds a candle and points to the small basin—a symbol of purity—where Jesus' foreskin—a symbol of sacrifice—will be placed.

The lamb is placed in a prominent position. The Circumcision spilled the first drops of Jesus' blood, almost foreshadowing his destiny as sacrificial victim.

Pitchers, basins, and immaculate linen clearly refer to the rite of Baptism, the sacrament that takes the place of circumcision for Christians.

▲ Federico Barocci, *The Circumcision*, 1590. Paris, Musée du Louvre

This single scene incorporates several elements: the child is consecrated within the Jewish community, Mary is "purified," the candles are lit, and Simeon and Anna prophesy.

The Presentation of Jesus in the Temple

The Place
Jerusalem

The Time
Two weeks after the birth of Jesus

The Figures
Jesus and his parents, the elderly priest Simeon, and sometimes the prophetess Anna

The Sources
The Gospel of Luke

Variants
The Canticle of Simeon; Nunc dimittis ("Now lettest . . . depart," the first words of Simeon's prayer [Luke 2:29])

Diffusion of the Image
Appears especially in cycles dedicated to Jesus, but also to Mary, relating to the seven joys and seven sorrows of the Virgin

The splendid temple that Solomon built in Jerusalem was a place charged with extremely powerful historical, religious, and cultural meanings. Jesus returned to the temple a number of times, and his visits presented opportunities to make clear distinctions between the material and spiritual worlds. There is, for example, the twelve-year-old Jesus' "escapade," when he left his parents and went to the temple to converse with its scholars. Jesus also energetically expelled the merchants and money changers from the building's inner courtyard, where they were debasing its holiness. There is also a similarity between the inevitable ruin of the temple's handsome stones and the "destruction" of Christ's body, which was then restored in three days with the Resurrection. There is, as well, Jesus' first visit to the temple, just two weeks after his birth, which is filled with tenderness and signs. An almost routine visit became the first occasion when Jesus was recognized as the Messiah, by the priest Simeon and the prophetess Anna.

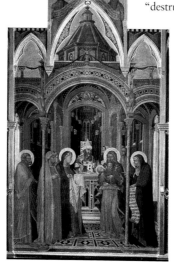

▶ Ambrogio Lorenzetti, *The Presentation of Jesus in the Temple*, ca. 1340. Florence, Galleria degli Uffizi

In fifteenth-century Flemish painting, scenes from the Gospels are often set within imposing Romanesque or Gothic basilicas. Here, the unfinished side emphasizes that the building of the Church, which Jesus began, is a task that must be constantly carried out.

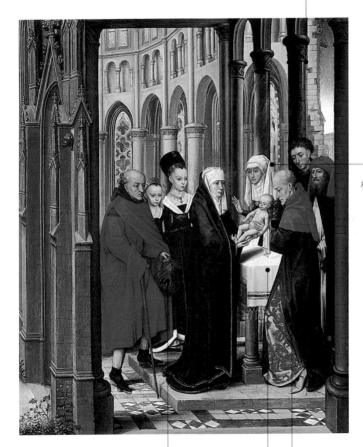

Behind the main group is the prophetess Anna, an eighty-four-year-old widow who lived in the temple. She raised prayers of thanksgiving to God when she saw Jesus.

Joseph brings an offering of two turtle-doves to the temple in an unusual jug-shaped wicker cage.

The altar, covered with a spotless cloth, gives the scene a sacramental meaning.

Old Simeon holds the Child carefully as he takes him from Mary's hands. Jesus' position between his mother and the priest symbolizes his dual nature, both human and divine.

▲ Hans Memling, *The Presentation in the Temple*, 1463. Washington, D.C., National Gallery of Art

The Presentation of Jesus in the Temple

Next to the altar is the prophetess Anna.

A gold bas-relief adorns the lavish altar. It depicts Moses with the Tablets of the Law, a reference to the relationship between Jesus and Jewish observance.

The attitude and vestments of the old priest Simeon— here in papal clothing— confirm the solemnity of the event.

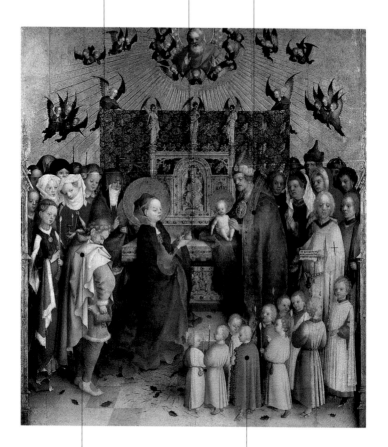

Mary makes a ritual offering of two small doves, while Joseph, behind her, prepares a monetary gift.

Simeon calls the tiny Jesus a "light for revelation" (Luke 2:32). The Presentation in the Temple has traditionally been celebrated on the holiday of Candlemas, to which the children holding candles refer. Lighting them marked the ritual end of winter.

▲ Stefan Lochner, *The Presentation in the Temple*, ca. 1447. Darmstadt, Hessisches Landesmuseum

The prophetess Anna expresses her great emotion.

The elderly Simeon is directly addressing Mary, saying, "Behold, this child is set for the fall and rising of many in Israel. . . and a sword will pierce through your own soul also" (Luke 2:34–35).

Mary and Joseph kneel in wonder and devotion.

The radiance around Jesus is a visible manifestation of the words of Simeon, who describes the Christ child as "a glory to thy people Israel" (Luke 2:32).

▲ Rembrandt, *The Presentation in the Temple*, ca. 1628. Hamburg, Kunsthalle

In an innovative choice, Bellini decided not to locate the scene inside the temple, but rather in the open countryside. This allows a modest family event to take on universal significance; it comes out from within a closed building to affect the entire world.

Bellini replaced the elderly prophet Anna with a pretty young woman. Because the work was privately commissioned, the painting reflects specific requirements and tastes.

Bent with age, Simeon receives the Christ child with touching affection. Because there is no temple in this version, the title of the work is not the usual Presentation, *but the first words of the priest's prayer.*

▲ Giovanni Bellini, *Nunc dimittis*, ca. 1502. Madrid, Thyssen-Bornemisza Collection

Saint Joseph's complex and controversial iconographic and devotional role includes frequent angelic visions, which he experienced in dreams.

Joseph's Dreams

The recurring angelic apparitions and the warnings in dreams that characterized Jesus' conception and infancy were also common in the Old Testament. There are also dozens of examples in the poems of Homer, in Classical literature, and even in popular legends and fables. The angel (never mentioned by name) who persistently visited Joseph is proof of a "bridge" between the divine mysteries and the carpenter's humanity. Although Joseph appears doubtful and tired in the early Christian apocrypha, Matthew tended to present him as a "righteous man," who is ready to accept the angel's direction: "He did as the angel of the Lord commanded him" (1:24). The first time, the angel resolved the thorny circumstance of Mary's pregnancy by revealing the Jesus' divine origin to Joseph. In Bethlehem, the angel awoke Joseph in the middle of the night, urging him to leave for Egypt in order to escape the massacre that Herod had ordered. Finally, after Herod's death, the angel appeared to Joseph in Egypt, inviting him to return home. Matthew added, without specifying whether this was in the same dream vision or a later one, that the angel also warned Joseph not to return to Judea (where Bethlehem and Jerusalem are), but to push further north to Nazareth in Galilee.

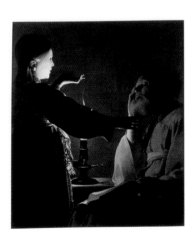

The Place
Nazareth, Bethlehem, and Egypt

The Time
There are three distinct dreams: when Joseph discovers Mary's pregnancy, just after the Magi depart, and at the end of the Holy Family's stay in Egypt.

The Figures
Joseph, an angel, and sometimes Mary, preoccupied with her domestic tasks

The Sources
The Gospel of Matthew, the Gospel of Pseudo-Matthew, and the Protevangelium of James

Variants
The generic description, "Joseph's Dream," is applied to three different, but not always distinct situations.

Diffusion of the Image
It is rather uncommon and was first found only in painting cycles dedicated to Mary; with the Counter-Reformation, it also appears as a self-contained scene.

Georges de La Tour, ◄ *Joseph's Dream*, ca. 1640. Nantes, Musée des beaux-arts

The angel whispers in Joseph's ear as he sleeps. Since Mary appears to be pregnant, this must be Joseph's first dream, in which he is reassured about Mary's virginity.

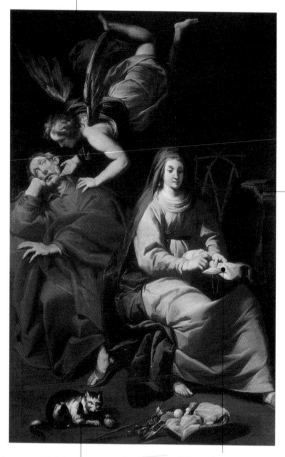

A prayer book is often open near Mary in Christian iconography, so much so that it becomes a visual reference point in devotional books made for high-ranking women. These *Hours of the Blessed Virgin* were often expensively decorated with miniatures.

The cat gives the scene a delightfully intimate and domestic tone. At the same time, its position next to the Madonna's sewing basket injects an unsettling element of unpredictability and disorder.

Sewing is one of Mary's characteristic activities. After first learning to sew from her mother, Anne, she perfected her skills during her years at the temple, finally standing out for her part in making the hangings for the tabernacle. Here we can imagine that she is sewing baby clothes for her expected child.

▲ Gian Giacomo Barbelli, *Joseph's Dream*, 1660. Private collection

Despite his sleepiness, Joseph seems to raise his head to hear the angel's words better. This posture may be understood in terms of the Gospels' theme of being always ready—even at night—for the divine call.

The scene's ambiguous setting, somewhere between a home and the temple, includes an altar with a bas-relief of the Tablets of the Law and Moses' face. Besides the usual theme of the Gospels' descent from the Old Testament, this detail can also be seen as an additional reference to Egypt: Moses received the tablets on Mount Sinai, during his people's difficult return from Egypt to Israel.

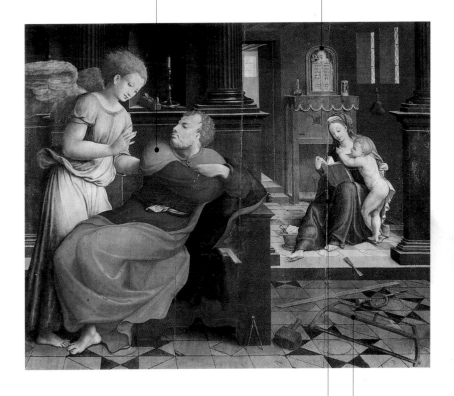

In the background, Mary reads a book to the Christ child, who has already grown quite a bit. This detail indicates that this is Joseph's third dream, in which the family is invited to return home after their period of exile in Egypt.

Joseph's carpentry tools are scattered on the ground and in other parts of the painting.

▲ Master of Dinteville, *Joseph's Dream*, 1541. Troyes, Musée de Vauluisant

The flight of the Holy Family into Egypt and their return to Nazareth represent an almost infinite field of legendary and figurative interpretations that blossomed from the few words of Matthew the Evangelist.

The Flight into Egypt

Among the frequent and often delightful artistic interpretations of the Flight into Egypt, it is useful to distinguish two separate moments. One—the actual "flight," with the Madonna often riding a donkey—is incontrovertibly dynamic, while the other—described as the "rest"—is entirely static.

The apocryphal writers, followed in part by Jacobus de Voragine in *The Golden Legend*, gave their imagination free rein, populating the Holy Family's itinerary with dragons, wild beasts, caves, chases, seasonal migrations of herds of sheep, bandits, broken idols, magic trees, lepers, miraculous waters, and so on. In turn, many artists have invented locations, events, situations, and surroundings. The following episodes have tended to predominate in the history of art: a date palm providing shelter and nourishment; statues of pagan gods that fall from their pedestals and shatter; and, during the return from Egypt, the meeting between Jesus and the Infant Saint John.

The Place
From Bethlehem to Heliopolis, across the Sinai Desert, then back to Nazareth

The Time
Jesus' first year of life

The Figures
The Holy Family and a donkey, often led by an angel

The Sources
Very few mentions in the Gospel of Matthew, and many details inferred from the apocryphal traditions and the Gospel of Pseudo-Matthew

Variants
Other than the Flight in itself, the moment of the Rest during the Flight

Diffusion of the Image
Extremely widespread, whether as part of a cycle or by itself; one particular, and in a sense definitive, example is the beautiful series of engravings by Giovanni Battista Tiepolo

▶ Orazio Gentileschi, *Rest during the Flight into Egypt*, 1628. Paris, Musée du Louvre

The Madonna rides the donkey that brought her to Bethlehem when she was about to give birth.

An angel shows the way. In the history of art, the angel often accompanies the Holy Family during their journey, taking on a variety of tasks along the way: guide, cook, ferryman, musician, and others.

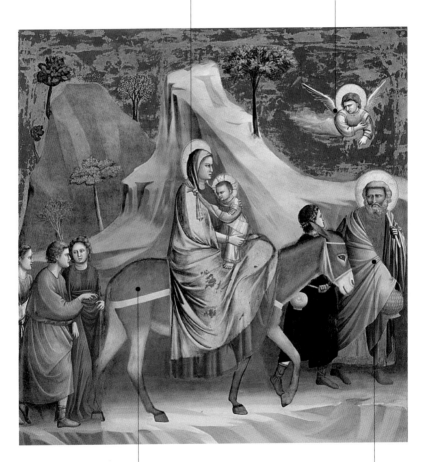

The donkey proceeds with a slow but sure step. In the cycle of frescoes in the Scrovegni Chapel in Padua, Giotto depicted almost identically this donkey and the one that Jesus rides into Jerusalem at the beginning of the Passion.

Joseph places himself at the head of the party. In addition to the Holy Family, the company is made up of four other figures, since Giotto was illustrating a passage from the Gospel of Pseudo-Matthew. According to a medieval tradition, these figures could be Joseph's older children, from a previous marriage.

▲ Giotto, *Stories of Christ: The Flight into Egypt*, 1304–6. Padua, Scrovegni Chapel

The German painter depicted
this starry sky with scrupulous
astronomical precision.

The group of shepherds
around a fire recalls the similar
scene at the Annunciation to
the Shepherds.

▲ Adam Elsheimer, *The Flight into Egypt*, 1609. Munich, Alte Pinakothek

The Holy Family occupies the center of the scene. Joseph holds a torch. Even in the middle of the night, the flight continues, creating a contrast between the absolute nocturnal quiet of the countryside and the need to escape Herod's fury.

The full moon is reflected in a pond, creating a magical effect of light. Although the comet of the Magi is not shining in this sky, the natural wonder of the heavens is accentuated.

According to the Gospel of Pseudo-Matthew, a date palm offered the Holy Family a double refreshment, both its fruit and the shade of its branches, which miraculously reached down to Joseph.

The painting portrays two different moments on the journey: in the foreground, the scene of repose near the palm tree, and, in the background, Joseph pointing out the road to Mary, who has gotten back on the donkey.

The Christ child gives the angels a palm branch. As a gesture of gratitude toward the tree that gave the Holy Family shelter and nourishment, the palm tree is brought to Heaven. Thenceforth, the palm branch was used as a symbol of martyrdom and of the glory of the saints.

According to ancient extrabiblical traditions, the ox also accompanied the ass and the Holy Family from Bethlehem to Egypt.

▲ Fernando de Llanos, *Rest during the Flight into Egypt*, 1507. Valencia, Cathedral

The fountain is decorated with an elaborately sculpted central pillar. This mysterious god or allegorical figure may prefigure the collapse of the statues of "idols"—the Egyptian gods—that according to the Gospel of Pseudo-Matthew occurs just as the Holy Family arrives in Egypt.

The river in the background recalls the episode of the Holy Family crossing it. According to the apocryphal writer, this occurred with the help of an angel and a fishing boat. However, it may also recall that Jesus is traveling in the opposite direction of Moses, who, as we know, was able to miraculously cross waters with God's help. In reality, however, this is a precise view of the Danube River in southern Germany.

Instead of the single angel sent to guide and help the Holy Family, Altdorfer painted a swarm of funny little ones.

Jesus is shown here in an unusual posture. It would seem that the Madonna is washing his behind in the fountain after a very human function.

▲ Albrecht Altdorfer, *The Holy Family at the Fountain*, 1510. Berlin, Gemäldegalerie

A robust ferryman rows vigorously.

An angel supports the vessel's mast. According to the apocryphal sources, an angel is always present during the journey to and from Egypt.

The boat's bow cuts quickly through the water, implying supernatural aid.

The Child is already older, showing that the Holy Family is returning from, not fleeing to, Egypt. They are crossing the Red Sea, just as Moses did when he traveled to the Promised Land.

▲ Lodovico Carracci, *The Flight into Egypt*, 1600. Private collection

In addition to giving the countryside an exotic touch, the palm tree recalls the episode of the refreshment offered to the Holy Family during their flight, when they were treated to the tree's fruit and shade.

This image is rich with fascinating details. In the background, the Holy Family journeys on, nearing the end of their return from Egypt to Nazareth. The title Rest during the Flight into Egypt *is therefore not quite accurate.*

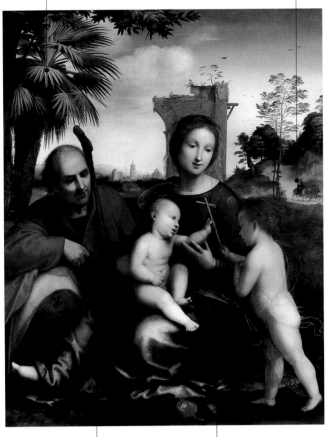

Unlike the Madonna, Joseph does not appear worried at all. Instead, he seems amused by the exchange between the two children.

The Infant Saint John, just six months older than Jesus (although the painter has somewhat exaggerated the difference in their ages), gives his little cousin a tiny cross of reeds. Mary seems almost to want to hold back her child's hand, which he stretches out to receive the gift that is so charged with premonition.

▲ Fra Bartolommeo, *The Rest During the Flight into Egypt with Saint John the Baptist*, ca. 1509. Los Angeles, J. Paul Getty Museum

There is no subject more atrocious in the entire history of sacred art. The slaughter of Bethlehem's newborns is an act of feral and incomprehensible fury.

The Massacre of the Innocents

If one wished somewhat cynically to provide historical facts, how many children were butchered by Herod's thugs? To put it another way, how many boys under the age of two might there have been in Bethlehem at the time? Painters and sculptors have animated frightful bloodbaths with numerous Innocents slaughtered in the most horrendous ways. But even if the actual number of victims was very small, the episode remains a great mystery. Why should babes in swaddling clothes, guilty of nothing, have to die? With so many poetic moments in Jesus' childhood, the Massacre of the Innocents brings in a terribly tragic note. Perhaps the emphasis placed on the Massacre of the Innocents in the history of art may be seen as a paradoxical response, an amplification that renders the ferocity of Herod and his cutthroats absurd and "impossible." And yet, the extreme tragedies of today's current events, in the very places cited in the Gospel, demonstrate that the Massacre of the Innocents is a recurring situation.

The angels distribute entire palm branches, which symbolize martyrdom and sanctity.

Reni focused on a limited number of large figures, but the small detail in the background lets us infer that the massacre is occurring elsewhere as well.

Their lowlife clothes and daggers tell us that the thugs who are carrying out the massacre are not regular soldiers but hired assassins whom Herod has enlisted for the occasion.

The crying mother in the foreground is in the typical pose of the Mater Dolorosa, *the image of the Madonna during the final stages of the Passion.*

▲ Guido Reni, *The Massacre of the Innocents*, ca. 1611–12. Bologna, Pinacoteca Nazionale

Saint Anne Metterza

It is interesting to note that the canonical Gospels never mention Jesus' grandmother. The figure of Saint Anne, enriched by the long story that precedes Mary's birth, is described only in the apocryphal tradition, particularly the Protevangelium attributed to James (and thus an apostle who was himself her grandson). The oldest images relative to her cult are fragments of eighth-century frescoes in the Church of Santa Maria Antiqua in Rome. The spurious and essentially verifiable sources of information about Saint Anne brought about the iconoclastic attentions of the Lutherans, and a significant number of works of art featuring this subject were certainly destroyed during the 1500s. And in fact there is no denying the sturdy power of the threefold block of figures formed by Saint Anne, the Virgin, and the Christ child. It is typically a static, frontal image—only in the early sixteenth century, thanks to the brilliant creativity of masters such as Leonardo and Dürer, did the traditional immobility of the group melt into a series of gestures, smiles, gazes, and relationships.

The Place
Nazareth

The Time
Undefined, but the early years of Jesus' life

The Figures
Saint Anne, Mary, the Christ child

The Sources
An image derived from the genealogy of Jesus in the Protevangelium of James

Diffusion of the Image
Quite widespread, especially during the fifteenth century, in Italy and north of the Alps, and as a sculptural group

▶ Master of the Engelberg Altar of the Madonna, *Saint Anne Metterza*, ca. 1485. Ljubljana, National Gallery.

Angels support a hanging and swing thuribles of incense; these acts of religious ceremony accentuate the scene's dignified and mystical tone. The throne and static frontal view of the figures also evoke solemnity.

Anne is the top of the family pyramid. The style of her veil is typical of older women and widows.

Mary, at the center, displays the albino traits that characterize Masaccio's Madonnas.

Saint Anne's foreshortened hand is just above the Christ child's head, in a gesture of protection and blessing.

The massive, solid throne depicted frontally recalls medieval iconography of the Madonna as Sedes sapientiae (Seat of wisdom).

▲ Masaccio, *Saint Anne Metterza*, 1424–25. Florence, Galleria degli Uffizi

Leonardo suggests a remarkable resemblance between Mary and Anne and almost alludes to a feeling of complicity between the two women in order to emphasize the strong ties between mother and daughter.

Anne's index finger points upward in a gesture that appears in other works by Leonardo and refers to the world above.

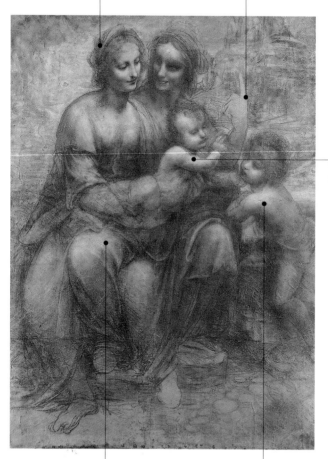

The Christ child is turned toward the Infant Saint John and gestures in blessing.

Mary is seated on Anne's knee. This pose places Leonardo's work—although revolutionary in many ways—within the iconographic tradition of "Metterza." The word comes from medieval Latin and corresponds to Selbdritt in German: Saint Anne "places [herself] third" ([si] mette per terza) in a group with Mary and Jesus.

The presence of the young John the Baptist is unusual. His hands together at his chest (a sign of devotion and prayer), he watches Jesus with an intense expression on his face.

▲ Leonardo da Vinci, *The Virgin and Child with Saint Anne and Saint John the Baptist*, ca. 1499–1500. London, National Gallery

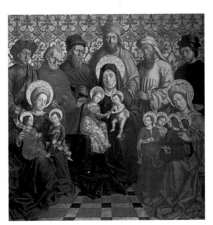

This is one of the most lovable and crowded scenes in sacred art; the devotional aspect seems secondary to a feeling of a family portrait or even a "photograph."

The Holy Kinship

Not only are there few works of art on this subject, they almost all date to the fifteenth and early sixteenth centuries. Nevertheless, they continue to capture our attention. According to a less-than-plausible, but evocative extrabiblical tradition, Anne, Mary's mother, married twice after being left a widow by Joachim's death. First she married Joachim's brother, Cleophas, and after he died, Salome. She is supposed to have had a daughter from each marriage, both of whom were named Mary (like her first daughter, married to Joseph). The second Mary, who married Alpheus, gave birth to four sons: the apostles James the Less, Simon the Zealot, and Jude (or Thaddeus), and another son called Joseph "the just." The third Mary, who married Zebedee, also gave birth to two future apostles: James the Greater and John the Evangelist. Anne's lineage, therefore, is quite articulated, due to a series of marriages that would lead us to expect a significant difference in the ages of her daughters and therefore of her grandsons. Instead, they tend to be rendered similarly in art.

Other than Anne, who is endowed with the characteristics of a grandmother, all their children are very close in age, as are the three Marys, who also resemble one another.

The Place
Nazareth

The Time
Unspecified, but within the first years of Jesus' life

The Figures
A small crowd: the complete version includes six men, four women, and seven children; individual figures are often identified by inscriptions or scrolls

The Sources
Apocryphal traditions retold in *The Golden Legend*

Variants
The Family of Saint Anne; sometimes in other languages the German phrase *Heilige Sippe* is used

Diffusion of the Image
Almost nonexistent in Italian and Spanish art, and not uncommon in the French and Flemish worlds, this iconography is significantly widespread within the area of German culture.

Master of Uttenheim, ◀
The Holy Kinship,
ca. 1455–60. Novacella,
Pinacoteca dell'Abbazia

According to a tradition that dates to before the Counter-Reformation, Joseph (Mary's husband) is typically portrayed somewhat apart. The fact that he is sleeping may refer to the several visions of angels that he received in his dreams.

Anne's three husbands are shown behind the balustrade. According to The Golden Legend, *they are Joachim, Cleophas, and Salome, respectively.*

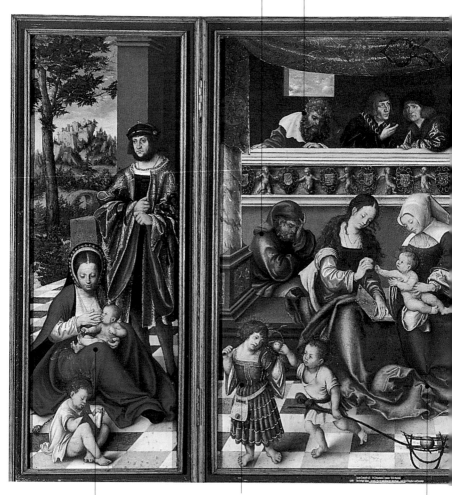

The left-hand panel shows Mary of Cleophas with her husband, Alpheus, and Simon and Jude, the two youngest of their four sons.

The children in the lower left of the central panel should be the other two sons of Mary of Cleophas, James the Less and Joseph the Just.

The group of Mary and Anne, who holds the Christ child on her lap, forms the center of the composition and refers to the iconographic theme of Saint Anne Metterza.

Although they are dressed differently, there is a strong resemblance between Zebedee and Alpheus, the husbands of the two Marys on the side panels—they could almost be brothers. Apart from Joachim and Joseph, the faces of the other four men in this triptych are very elaborated; the figures are dressed in rich clothing of the period. These are probably portraits of the work's patrons, whose coats of arms appear on the balustrade in the central panel.

The right-hand panel shows Mary of Salome with her husband, Zebedee, and their two sons, John the Evangelist and James the Greater.

Lucas Cranach the Elder, *Altar of the Holy Kinship*, 1509. ▲
Frankfurt, Städelsches Kunstinstitut

Popular prayer joins Jesus, Mary, and Joseph in a single, tightly knit family unit, effectively overcoming the delicate question of Joseph's "paternal" role.

The Holy Family

The theme is simple, yet at the same time extraordinarily complex. From the iconographical point of view, the subject is immediately recognizable. The three figures are in paradigmatic poses, as if arranged for a family portrait. Mary is a young, attentive mother, often veiled by a touch of melancholy; Jesus is a delightful child; and Joseph—who is often set slightly apart—is an elderly but solicitous father.

This, of course, is just one of Jesus' families, his earthly one. The image, in fact, may be seen as paralleling that of the Trinity, which, in its most common form, shows the Crucified Christ with God the Father and the Holy Spirit. At this point (setting aside the question of Joseph's role), the difficulty of Mary's position and definition arises. She is fully Jesus' mother, although at the same time, as Dante wrote, "daughter of your Son" (*Paradiso*, 33). Thus a mystical dimension overlies the Holy Family's everyday, domestic intimacy. This superimposition is resolved in the Coronation of the Virgin, where the usual threefold "family" rhythm (Jesus-Mary-Joseph or Father-Son-Holy Spirit) requires a new element, due to the presence of the Madonna.

▶ Jacob Jordaens, *The Holy Family*, 1625. Bucharest, National Museum of Art

Joseph is working at his carpenter's bench. The shape of the trunk that he is rough-hewing resembles a yoke for a cart. This may refer to a phrase from Matthew's Gospel: "For my yoke is easy, and my burden is light" (11:30).

As is often the case in art, Mary is reading a book. In Gothic and Renaissance art, these were small, lavishly illuminated prayer books, while in cultured seventeenth-century Protestant Holland, she holds a printed Bible.

The angels' expressions, which are anything but joyous, support the poetic, yet subtly melancholy atmosphere of this scene.

Despite the entirely realistic treatment of this work, it may contain subtle religious and autobiographical references. Jesus sleeping soundly in a cradle that Mary is about to cover with a heavy cloth could allude to Christ sleeping in the tomb, which was closed with a rock. Rembrandt repeatedly experienced the pain of losing a child in its first months of life.

▲ Rembrandt, *The Holy Family with Angels*, ca. 1645. Saint Petersburg, Hermitage

Luke wrote: "And the child grew and became strong, filled with wisdom; and the favor of God was upon him" (2:40). "And Jesus increased in wisdom and in stature, and in favor with God and man" (2:52).

The Childhood of Jesus

The Place
Nazareth

The Time
The first ten to twelve
years of Jesus' life

The Figures
Jesus, Mary, and Joseph

The Sources
The canonical Gospels
are almost completely
silent on the subject: two
passages in Luke are the
only references to Jesus'
infancy in the Gospels.
This absence is amply
and ingeniously filled by
many apocryphal sources
(which are collected in
the so-called Infancy
Gospels) and myriad
local legends.

Variants
The various episodes
appear with different
titles.

Diffusion of the Image
Especially in works
created for popular
devotion

▶ Georges de La Tour,
The Newborn Child,
ca. 1648. Rennes, Musée
des beaux-arts

Much sacred art is based on a relationship of identification and dialogue, an empathy that sparks between the image and the feelings, emotions, and experiences of the viewer. In the case of the Gospel stories, the lack of scriptural references was filled in with the apocryphal sources and traditions, but also with personal sensations.

This section, dedicated to images that do not directly depict specific Gospel passages, could comprise all the infinite number of Madonna and child images that have been conceived and created precisely in order to evoke feelings of tenderness, ease, and human connection. We have chosen primarily dynamic episodes, scenes where "something happens," rather than the simple embrace between mother and child. In addition, we have attempted to have the sequence of images trace the little Jesus' physical growth through infancy and childhood, relying case by case on the artists' interpretations.

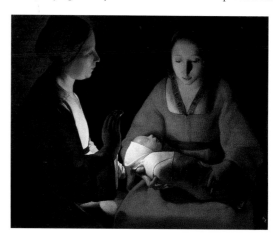

The theme of the Madonna staring intensely at the Christ child—a subject also called the Madonna del Colloquio *(Madonna of the Conversation)*—is common in Gothic painting and sculpture from Tuscany.

Profoundly innovative in its realistic immediacy, this scene was inspired by the human experience of a mother nursing a newborn. The breast, the glance of the sucking Christ child, and the Madonna's backward-leaning posture derive, not from some fixed and unchangeable stereotype, but from a direct vision of reality.

The naked Jesus is held in a white cloth. This cloth, taken together with the nudity, is sometimes associated with the shroud in which Christ's body was wrapped.

▲ Ambrogio Lorenzetti, *Nursing Madonna*, 1330. Siena, Palazzo Archivescovile

Despite her veil, Mary wears her long, fine hair unbound, a symbol of purity and virginity.

The rucksack, like the road that goes through the arch visible in the background, refers to the journey that Mary and Jesus made during the Flight into Egypt.

The prayer book and the sewing basket are typical attributes of Mary's pious industry.

With delightful realism, the Flemish painter portrayed the Christ child firmly holding a spoon . . . upside down.

The bread, the wormy apple, and the knife in the foreground may represent merely a still life or be mystically interpreted as a reference to the sacrifice of Christ (the knife), who offers his body (the bread) as redemption from original sin (the apple that the serpent offered Eve, to which the worm adds an element of corruption).

▲ Gérard David, *The Madonna and Child with Spoon*, ca. 1515. Brussels, Musées royaux des beaux-arts

Jesus holds a small olive branch, another reference to the beginning of the Passion.

An angel heats up the Christ child's mush in the background.

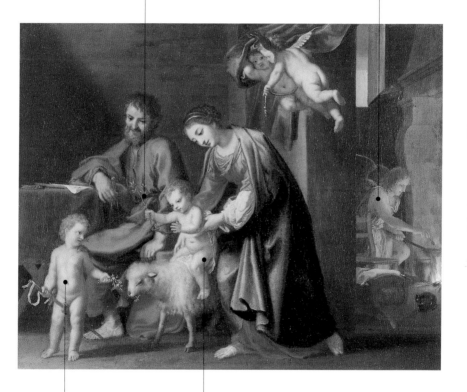

The Infant Saint John leads the lamb—his usual attribute in art. This is connected to the phrase "Behold, the Lamb of God" (John 1:29).

Mary places Jesus astride a lamb. What seems to be child's play actually foreshadows Jesus' entry into Jerusalem riding a donkey.

▲ Jacques Stella, *The Holy Family with Saint John*, 1651. Dijon, Musée des beaux-arts

The Childhood of Jesus

Sewing and spinning
are Mary's usual
domestic activities.

Leaning against the knees of an unusually young
Joseph, the Christ child, clutching a bird, plays
with a little puppy. These details give this intimate
scene, which at first glance seems happy and
domestic, a premonitory meaning, since the
little bird is a symbol of the Passion.

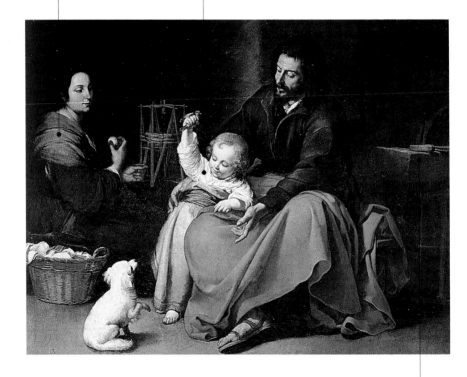

Frequently in paintings by Murillo, the
narrative details accurately reflect
everyday life. In the background are
Joseph's carpenter's bench and tools.

▲ Bartolomé Esteban Murillo, *The Holy Family with Puppy*, ca. 1650. Madrid, Museo del Prado

His parents' astonished and pleased expressions echo the amazement that the Gospels describe as the predominant feeling of everyone who met Jesus as a child and later as an adolescent.

The theme of the Benedicite, *the brief prayer said at table in thanksgiving to God for food, appears more frequently in French art than in any other national school.*

The table almost looks like an altar. The objects arranged on it (the bread, knife, and plate of apples) become the accoutrements of a domestic liturgy blessed by Jesus.

The juxtaposition of the humble carpenter's tools and the valuable, shining pitcher is meant to emphasize the dignity and honor of work and its instruments.

▲ Charles LeBrun, *The Holy Family*, 1655. Paris, Musée du Louvre

The dynamic appearance of God the Father recalls similar irruptions in images of the Baptism of Christ.

Another symbol of the Passion is the column to which Jesus is said to have been tied for the Flagellation.

Joseph is still identifiable by the branch of his betrothal to Mary, which flowered miraculously.

The cross that the angels bear is the most obvious and explicit symbol of the Passion.

Jesus is shown here as a child of about eight years old. It is always very difficult to determine Jesus' age during his childhood. The only sure reference point is the disputation with the doctors in the temple, which occurs when he is twelve years old. There are other episodes in the Christian apocrypha, but they have not been used much by artists.

▲ Luca Giordano, *The Holy Family Has a Vision of the Symbols of the Passion*, 1660. Naples, Museo di Capodimonte

The ray of light refers to the swift phrase "the favor of God was upon him" (Luke 2:40), which refers to Jesus' infancy.

The Madonna's expression of bitter foreboding is particularly emphasized here, although it is quite common in paintings of Jesus' childhood. It refers to Luke's words "Mary kept all these things, pondering them in her heart" (2:19).

Jesus pricks his finger as he is braiding bramble twigs into a wreath for fun. The reference to the crown of thorns is obvious.

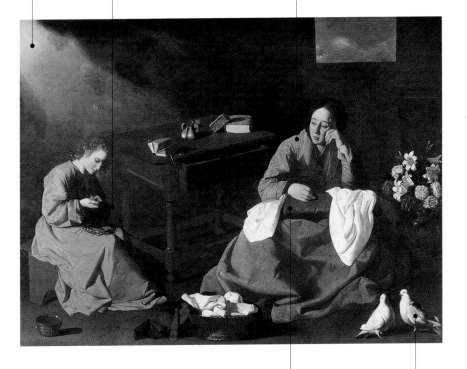

Mary is once again engaged in her traditional sewing.

The white doves are a symbol of purity, but they also recall the sacrificial gift that Mary and Joseph brought at the Presentation of Jesus in the Temple.

▲ Francisco de Zurbarán, *Christ and the Virgin in the House of Nazareth*, 1640. Cleveland Museum of Art

Joseph is intent on his activity in his carpentry shop in Nazareth.

Jesus holds a candle to light Joseph's work. This is, of course, a metaphor for the light that Jesus brings into everyday life. Historically, it is extremely likely that Jesus worked in his earthly father's shop during his adolescence and as a young adult.

Two angels discuss the scene.

▲ Gerrit van Honthorst, *The Childhood of Christ*, 1620. Saint Petersburg, Hermitage

This is the only episode mentioned in the canonical Gospels that occurs during Jesus' first thirty years of life, between the first weeks after the Nativity and the beginning of Jesus' public life.

Christ among the Doctors

Luke's narrative is rich with scenic and psychological details, and the power of this glimpse into the life of Jesus as a boy is far greater than the legendary tales of the apocryphal writers or popular traditions. It gives the impression that the evangelist sought to concentrate a huge wealth of meaning around the episode. First of all, it confirms that the Holy Family fully adhered to Jewish customs, including traveling to Jerusalem to celebrate Passover. Then there is a human element with which the reader can identify: a caravan of people, a lost boy, the belief that he is with other relatives or friends, the moment of anguish, the parents' return to Jerusalem, and their surprise to find their son engaged in a doctrinal dispute with the teachers at the temple. And there are the reproachful questions: Mary's human one— "Son, why have you treated us so? Behold, your father and I have been looking for you anxiously"—then Jesus' one, which Luke describes as incomprehensible at this point—"How is it that you sought me? Did you not know that I must be in my Father's house?" (2:48–49). A happy ending follows, although from this moment on the temple will be the setting for the conflict between human reality and divine revelation.

The Place
Jerusalem

The Time
A.D. 12

The Figures
The twelve-year-old Jesus, a dense crowd of priests and scholars, Mary, and Joseph

The Sources
The Gospel of Luke

Variants
The Dispute of Jesus in the Temple

Diffusion of the Image
Fairly widespread and often quite enjoyable in all Christian art, from the Middle Ages to the Baroque, often with novel interpretations

Christus among the Doctors, ◀ early sixteenth-century German wood sculpture. New York, The Metropolitan Museum of Art

The groups of teachers gather at Jesus' side.

As frequently happens in Italian Renaissance painting, the scene unfolds in front of the temple—not inside it—in order to emphasize the perspectival and architectural setting.

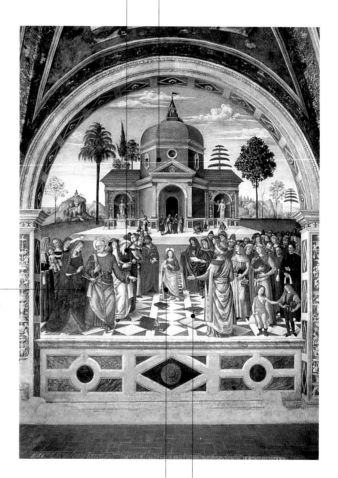

Joseph and Mary enter the scene with a combination of relief and surprise.

The twelve-year-old Jesus is set apart, exactly at the center of the composition.

The books on the ground symbolize the defeat of the priests' knowledge.

▲ Pinturicchio, *The Dispute in the Temple*, ca. 1510. Spello, Church of Santa Maria Maggiore, Baglioni Chapel

The Bible verses worn on the forehead indicate strict Jewish observance.

In an utterly unusual, yet effective manner, Dürer focused the scene closely on the characters alone—here, only five—abandoning any details of the setting. Instead of a detailed narrative of the episode, we have a dense, disconcerting debate.

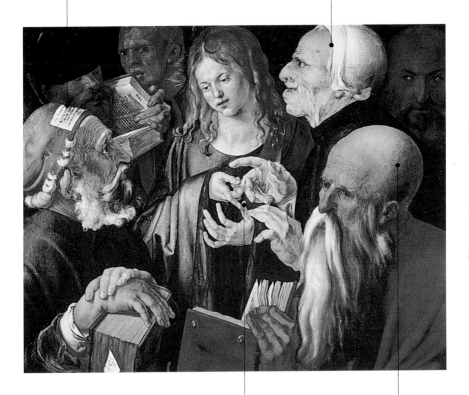

Hand motions are key in this scene. The twelve-year-old Jesus calmly counts off his concepts, like a teacher explaining things to students, while the gnarled hands of the doctor on the right express nervousness and confusion.

There are various theories concerning the appearance of the four doctors that surround Jesus. Dürer probably intended to portray the pervasive doctrine of the four temperaments that govern personality.

▲ Albrecht Dürer, *Christ among the Doctors*, 1506. Madrid, Thyssen-Bornemisza Collection

STORIES OF SAINT JOHN THE BAPTIST

The Birth of the Baptist
The Baptist in the Wilderness
The Preaching of the Baptist
The Baptism of Christ
The Feast of Herod

◀Philippe de Champaigne,
*Saint John the Baptist in the
Desert*, 1645. Grenoble,
Musée des beaux-arts

▶ Giovanni Bellini, *The
Baptism of Christ* (detail),
1502. Vicenza, Church of
Santa Corona

A number of revealing details distinguish the Nativity of the Baptist from that of Jesus: the age of the mother, the setting, and, above all, the singular figure of Zechariah.

The Birth of the Baptist

The Place
The house of Zechariah and Elizabeth

The Time
About six months before the birth of Jesus

The Figures
Elizabeth, the newborn John, and the usual animated group of women helping the new mother and the baby; Zechariah carefully writing the child's name; sometimes Mary holding John in her arms

The Sources
The Gospel of Luke and *The Golden Legend*

Variants
The Nativity of Saint John the Baptist; Zechariah Writes the Name of the Baptist

Diffusion of the Image
This is a minor but very enjoyable episode, generally included in cycles dedicated to John the Baptist.

▶ Fra Angelico, *Zechariah Writes the Name of John the Baptist*, 1433. Florence, Museo di San Marco

The birth of the Baptist is one of the most charming scenes in sacred art, in part because it has always lent itself to realistic contemporary interpretations that often provide valuable information about everyday life and household furnishings. In fact, the miraculous, or at least divine, aspects of the episode are almost irrelevant; what prevails is the lively turmoil of a home birth, with the men banished from the new mother's room.

Zechariah's part in the proceedings is a scene unto itself. As the elderly priest was burning incense at the temple, the archangel Gabriel appeared to him, announcing that his wife, Elizabeth, would bear a son, whom Zechariah was to call John. Zechariah was skeptical, so, to punish him, Gabriel struck him mute until the prophecy was fulfilled. Eight days after the child was born, at the circumcision, Elizabeth astonished everyone when she declared that she wanted to name the child John, which was not a family name. At this point, people made signs to Zechariah asking him what he wanted the name

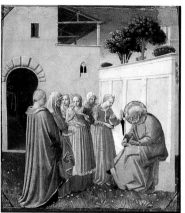

to be. He motioned for a writing tablet and wrote, "His name is John" (1:63). At that moment "his mouth was opened and his tongue loosed, and he spoke, blessing God" (1:64).

Zechariah, who was skeptical at first, raises his eyes to Heaven, as if seeking confirmation of Elizabeth's miraculous pregnancy. His red hat shows him to be a rich member of the priestly class.

Elizabeth turns toward the viewer with a steady, assured gaze.

The figure of the shepherd with the lamb is an obvious reference to John the Baptist, the fruit of Zechariah and Elizabeth's union.

The two spouses embrace intensely, almost as if manifesting their unwavering union. Zechariah's hand rests on Elizabeth's stomach, to emphasize her pregnancy.

▲ Tanzio da Varallo, *The Conception of Elizabeth*, ca. 1620. Turin, Galleria Sabauda

The Birth of the Baptist

According to The Golden Legend, Mary was the first to hold the newborn John.

Elizabeth's room—here furnished in fourteenth-century style—reveals a degree of wealth. Zechariah was an affluent priest. According to one apocryphal tradition, he was actually the same high priest who had welcomed the child Mary into the temple.

Exhausted from the birth, Elizabeth rests in bed.

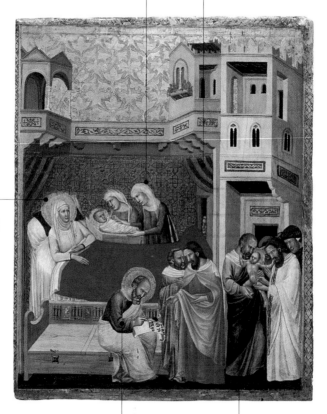

The priest Zechariah, who has become temporarily mute as divine punishment for refusing to believe that his elderly wife, Elizabeth, would become pregnant, writes on a sheet of paper the name that he has chosen for his son: John. Immediately afterward, he recovers his voice.

John's circumcision is shown on the right. The ritual was carried out eight days after birth.

▲ Giovanni Baronzio, *The Nativity of John the Baptist*, ca. 1330–40. Washington, D.C., National Gallery of Art

Although there are narrative interpretations, the figure of the Baptist in the wilderness is fascinating in itself, as a half-savage ascetic, alight with the flame of prophecy.

The Baptist in the Wilderness

"*Vox clamantis in deserto,*" the voice of one crying in the wilderness. This is how John the Baptist described himself in the Gospel of Luke. The movie directors who have made epics about the life of Christ have tended to exaggerate him— his tousled look, rough apparel, and prophetic and "apocalyptic" (*ante litteram*) preaching—because the setting of the desert and the Jordan River allow for a strong characterization. Works of art usually render a somewhat less savage Baptist, distinguishing at least two periods. In his adolescence, shortly after deciding to leave his parents, the young Saint John appears very youthful and athletic, and is often accompanied by the lamb that would become his symbol. Closer to the time of the Baptism of Christ, however, when he is thirty years old, the Baptist looks worn from fasting, the blazing sun (he is often portrayed extremely tanned), and his concern to announce the new epoch and urge people to repent, in view of the imminent arrival of the Messiah, "the thong of whose sandals I am not worthy to untie" (3:16).

The Place
The desert of Judea, outside Jerusalem, not far from the Jordan River

The Time
A.D. 15–30

The Figures
In this context, John the Baptist is usually alone

The Sources
The figure of John the Baptist is mentioned in all four canonical Gospels.

Variants
There are a few typical moments, such as John's farewell to his parents.

Diffusion of the Image
Very widespread, especially as an isolated figure

Leonardo da Vinci, ◄
Saint John the Baptist,
1508–13. Paris, Musée du Louvre

A disk-shaped halo already shows John's holiness. This has been somewhat controversial: according to a devotional and iconographic tradition, John is one of the people that Jesus frees from Limbo after the Resurrection. According to Matthew, Jesus declared, "Among those born of women there has risen no one greater than John the Baptist; yet he who is least in the kingdom of heaven is greater than he" (11:11).

The impassable path stands for the way of perfection. It echoes Isaiah's prophecy that refers to John: "Prepare the way of the Lord, make straight in the desert a highway for our God" (40:3).

The adolescent John leaves his parents' house and goes to live in solitude. In this fascinating painting, the precursor of Christ is taking off his clothes. He will put on his characteristic garment of coarse camel hair.

A thin stream wells up from the rock, foreshadowing the baptismal rite that John carried out by the Jordan River.

▲ Domenico Veneziano, *Saint John in the Wilderness*, 1445. Washington, D.C., National Gallery of Art

One of John's usual attributes is
a cross made of two reeds tied
together. It emphasizes his role
as forerunner of Jesus.

Having left his parents' house as a child or
adolescent—the traditions diverge slightly—
John seeks penance and mortification in the
desert. The cave is a symbol of solitude and the
absence of comfort, but also of inner purity.

John's gesture is unmistakable:
inspired by Heaven, he points to the
lamb, a prefiguration of Jesus, who is
destined to be sacrificed to expiate
the sins of humanity.

▲ Tanzio da Varallo, *Saint John the Baptist*, ca. 1629. Tulsa, The Philbrook Museum of Art

The lamb, a typical attribute of John's, often becomes a sort of pet, its master's inseparable companion.

The wilderness that witnessed John's years of prayer and penance is here replaced by a naturally harmonious, bright countryside resembling the Garden of Eden. It is as if the world itself were experiencing a new creation because of Jesus and the sacrament of baptism.

The Jordan River runs through the background of this lush countryside.

John is wrapped in a heavy cape, almost a monk's habit, that accentuates his solid physicality. His bare feet symbolize penance.

Following the Renaissance practice, John assumes the typical pose of a melancholy thinker. It is a lonely and sad phase, but necessary for intense meditation and for then accomplishing great undertakings.

▲ Geertgen tot Sint Jans, *Saint John the Baptist in the Wilderness*, ca. 1495. Berlin, Gemäldegalerie

Narrative scenes of the Baptist in action are relatively rare; these are often overshadowed by the much more frequent illustrations of the Baptism of Christ.

The Preaching of the Baptist

After living a long time in the solitude of the desert, the Baptist found a growing crowd of believers around him. Profoundly moved by his passionate words and unusual appearance, they considered him a prophet and followed him. Two sorts of images have been inspired by the relationship between the Baptist and his disciples: the iconography of him preaching in a forest clearing, and that of him baptizing converts on a riverbank. We may add a third, in which the Baptist points to Jesus as the Messiah.

The distinction between the Baptist and Jesus is important. Even their disciples must have sometimes been confused about the two "prophets," who were second cousins on their mothers' side and practically the same age. King Herod himself, as recounted in the Gospel of Mark, upon hearing of Jesus, feared that it was John, come back to life.

The Place
The desert of Judea, outside Jerusalem, not far from the Jordan River; the Gospel of John mentions two sites: Bethany and Aenon near Salim, "because there was much water there" (John 3:23)

The Time
About A.D. 30

The Figures
Besides the Baptist, a crowd composed of people of a variety of ages and social classes; sometimes Jesus appears, and the Baptist points him out

The Sources
The figure and activity of John the Baptist can be found in all four canonical Gospels.

Variants
The Baptist amid the Crowds; the Baptist Baptizes the Crowds

Diffusion of the Image
The subject of the Baptist preaching is more common than that of his baptism of the crowds.

Jan Swart van Groningen, ◀
The Preaching of Saint John the Baptist, ca. 1600. Munich, Alte Pinakothek

The Baptist turns suddenly and points at Jesus behind him, exclaiming "Behold, the Lamb of God" (John 1:29).

In the background, Jesus strolls peacefully near the banks of the Jordan River.

The monochrome images along the edge of the page include the Baptism of Christ and the Preaching of the Baptist from a high pulpit.

This miniature relates to the Gospel of John. The river in the foreground underscores the contrast between baptism with water, administered by the Baptist, and baptism in the Holy Spirit, which was brought by Jesus.

▲ *Saint John the Baptist*, from the Grimani Breviary, 1490–1500. Venice, Libreria Marciana

Those about to be baptized kneel
before John. Matthew tells that a
confession was necessary before
baptism.

Neophytes undressing in order to be
baptized are frequently represented in
art. The act also refers to a baptized
person's new appearance, symbolized
by the white garment that is still given
to them today.

The presence of women and
children characterizes the
greater openness of the
Catholic Church after the
Counter-Reformation. It
should still be noted, however,
that in Poussin's painting only
the men are being baptized.

▲ Nicolas Poussin, *The Baptist Baptizes the Crowds*, 1632. Paris, Musée du Louvre

This is one of the most recognizable and frequent images in Christian art. The few variations on what is basically a set composition are expressions of the artists' temperaments.

The Baptism of Christ

The Place
The shores of the Jordan River near Bethany

The Time
About A.D. 30

The Figures
John the Baptist and Jesus, the Holy Spirit in the form of a dove, sometimes God the Father, angels, and other neophytes who have just been baptized or wait their turn

The Sources
This episode, described in all four canonical Gospels, marks the beginning of Jesus' public life.

Diffusion of the Image
Extremely widespread; especially popular in buildings and chapels used as baptisteries

► Juan de Flandes, *The Baptism of Christ*, 1496–99. Madrid, Juan Abellé Collection

The relative standardization of images of the Baptism results essentially from the brevity of the episode in the canonical Gospels, which would, however, have allowed subtle differences.

Matthew, the only evangelist to report the concise dialogue between Jesus and John before the Baptism, provides the most detailed description. According to him, as Jesus emerges from the water after being baptized, the heavens open, and John—and only John—sees the Holy Spirit descend upon Jesus in the form of a dove. A voice from Heaven is heard: "This is my beloved Son, with whom I am well pleased" (3:17). Immediately afterward, the Holy Spirit leads Jesus into the desert.

Mark's narrative is similar to Matthew's. According to Luke, however, the dove's appearance and the heavenly voice are directed to Jesus, who is collected in prayer after being baptized: "Thou art my beloved Son; with thee I am well pleased" (3:22).

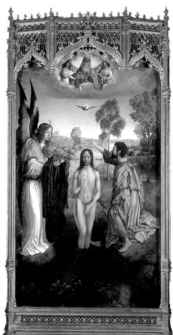

This painting combines various actions: in the background, John preaches to the crowds as he leans against a rustic railing.

The figure of God the Father appears among the clouds; he points at Jesus as he sends the Holy Spirit in the form of a dove. The perfect axis down the center of the painting signifies the unity of the three persons of the Trinity.

John is pointing at Jesus in the distance, and some of his disciples have turned their heads to look.

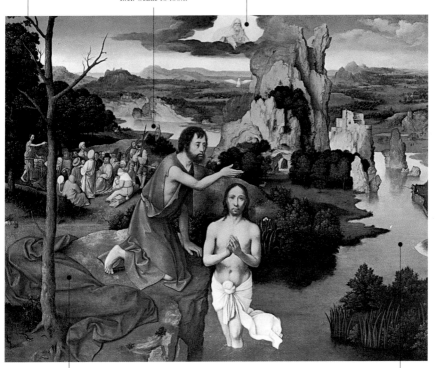

Jesus, like the other converts, leaves his clothing at the water's edge.

The Jordan winds between jagged, rocky banks to flow between serene, grassy shores near Jesus. The Flemish painter intended, perhaps, to reflect the Baptist's role in preparing the way of the Lord and making his paths straight.

▲ Joachim Patinir, *The Baptism of Christ*, 1515. Vienna, Kunsthistorisches Museum

The smooth, light-colored trunk of the tree is clearly compared with Jesus' body. It symbolizes both the tree of Abraham, which protects the just with its branches, and lignum vitae *(the Tree of Life)*, the salvation brought about by the wood of the cross.

The dove, the visible form of the Holy Spirit, hovers in place with wings spread open. Piero chose to focus the scene's mysticism entirely on this emblem, and not portray God the Father in Heaven.

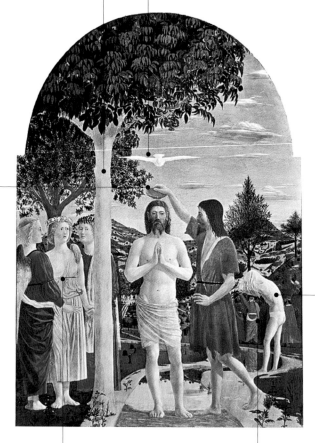

The perfect stillness of the middle of the painting—between Christ's face and the dove of the Holy Spirit—seems almost to include the water that the Baptist pours from a bowl.

The neophytes take off their clothes in preparation for their baptism.

The three angels who embrace on the left symbolize harmony. One or more angels often appear at the Baptism of Christ, although none of the Gospels mentions them.

In the background are the Pharisees and Sadducees whom the Baptist fulminated with invectives.

▲ Piero della Francesca, *The Baptism of Christ*, ca. 1440. London, National Gallery

Many masters, from the Middle Ages on, have been fascinated by the events of the capture and execution of John the Baptist, taking place amid the court's seductions and horror, decadent pageantry, and cruelty.

The Feast of Herod

At times humanity's weaknesses mark history. King Herod Antipas had not reacted to the danger of sedition and disorder aroused by the Baptist's preaching, but when he was personally accused of having taken Herodias, his brother Philip's wife, as his lover, he had John arrested. This is where the evangelists' interpretations diverge. According to Matthew, Herod was looking for an excuse to get rid of the Baptist, whereas, according to Mark, the king heard him willingly and "respected" him. Not so the treacherous Herodias. Knowing Herod's frailties, she convinced her beautiful daughter Salome to dance before the king during a banquet (which we may imagine well watered with libations). Beguiled and befuddled, Herod granted Salome any gift she wished, "even half of my kingdom"(Mark 6:23). Salome consulted with her mother and, following her mother's advice, asked for the Baptist's head on a plate. The king was "exceedingly sorry" (6:26), but did not retract his word. He sent a soldier to the prison where the Baptist was held and ordered him beheaded. The head on a platter was given to Salome, who in turn gave it to her mother. The Baptist's disciples were permitted to bury the body.

The Place
The king's palace in Jerusalem and a prison that may have been located near the Dead Sea

The Time
A.D. 30

The Figures
Besides the Baptist, the main characters are King Herod Antipas (not to be confused with his father, King Herod Ascalonite, or Herod the Great, who was king at the time of Jesus' birth), Herodias, and Salome.

The Sources
The Gospels of Matthew and Mark

Variants
The individual moments in the episode: the Arrest of the Baptist, the Feast of Herod, the Dance of Salome, the Beheading of the Baptist, and Herodias Receives the Head of the Baptist

Diffusion of the Image
Quite widespread, along with the cult of the Baptist

Salome with the Head of ◄ the Baptist, mid-fourteenth-century mosaic. Venice, Basilica of San Marco

John accuses Herod of various sins, including living with his brother's wife, Herodias.

Preti follows the image of Herod, tetrarch of Galilee, that can be found in Mark's Gospel. The king appears perplexed and worried by the words of the Baptist, whom he considers a righteous man and whose preaching he readily listens to.

Salome, daughter of Herodias and Philip (King Herod's brother, who had been left by his wife), is a lovely, but obviously fatuous young woman, an instrument in the hands of her mother.

Herodias, seated beside the king, is the true instigator of the Baptist's martyrdom. The decision to have him put to death was far more hers than the easily manipulated king's.

▲ Mattia Preti, *The Baptist before Herod*, ca. 1665. New York, private collection

The moment of his arrest is further confirmation that John is the precursor of Christ. Besides the urban setting, the scene is very similar to Christ's own arrest, and the Baptist expresses Christ's gentle acceptance.

The tiny lamb on a book is John the Baptist's characteristic attribute.

The Baptist wears a rich tunic over his garment of rough camel hair. It symbolizes the sainthood that he achieved through martyrdom.

Members of the aristocratic priestly class are also present at the arrest. The Baptist violently attacked them in his sermons.

▲ Master of Miraflores, *The Arrest of the Baptist*, 1490. Madrid, Museo del Prado

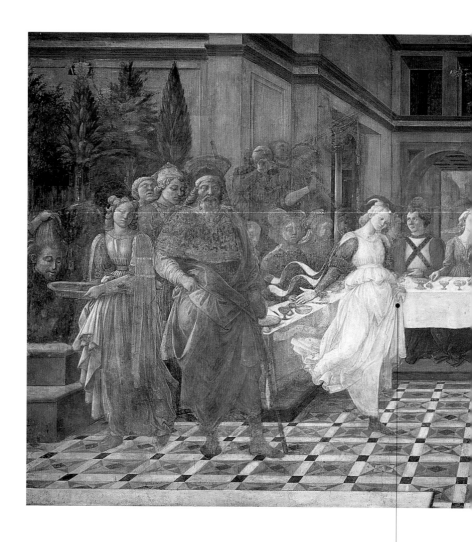

*Salome dances before the
sumptuous table prepared for
King Herod's birthday.*

▲ Filippo Lippi, *Stories of John the Baptist: The Banquet of Herod*, 1452–64. Prato, Duomo

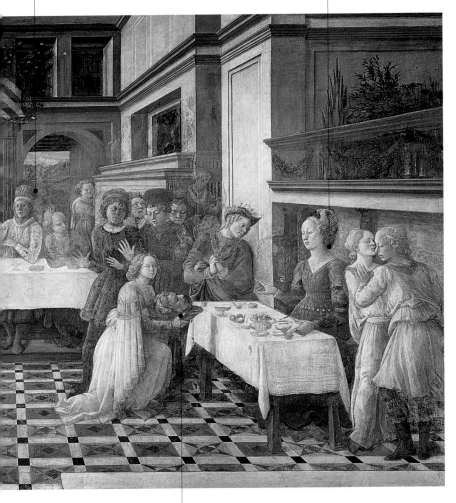

Herod sits next to the wicked Herodias at the center of the banquet table. She calls his attention to Salome's attractiveness.

Herodias seems satisfied. Her cruel plot has been accomplished.

Salome brings Herodias a macabre trophy: the head of the Baptist on a platter.

The crown, the embroidered garments, and the footrest are all emblems of Herod's royalty.

Herod caresses Salome's chin. In the medieval aesthetic, this affectionate gesture signifies a sinful sensuality.

Herod's hand on his thigh indicates his strong will and sense of power.

Salome's legs are crossed in a dance step.

▲ *Herod and Salome*, a twelfth-century Romanesque capital. Toulouse, Musée des Augustins

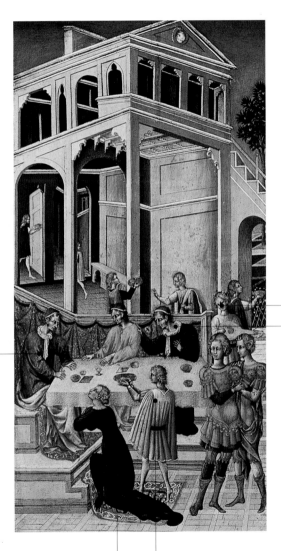

A servant sets off for the place where the Baptist will be executed.

The dinner guests listen, saddened and horrified by Salome's request.

This scene combines various moments of the episode in a single place. Here Herod sits at the head of the table and is visibly startled by Salome's chilling request.

After her seductive dance, Salome turns to Herod to ask him to grant her the head of the Baptist.

A servant brings the silver tray on which the Baptist's head will be placed.

▲ Giovanni di Paolo, *Salome Requests the Head of the Baptist*, ca. 1450. Art Institute of Chicago

The heavy door emphasizes the setting: a dark prison. The dim light of torches and candles accentuates the dramatic effect.

The executioner waits until the Baptist is in the correct position to be beheaded.

Two women watch from the doorway, an elderly woman with a candle and a younger one. They are difficult to identify; they may be two servants sent by Herodias.

His hands tied, the Baptist is already kneeling at the block on which he will be executed. The silver platter that will hold his severed head is on the ground.

▲ Antonio Campi, *The Beheading of the Baptist*, ca. 1571. Milan, Church of San Paolo Converso

God the Father watches over the entire scene from on high, among the clouds.

In the background, inside Herod's palace, Salome dances before the banquet table of the king.

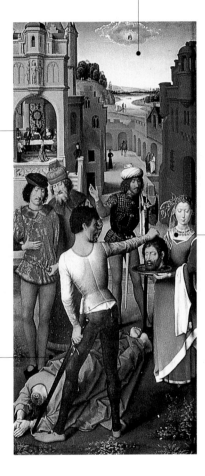

Appalled yet determined, Salome receives the Baptist's severed head from the executioner.

The decapitated body of the Baptist is stretched out on the ground. The hands are folded in a final gesture of prayer.

▲ Hans Memling, *The Beheading of the Baptist*, 1474–79. Bruges, Memlingmuseum

A horrified old woman clutches her head.

An official points to the large tray on which the Baptist's head is to be placed.

A young servant, not Salome, holds the tray.

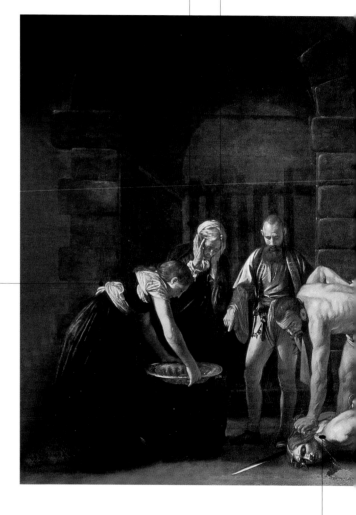

The beheading has been imperfectly accomplished: the executioner's blow has only partially severed the head from the body. The executioner is unsheathing a knife called a "misericordia" (mercy) to deal the deathblow.

▲ Caravaggio, *The Beheading of John the Baptist*, 1608. La Valletta, Malta, Cathedral of Saint John

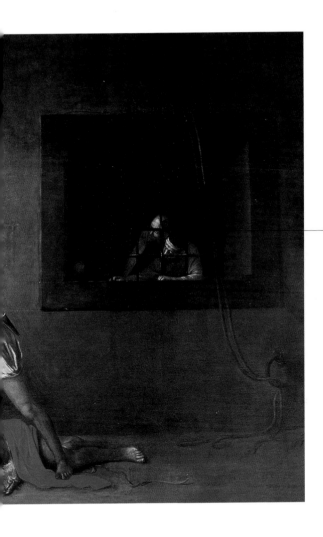

The capital execution takes place in the courtyard of a prison. Two prisoners watch the scene through the bars. Here Caravaggio joined a dramatic and absorbing realism with a careful reading of the text: the Baptist was not, in fact, kept alone in a dungeon in Herod's royal palace, as the scene is sometimes represented, but rather in a fortress near the Dead Sea, probably Machaerus.

Partly because of the complicated legendary adventures of the saint's relics, the severed head of the Baptist became a devotional object in its own right and the subject of a large number of paintings like this one.

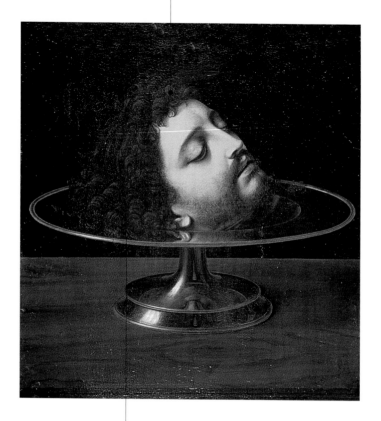

The tray holding the Baptist's head is interpreted here as a refined Renaissance fruit dish, a typical example of goldsmith work from Lombardy.

▲ Andrea Solario, *The Head of the Baptist*, 1507. Paris, Musée du Louvre

As is common in medieval art, the prison where John was held is shown as a grim tower of massive stone blocks.

The executioner returns to its scabbard the sword he used for the beheading.

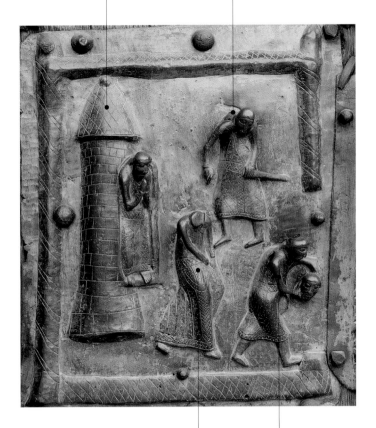

John's decapitated body, its hands bound, remains standing. Although this seems like medieval naïveté, it was not unusual in capital punishment cases of this kind for a body to have a few autonomic tremors after it was beheaded.

A servant carries away John's head.

▲ First Master of S. Zeno, *The Beheading of the Baptist*, tenth- or eleventh-century bronze door. Verona, Basilica of Saint Zeno

Herod jerks
backward in
horror and
shock; only the
wicked Herodias
leans toward the
grisly trophy.

With an extraordinary sense of perspectival
space, Donatello built the scene by beginning
with the background, upper left, where a
servant bears the Baptist's head on a tray.

At the center of the
middle ground is a
viola player.

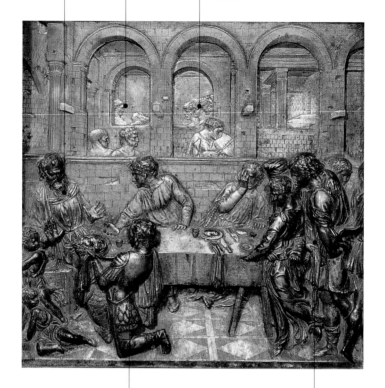

One of the executioners
haughtily kneels before
Herod, presenting
John's head to his king.

The dinner guests retreat to the foot of
the table. At the center of the group, in
the foreground, is Salome, whose very
elegant pose recalls the seductive dance
she has just finished.

▲ Donatello, *The Feast of Herod*, 1423. Siena, baptismal font of the Baptistery

All of the dinner guests are unattractive in one way or another. Following Flemish tradition, Rubens endowed his characters with features and expressions that are charged with negative connotations.

Herodias smugly receives the charger with the Baptist's head and turns to Herod with a look of spiteful complicity.

The triumphal tableware is in marked contrast with the platter on which the Baptist's head is displayed.

Salome displays the Baptist's head with satisfaction.

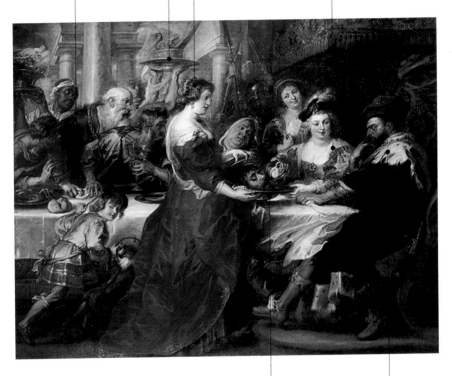

Rubens accentuates the inhuman aspects of the scene: the head of the Baptist is on a covered dish, the kind used to keep food from getting cold, and Herodias seems to test it with a fork, as if to see if it is properly cooked.

Herod's horror and perturbation are evident in his expression and in the tension with which he clutches the tablecloth.

▲ Peter Paul Rubens, *The Feast of Herod*, 1630. Edinburgh, National Gallery of Scotland

THE PUBLIC LIFE
OF JESUS

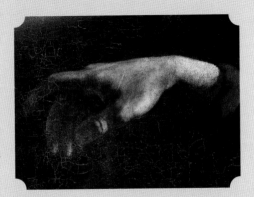

◀ *Jesus Healing the Hemorrhaging Woman*, early Christian fresco. Rome, Church of Santi Pietro e Marcellino

▶ Caravaggio, *The Calling of Saint Matthew* (detail), 1599. Rome, Church of San Luigi dei Francesi

The conflict between the weakness of the flesh and the strength of the spirit is a recurring theme in the Gospels. In this case, the dramatic duality between good and evil touches Jesus directly.

The Temptations

In order to discern the references to the three temptations of Jesus in works of art, we must pay attention to the details. For example, there is the cloven foot of Jesus' interlocutor, who from the fifteenth century on tends to lose the monstrous characteristics of earlier centuries.

We may distinguish different moments in this episode. First of all, there are Jesus' fasting and solitude in the desert, with only animals around him. Then, in order, are the devil's three temptations. The first—the most frequently represented—is to turn stones into bread in order to assuage his hunger after forty days of fasting. The second is to throw himself from the spire of the temple and call on the angels for help. In the third, the devil offers Jesus all the world's riches if he will worship him once. At that point, Jesus drove Satan away, and shortly after was comforted by the angels.

The Place
The "Mount of the Forty Days" in the desert near Jerusalem

The Time
Forty days after the Baptism of Christ

The Figures
Jesus and the devil as tempter

The Sources
The Gospels of Matthew, Mark, and Luke (the synoptic Gospels)

Variants
The Temptations of Christ in the Desert; "*Vade Retro, Satana!*"; Christ Ministered by Angels

Diffusion of the Image
Rather rare; the episode is not always immediately recognizable, especially when Jesus is invited to change stones into bread

► *The First Temptation of Christ, from an illuminated psalter, ca. 1222. Copenhagen, Det kongelige Bibliotek*

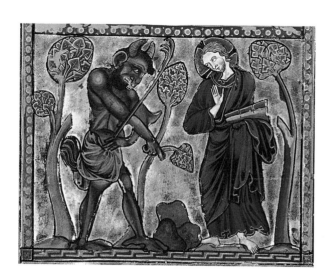

Among the many animals that surround Jesus, the stag most meaningfully expresses Christ's situation. According to the Psalms, the soul searches for God as the hart longs for a stream. In addition, medieval bestiaries held that stags are impervious to snake venom because they drink a great deal of spring water. In the same way, Christians can resist the snares of sin by turning to Christ.

The angels do not intervene during Jesus' forty days of fasting in the desert or even during the temptations that followed, but only at the end of the entire episode.

A hand on a cheek traditionally signifies solitary and melancholy meditation.

▲ Moretto da Brescia, *Christ in the Wilderness*, ca. 1540. New York, The Metropolitan Museum of Art

The devil brings Jesus to a mountaintop. Here he offers him the kingdoms of the world in exchange for a gesture of submission.

The devil approaches Jesus offering him a stone. He is dressed in a sort of monastic habit, but is recognizable by his pointed beard and the small horns on his head.

This painting illustrates the first temptation. The devil shows the famished Christ a stone and proposes that he turn it into a loaf of bread.

The devil brings Jesus to the highest tower in Jerusalem. Here he challenges Jesus to hurl himself down and be caught by angels.

▲ Juan de Flandes, *The Temptation of Christ*, 1496–99. Washington, D.C., National Gallery of Art

While in other images the devil appears in human form, Duccio here reveals his otherworldly nature by showing his wings, his original state as a rebellious angel.

Jesus' gesture and expression explicitly refer to the end of the episode and the phrase "Begone, Satan!" ("Vade retro, Satana!"; Matthew 4:10).

At the victorious conclusion of the devil's third and final challenge, two angels approach Jesus to comfort him.

The walled cities, which resemble little models, refer to the kingdoms of the world that the devil showed Jesus during the final temptation.

▲ Duccio di Buoninsegna, *The Temptation on the Mountain*, from the *Maestà* altarpiece, 1308–11. New York, Frick Collection

This is among the most recognizable Gospel stories, but also one of the most ambiguous, since it can relate to either of two different—yet visually similar—moments.

The Miraculous Draft of Fishes

The Place
Lake Gennesaret (also known as the Sea of Tiberias or Sea of Galilee)

The Time
The beginning of Jesus' public life, or ministry, in Galilee

The Figures
Jesus and the first disciples: James and John, Zebedee's sons, and so relatives of Jesus, and the other pair of brothers, Andrew and Simon, also called Peter

The Sources
The Gospel of Luke

Diffusion of the Image
Artists often confuse this episode with other scenes of fishing on the lake, especially that of the risen Christ, as described in the Gospel of John.

The episode of the Miraculous Draft of Fishes and the conversion of Simon Peter, a rough fisherman, has sparked the imagination of many artists of various times and countries. After the first miraculous catch, found only in Luke (5:1–11), the fishermen continue their trade; Jesus will walk upon the lake's waters twice, and finally, after the Resurrection, will repeat the miracle of the extraordinary catch. Jesus' first miracle, which occurred during the calling of the first apostles ("I will make you fishers of men"; Matt. 4:19), was followed by his appearance on the waters of the lake at Bethsaida. Thanks to Jesus' intervention, from a hundred yards out, Peter and his five companions were able to haul in an astonishing 153 "large fish" (John 21:1–14).

► Jacopo Bassano, *The Miraculous Draft of Fishes*, 1545. London, private collection

Astonished at the marvel of the miraculous catch, Peter confesses that he is a sinner and suggests that Jesus depart.

Jesus blesses Peter and announces, "Henceforth you will be catching men" (Luke 5:10).

The net is stretched with fish almost to the breaking point.

▲ *Christ Walks upon the Water*, a panel originally from the bronze door of the Benevento cathedral. First half of the thirteenth century. Benevento, Biblioteca Capitolare

The scene in the middle ground refers to the appearance of the risen Christ on the Sea of Tiberias. Peter dives into the water to reach the shore, while his companions hoist the net overflowing with fish a short distance from the banks.

Large baskets of fish are unloaded from Peter's boat, perhaps alluding to the similar situation at the miracle of the Multiplication of the Loaves and Fishes.

▲ Joachim Beuckelaer, *The Miraculous Draught of Fishes*, 1563. Los Angeles, The J. Paul Getty Museum

Accurately following John's text, Beuckelaer shows
Christ appearing along the beach, not walking upon
the water. Behind him in the background is the modest
meal of bread and grilled fish that Jesus prepared for
the Apostles.

Despite the many references to the Gospel of
John, the painting has a primarily secular
look, like a realistic portrayal of the sale of
fish fresh off the boat.

A fishing boat and a tax collector's counter are the settings of the most famous "callings" of the apostles. In the case of Peter and Andrew, the subject is linked to the Miraculous Draft of Fishes.

The Calling of the Apostles

The Place
Capernaum, along the banks of Lake Gennesaret (also known as the Sea of Tiberias or Sea of Galilee)

The Time
The beginning of Jesus' public life, or ministry, in Galilee

The Figures
Other than Jesus, various apostles, including James, John, Andrew, and Matthew

The Sources
The synoptic Gospels

Variants
A title will refer to the "calling" or "vocation" of an individual apostle

Diffusion of the Image
Connected with the cult of the various saints. The calling of Matthew is the most popular, especially during the seventeenth century, when Caravaggio created his unforgettable masterpiece for the Church of San Luigi dei Francesi in Rome.

▶ Hendrick ter Brugghen, *The Calling of Saint Matthew*, 1621. Utrecht, Central Museum

Although there are relatively few important works with this subject, scenes of the calling of the apostles have often proved to be opportunities for experimentation and unusual solutions in art.

Matthew's calling is particularly famous: the few Gospel verses (for example, Matt. 9:9) became, in the early seventeenth century, the image of a group of guards, soldiers, and tax officials playing cards or dice. This iconography became so popular in itself that soon the presence of Jesus and other religious references became superfluous.

We should add that the traditional titles of works of art are not always helpful. For example, after he is called to be an apostle, Matthew organized a lavish dinner with many guests. This is the banquet identified in art as the Supper in the House of Levi (Matthew's other name).

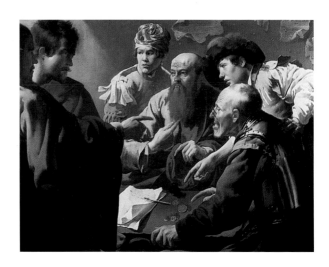

This image follows the Gospel of Mark (1:18–20) word for word. Jesus is flanked by the first two apostles, Peter and Andrew.

Other fishermen continue their activity on the still waters between the mountains. This painting, made for a friars' church, refers to the balance between the active and the contemplative life.

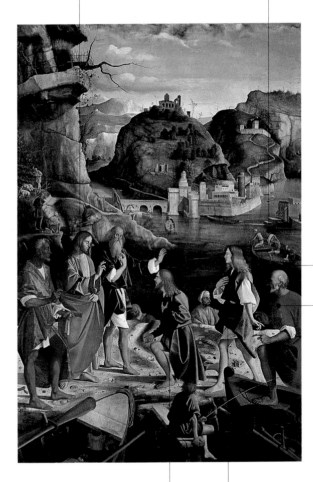

This painting is considered to be the first altarpiece in Venetian art to have a narrative theme.

Zebedee, James and John's father, stays in the boat and watches his sons answer Jesus' call.

James the Greater, who will become the patron saint of pilgrims, kneels before Jesus.

John, the "beloved disciple" and future evangelist, places his hand on his heart, a gesture that occasionally recurs in images of the Last Supper.

▲ Marco Basaiti, *The Calling of Zebedee's Sons*, 1510. Venice, Gallerie dell'Accademia

The Calling of the Apostles

Jesus is barefoot, but wears an unusually rich cloak.

Levi, or Matthew, follows the call and bows before Jesus. His clothes signal that he is affluent, which is confirmed by the banquet he holds that same evening to celebrate his new life as an apostle.

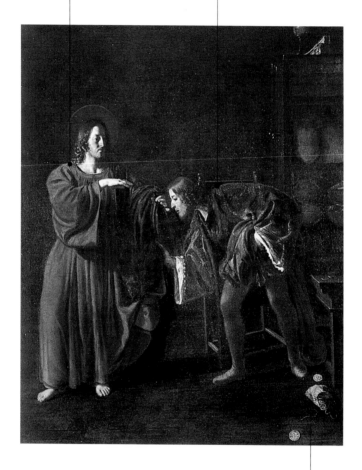

The coins scattered on the floor refer to Matthew's profession—tax collector—as well as to his renunciation of worldly goods to follow the call of Jesus.

▲ Guido Cagnacci, *The Calling of Saint Matthew*, ca. 1635–45. Rimini, Museo della Città

After Mary Magdalene, who has her own iconography, including images without Jesus, the woman of Samaria is the most commonly depicted Gospel female in the history of art.

In this episode, the Gospels once again offer artists a number of precise details of setting, narrative, mood, and characterization. At the same time, artists have never succeeded in giving figurative substance to the extremely subtle psychological plot; the gradual relinquishing of certainties; and the suspended balance between political and religious hostilities, physical demands, and spiritual horizons. The central theme of adoring God "in spirit and truth" (John 4:23) also almost never appears.

Christ and the Woman of Samaria

The Place
Outside the village of Sychar, in Samaria, near Jacob's Well

The Time
During Jesus' move from Judea to Galilee

The Figures
Jesus and the woman from Samaria; some of the apostles may also appear in the background

The Sources
The Gospel of John

Variants
The Samaritan Woman at the Well; Christ and the Samaritan Woman

Diffusion of the Image
Quite widespread, especially during the sixteenth century; the scene is also adapted to be an allegory of eloquence

At any rate, at least two distinct moments may be noted in the various interpretations of the meeting of Jesus and the woman of Samaria near Jacob's Well in Sychar. Some painters elected to focus on the first part of the dialogue, when Jesus surprises the woman by asking her for water. Others, instead, emphasized the final exchange, when the woman bows her head before Jesus' revelation that he is the Messiah.

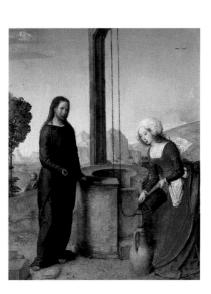

Juan de Flandes, *Christ* ◀ *and the Woman of Samaria*, 1496–99. Paris, Musée du Louvre

Christ and the Woman of Samaria

As is characteristic of academic art and classicism, Carracci accurately follows the Gospel text. The apostles are returning from the city of Sychar with food.

The scene takes place in the country, on the farm that the patriarch Jacob was said to have given his favorite son, Joseph. Because of the divisions of land among Jacob's children, there had been deep political and religious rivalries between the Israelites and the Samaritans for centuries. Each side accused the other of heresy.

Jesus is performing two gestures: with his right hand on his breast he refers to himself as the Messiah, while with his left he points to the city of Sychar, inviting the Samaritan woman to spread the news of their encounter.

The jug between Jesus and the Samaritan woman recalls their dialogue on the subject of physical and spiritual thirst.

Jacob's Well was actually an abundant spring that was used not only as a well but also as a source of water for animals.

The Samaritan woman, who tried initially to keep up with Jesus in their dialogue, appears to be won over by his eloquence and his revelations.

▲ Annibale Carracci, *Christ and the Woman of Samaria*, 1563–94. Milan, Pinacoteca di Brera

Like the Gospel text, artists have focused primarily on the dialogue between Jesus and the Canaanite, rather than on the miracle of the healing of her daughter, who had been tormented by a demon.

Christ and the Canaanite Woman

The northernmost of Jesus' miracles occurred in a small Phoenician town—the dialectical cleverness of this nation of famous merchants can be seen in the quick-wittedness of the Canaanite woman. With imploring cries, she tried to capture Jesus' attention and have him heal her possessed daughter. Despite his silence and the apostles' attempts to make her stop, she would not quit. Somewhat brusquely, Jesus pointed out to her that it was wrong to take food from children (meaning the Israelites) and throw it to the dogs (meaning the pagans). The woman retorted instantly, "Yes, Lord, yet even the dogs eat the crumbs that fall from their masters' table" (Matt. 15:27). Jesus praised the woman's faith, and the miracle took place. It is significant to note that the few artistic renderings of this episode do not show the miraculous healing of the girl, but only the dialogue between the mother and Jesus.

The Place
The city of Canaan in Phoenician territory (present-day Lebanon), not to be confused with Cana, the place near Nazareth where Jesus attended a marriage banquet

The Time
During Jesus' journey through the territories of the cities of Tyre and Sidon

The Figures
A dialogue between Jesus and the woman from Canaan, with the apostles and a crowd of other figures

The Sources
The Gospels of Matthew and Mark

Variants
The Healing of the Canaanite Woman's Daughter

Diffusion of the Image
A rather rare episode

Juan de Flandes, *Christ* ◀ *and the Canaanite Woman*, ca. 1496–1503. Madrid, Royal Palace

Depictions of the scene of the storm on the lake are uncommon, but easily identified by the figure of Jesus sleeping peacefully in the boat while the apostles are terrified.

The Bark

The scene of the night storm on the lake is rare in the history of art and was often superimposed on the similar boating scene of Jesus walking on the water. The story of the "bark," the apostles' boat that was beaten by a head wind and about to sink with Jesus on board, is included in the three synoptic Gospels and described almost identically. Jesus slept through the storm's fury. Awakened by the terrified apostles, "he awoke and rebuked the wind, and said to the sea, 'Peace! Be still!' And the wind ceased, and there was a great calm" (Mark 4:39). But let us recall the beginning of the episode: inviting them to "go across to the other side" (4:35), Jesus had urged the apostles to hoist their sails. The "two sides" of the lake become a metaphor for the extremities of earthly life: the anxiousness of the apostles in the storm while Jesus sleeps echoes the fears that assail us all in difficult moments, and the question that Jesus asked when he awoke—"Have you no faith?" (4:40)—takes on a significance that goes far beyond the possible shipwreck of a boat full of fishermen.

The Place
Lake Gennesaret (also known as the Sea of Tiberias or Sea of Galilee)

The Time
Early in Jesus' public ministry

The Figures
Jesus, Peter, and the other apostles in a boat

The Sources
The synoptic Gospels

Variants
Jesus Calms the Storm

Diffusion of the Image
This subject had a resurgence during the Counter-Reformation because it implies Peter's primacy and represented the Church's troubles.

▶ *The Calming of the Storm,* a twelfth-century mosaic. Venice, Basilica of San Marco

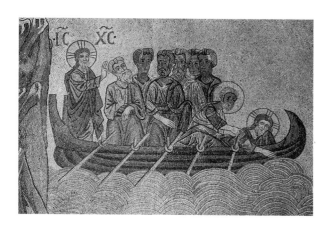

The sail, ripped by the storm, whips uncontrollably.

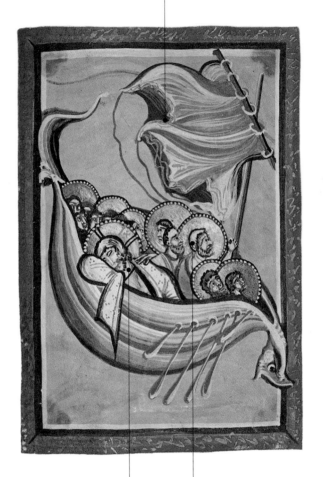

Jesus sleeps peacefully toward the stern.

A wide-eyed Peter joins his hands in a gesture that expresses more terror than prayer.

▲ *Christ Calms the Storm*, from the Gospels of the Abbess Hitda, early eleventh century. Darmstadt, Hessische Landesbibliothek

The image of Peter's boat and Jesus walking on the water can correspond to several moments in the Gospels, during the public life of Jesus and after the Resurrection.

Christ Walking upon the Water

The Place
Lake Gennesaret (also known as the Sea of Tiberias or Sea of Galilee)

The Time
This scene may refer to the early period of Jesus' ministry, or (more rarely) to his appearance after the Resurrection.

The Figures
Jesus, Peter, and the other apostles

The Sources
The Gospels of Matthew, Mark, and John

Diffusion of the Image
This episode is related to the debate regarding Peter's primacy and the Roman Catholic Church.

Generous, dynamic, expansive, moody, and intensely human, Peter is one of the most easily recognizable saints in art. On two occasions, he did not hesitate to dive into the waves of the lake, and images of the two episodes tend to overlap. The first occurred as the apostles were struggling with an unfavorable wind, and Jesus walked over the water from the shore to help them. When he was near the boat, he invited Peter to walk on the water, too. For a while Peter stayed on top of the waves, but then, because of his fear, he began to sink. Jesus held him up, saying, "O man of little faith, why did you doubt?" (Matt. 14:31). After the Resurrection, Jesus appeared to the apostles as they were fishing. This time, however, he did not walk on water but remained on shore.

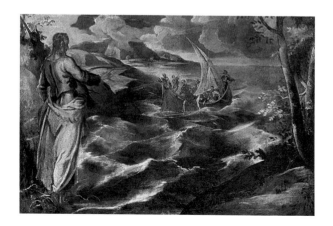

► Jacopo Tintoretto, *Christ Walks upon the Water*, 1591. Washington, D.C., National Gallery of Art

Although distinguished by halos, the
fishermen-apostles are realistically
shown at their tiring labor.

The scene is set in the
countryside around Lake
Geneva, which was well
known to this Swiss
painter. The glaciers of
Mont Blanc can be seen
in the distance.

The net is so laden with the
extraordinary quantity of fish
that it is about to break.

Peter dives into the lake in order
to reach Jesus, but gradually
begins to sink.

Jesus glides across the waters toward
Peter, as if weightless. It should be
pointed out that while all the other
figures are reflected in the waters of
the lake, Jesus' red cape is not
mirrored on the sea.

▲ Konrad Witz, *The Miraculous Draft of Fishes*, a panel from the Altar of Saint Peter, 1443–44. Geneva, Musée d'art et d'histoire

No distinction is made in the history of art between the two occasions when Jesus miraculously fed thousands of people with such abundance as to leave many baskets of leftover food.

The Multiplication of the Loaves and Fishes

The Place
Bethsaida, on the shores of Lake Gennesaret (also known as the Sea of Tiberias or Sea of Galilee)

The Time
According to Mark, this miracle was repeated twice.

The Figures
Jesus, the apostles, and a crowd of people

The Sources
The episode is described in all the canonical Gospels, and the miracle occurs twice in Mark's.

Diffusion of the Image
A relatively uncommon image, it had a resurgence in relation to the debate about the Eucharist.

All four Gospels minutely describe this miracle, which satisfied material and logistical needs born of the great popularity reached by Jesus' sermons. We know precisely how many people were fed, how many barley loaves and fish were distributed, how many baskets of food were left over, and even that the hungry were divided into groups of fifty.

John explained Jesus' insistence on these details. After the miracle, Jesus and the apostles embarked for Capernaum. Some of the new believers followed, and Jesus addressed his great eucharistic sermon to them, to teach them the difference between the bread that satisfied their hunger, the manna that God sent to nourish Moses and the Jews during their flight from Egypt, and the spiritual "bread" that is Christ himself: "For the bread of God is that which comes down from heaven, and gives life to the world" (John 6:33).

► Giovanni Lanfranco, *The Multiplication of the Loaves and Fishes*, 1624–25. Dublin, The National Gallery of Ireland

The crowd of faithful who have
come to hear Jesus reaches into the
distance. John calculated that there
were close to five thousand people
there.

Many, many baskets of food are
passed among the faithful on the
grassy hill by the Sea of Tiberias.
In the end there will be twelve
baskets of food left over.

Once again, the gesture that
Jesus uses to perform the
miracle is one of blessing.

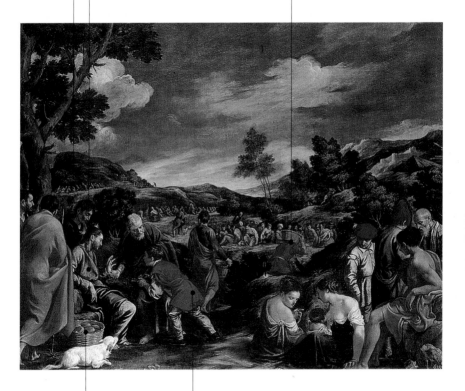

The presence of a boy with two tiny fish indicates the
exact source for this picture in the Gospel of John. By
the same token, we know that the apostle next to the
boy is Andrew, Peter's brother.

This basket with barley loaves was the meager first donation of food; the apostle
Philip had figured that it would have cost at least two hundred denarii to give each
of the faithful just a small piece of bread.

▲ Pedro Orrente, *The Miracle of the Loaves and Fishes*, 1605. Saint Petersburg, Hermitage

Mary Magdalene is the key figure in this episode. She bathed Christ's feet with her repentant tears, dried them with her long hair, and anointed them with perfumed ointment.

The Supper in the House of Simon

The Place
Capernaum or Nain (this episode follows shortly after the resurrection of the boy from the latter town)

The Time
The beginning of Jesus' public life

The Figures
Jesus, Mary Magdalene, and other dinner guests

The Sources
The Gospel of Luke

Variants
Supper in the House of the Pharisee; there are a number of mistakes and overlappings between this and the similar episode that occurred in Bethany just before the Passion.

Diffusion of the Image
After the Last Supper, this dinner—together with the marriage banquet at Cana—is the most frequently represented Gospel meal.

▶ Moretto da Brescia (Alessandro Bonvicino), *Supper in the House of the Pharisee*, ca. 1540. Brescia, Church of Santa Maria Calchera

Extrabiblical traditions and Saint John Chrysostom's interpretation identify Mary Magdalene, the repentant sinner, as the anonymous woman who, during the dinner that Simon the Pharisee offered Jesus (Luke 8:36), performed an act of deep humility. With ointment from an alabaster jar, she anointed and perfumed Christ's feet, then dried them with her own hair. In Matthew, Mark, and especially John, the episode occurs just before the Passion.

John provided alternate details. His scene (12:1–8) took place in Bethany at the house of Mary, Martha, and Lazarus: this clarifies that this Mary was "the Magdalene." She used a pound of expensive pure spikenard; disputes arose over the money wasted on this ointment, which could have been given to the poor. Matthew and Mark spoke of disdain and general murmuring, while John specified that it was Judas who objected.

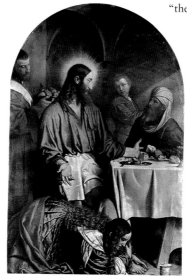

Simon is appalled that Jesus lets himself be approached by a sinner. In reality, Luke's Gospel says that the Pharisee only asked himself questions that Jesus intuited. If anything, it was Judas who expressed his disappointment, at an iconographically similar dinner in Bethany. Here the two scenes have been visually superimposed.

Jesus replies calmly to Simon the Pharisee's perplexity and at the same time blesses Mary Magdalene with his right hand, forgiving her many sins.

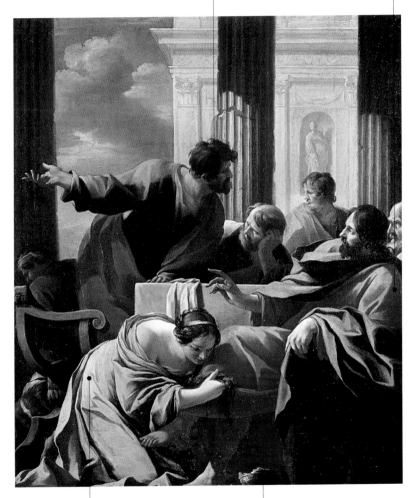

Mary Magdalene dries Jesus' feet with her own hair in an act of humility, repentance, and homage.

The alabaster jar that contains the precious ointment has become Mary Magdalene's attribute in art.

▲ Simon Vouet, *Mary Magdalene in the House of Simon*, 1640. United States, private collection

The Supper in the House of Simon

The Gospels do not say, but there is every reason to think that the apostles were invited to the dinner. The person next to Jesus can be identified as Peter.

As in all his supper scenes, Veronese mixes figures in contemporary clothing with others wearing the apostles' traditional costumes.

Mark specifies that Mary Magdalene broke the alabaster ointment jar (14:3).

Mary Magdalene prostrates herself at Jesus' feet to dry them with her very long blond hair.

Jesus' peaceful figure is on the far left of the huge picture (some twenty-six feet wide). This created a challenge for Veronese to guide the viewer's eye directly to one side, rather than to the middle of the work.

▲ Paolo Veronese, *Supper in the House of Simon*, ca. 1570. Milan, Pinacoteca di Brera

The man who leaps to his feet, shocked at Mary
Magdalene's entrance, is very probably Judas. His
purse is an unequivocal clue, referring both to his
function as administrator of the small fund that the
apostles share and to the purse of thirty silver
denarii that he received for betraying Jesus.

Like the births of Mary and John the Baptist, this episode was frequently interpreted in a descriptive, realistic, and contemporary vein. The religious became entirely marginal.

Christ in the House of Martha and Mary

The Place
Bethany, a village at the gates of Jerusalem

The Time
His relationship with Martha, Mary, and their brother, Lazarus, marks a crucial turning point in Jesus' public life.

The Figures
Jesus, Martha, Mary, and sometimes other guests

The Sources
The Gospel of Luke

Diffusion of the Image
Very widespread during the sixteenth and seventeenth centuries, partly as an opportunity for still lifes

Jesus' friendship with the three siblings of Bethany (Martha, Mary, and Lazarus) probably began with the dinner at Simon's house, where a woman, identified as Mary Magdalene, anointed Jesus' feet with a precious ointment as a sign of repentance. Nevertheless, according to Luke's narrative, it was not Mary who invited Jesus to their house, but her sister, Martha. Martha went to a great deal of trouble to welcome their guest appropriately, while Mary sat at Jesus' feet to listen to him. Martha pressed her sister to help, but Jesus calmly reprimanded her: "Martha, Martha, you are anxious and troubled about many things; one thing is needful. Mary has chosen the good portion" (10:41–42).

► Jan Vermeer, *Christ in the House of Martha and Mary*, ca. 1655. Edinburgh, National Gallery of Scotland

However, temperament often prevails over teachings: according to John, during the difficult circumstances of Lazarus's death, Martha was the first to run to Jesus, while Mary sat at home.

Martha's apron emphasizes her busy preparations for the meal. Although Jesus' reply favored Mary's contemplative calm, Martha is so positive a figure that she became the patron saint of housework.

The theme of the painting is often an excuse for realistic genre scenes. Nevertheless, these two painters from Antwerp followed Luke's text closely. Martha does not address her sister, but Jesus, who replies eloquently.

The dog next to Martha is the symbol of the readiness of faith and of vigilance.

Mary sits lower than Jesus as a sign of humble and pious attention.

On the right is the kitchen where the meal is being prepared.

▲ Peter Paul Rubens and Jan Peeter Brueghel, *Christ in the House of Martha and Mary*, 1628. Dublin, The National Gallery of Ireland

Christ in the House of Martha and Mary

Mary is beside Jesus. Identified with the penitent Mary Magdalene, Martha and Lazarus's sister expresses her intense devotion to Jesus.

Jesus replies calmly to Martha's objections and to her request for Mary's help with the household chores.

Animatedly, and not without reason, Martha calls her sister to do her part with the practical side of receiving Jesus.

The boy with the basket of fish refers to the miracle of the Multiplication of the Loaves and the Fishes, albeit in an immediate and realistic context.

Despite Martha's complaints, everything is ready for a simple, yet complete reception. The table is well set, the cook is giving the final touches to the soup on the fire, and a man (Lazarus?) is slicing a salami.

▲ Jacopo Bassano, *Christ in the House of Martha and Mary*, ca. 1576–77. Houston, Sarah Campbell Blaffer Foundation

The diffusion of individual cults of single saints has evidently curtailed the spread of collective and essentially indistinguishable images of the apostles.

Christ Commissioning the Apostles

Two distinct "missions" can be discerned in the Gospels (the term has the etymological meaning of "sending"). One of the Gospel missions is short-range, with a practical and direct goal; the other, far more demanding, is open-ended. Matthew, toward the beginning of Jesus' public ministry, described the first type. Gathering the Twelve Apostles, Jesus sent them to preach the kingdom of God, cure the sick, and exorcise those possessed by demons in nearby villages. The last paragraph of the same Gospel, however, describes a very different mission. The risen Jesus gathered the apostles on a mountaintop in Galilee and charged them with baptizing all the people of the earth, "teaching them to observe all that I have commanded you" (28:20). With this exhortation, reinforced by the descent of the Holy Spirit at Pentecost, the Church's true "mission" of evangelization began.

The Place
Caesarea, or (according to Luke) the countryside near Jerusalem

The Time
During Jesus' ministry

The Figures
Christ and the apostles

The Sources
The Gospel of Luke and later traditions (for the apostles' destinations)

Variants
In a higher and more solemn form, this is sometimes described as *Traditio Legis*, and is restricted to Peter and Paul, who receive the keys and the Gospel, respectively.

Diffusion of the Image
Not particularly common; may be superimposed on the episode of the apostles' departure after the Ascension.

Master of the Choirs, ◀
Commissioning the Apostles,
1467. Kraków, National
Museum

In the history of art, this title has been applied to the two distinct episodes concerning taxpaying in the Gospels.

The Tribute Money

The two accounts of Jesus paying taxes come from the Gospel of Matthew, who, before Jesus called him, actually was a tax collector. He was thus the best witness to identify the political allusions and the provocative intentions of those who wanted to find out Jesus' position concerning tribute money to be paid to the Roman emperor Tiberius.

In one episode, Jesus provided Peter, who had wanted to know whether and how to pay the two drachmas for the temple, with the opportunity to find the coin he needed inside a fish. This would, in fact, have been a silver stater, worth four drachmas, so Peter was able to pay both his and Jesus' tax. In a second episode, when the Pharisees attempted to trick Jesus by asking him whether or not to pay taxes to the emperor, Jesus replied that they should distinguish between the material

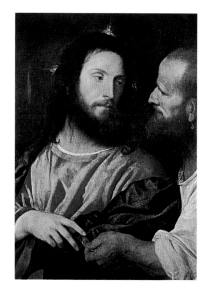

and spiritual worlds: "Render therefore to Caesar the things that are Caesar's, and to God the things that are God's" (22:21).

The Place
Capernaum and Jerusalem

The Time
Two different episodes of Jesus' ministries in Galilee and Judea

The Figures
Jesus, Peter, tax collectors, and sometimes the other apostles

The Sources
The synoptic Gospels

Variants
The Payment of the Tribute Money; Christ and the Coin

Diffusion of the Image
Other than in cycles about Saint Peter, the episode of the Tribute Money (proof of Christ's respect for the prevailing laws) was widespread in Renaissance and Baroque art as a typical theme in "establishment" pictures.

▶ Titian, *Christ and the Coin*, 1516–18. Dresden, Gemäldegalerie

A tax collector dresses quite elegantly; this is confirmed by the images of the calling of Matthew, who was also an excise man.

Jesus' calm and decisive gesture confirms his serene participation in civic duties.

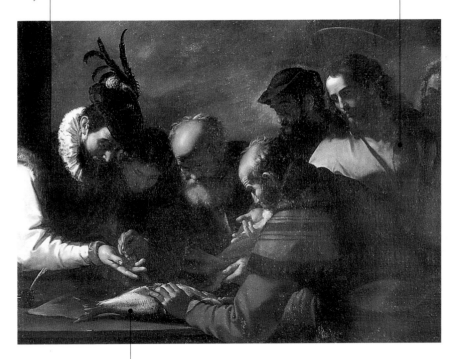

At Jesus' suggestion, Peter has caught a large fish, in whose entrails is the coin to pay the tribute.

▲ Mattia Preti, *The Tribute Money*, ca. 1635. Rome, Galleria Corsini

Unfortunately, there are only a few paintings of quality that are dedicated to this lovable subject, due to the persistent cultural hostility that adults manifested toward children for centuries.

Sinite parvulos

A few verses from Matthew, Mark, and Luke refer directly to Jesus' encounters with children. Yet the subject of Jesus' relationship with the "little ones" appears, either explicitly or subtly in many passages, including those treating the miracles and parables. His attitude of openness and availability to them was astonishing for the time and only partly captured in a history of art that has always been predominantly "adult." Only recently, in fact, has the Church definitely taken up the defense of children, following the general cultural developments of the time.

Jesus' speech is very clear. His exhortation *sinite parvulos*—"let the children come to me" (Mark 10:14)—is addressed to the disciples, who were shouting at the children who were running up to Jesus, and trying to keep them away from him. His assertion "to such belongs the kingdom of God" (10:14) and the invitation to become "like a child" (10:15) have no precedent in the literature or philosophy of antiquity.

The Place
Capernaum, or the region of Judea just beyond the Jordan River

The Time
The transition of Jesus' ministry from Galilee into Judea

The Figures
Jesus surrounded by a crowd of children

The Sources
The synoptic Gospels (although different places are cited)

Variants
"Let the Children Come to Me"; Jesus Blesses the Children

Diffusion of the Image
Rare in the history of art; extremely widespread, however, in the field of holy pictures and devotional images beginning in the nineteenth century

▶ Lucas Cranach the Elder, *Christ Blessing the Children*, mid-1540s. New York, The Metropolitan Museum of Art

The rescue of the adulterous woman from stoning has never had an "official" formula in art, but has been freely and variously interpreted case by case.

The Woman Taken in Adultery

John made it clear that the threatened killing of a woman found in flagrant adultery was actually an attempt to trap Jesus, or even a pretext to bring charges against him. The scribes and Pharisees were trying to test Jesus' faithfulness to Judaic law. Dragging the unfortunate woman before him, they asked Jesus: "Moses commanded us to stone such. What do you say about her?" (8:5). Jesus wrote something in the dust with his finger and then said: "Let him who is without sin among you be the first to throw a stone" (8:7). Then he began to write on the ground again. One by one, "beginning with the eldest" (8:9), the Pharisees left, dropping their stones. The scene concludes with Jesus forgiving the woman: "Neither do I condemn you; go, and do not sin again" (8:11).

The Place
The Temple of Jerusalem

The Time
In John's structure of groups of seven episodes, this one belongs to the period of the seven miracles.

The Figures
Jesus, a woman, and a mob of furious men

The Sources
The Gospel of John

Variants
The Adulteress

Diffusion of the Image
Fairly popular from the fifteenth to the eighteenth century

Valentin de Boulogne, ◀
Christ and the Adulteress, ca.
1620. Los Angeles, J. Paul
Getty Museum

Christ is shown standing, steady and assured at the center of attention.

Rembrandt sets the scene inside the temple, amid mysterious gleams of the gilding and imposing and shadowy architectural allusions.

The woman taken in adultery is emphatically presented by the scribes and Pharisees who have hurried to the temple. Rembrandt highlighted the fact that her possible stoning was in reality a provocation of Jesus, intended to test his observance of the Law of Moses.

The adulteress kneels, crying from shame and remorse.

▲ Rembrandt, *The Woman Taken in Adultery*, 1644. London, National Gallery

The woman kneels in a very human gesture of submission.

After first assuming an almost indifferent attitude, Jesus stands and speaks the famous words, "Let him who is without sin among you be the first to throw a stone" (John 8:7). In this way, he counters the trap laid by the Pharisees with a powerful moral provocation of his own.

Scrupulously following the sources to the letter, Poussin depicted the adulteress's accusers departing one by one.

A few figures bend over to decipher the words that Jesus has written in the sand. The Gospels do not say what he wrote.

▲ Nicolas Poussin, *Christ and the Woman Taken in Adultery*, 1640. Paris, Musée du Louvre

Only three people witnessed this profoundly mystical episode, including Saint Peter, who described it in his second letter, thus adding a personal memory to the Gospels.

The Transfiguration

In his second letter (1:16), Peter defined himself as one of the "eyewitnesses of his majesty," the spectacular, ineffable manifestation of God's glory. The Transfiguration marked the culmination of the public life of Jesus. Together with Peter, John, and James (the same three apostles who fell asleep when Christ was arrested), Jesus ascended a mountain and was transformed: "his face shone like the sun, and his garments became white as light" (Matt. 17:2). Moses and Elijah appeared and talked with him. At this point, Peter exclaimed, "Lord, it is well that we are here" (17:4), and offered to raise three tents, one for Jesus, one for Moses, and one for Elijah. But just then a bright cloud enveloped them all, and the same words that were heard at the Baptism of Christ resounded from Heaven: "This is my beloved Son, with whom I am well pleased; listen to him" (17:5). The apostles fell down from fear. When they had collected their senses, they saw only Jesus, who enjoined them to say absolutely nothing about what they had seen. The episode ends with Jesus healing an epileptic boy just after coming down from the mountain of the Transfiguration.

The Place
The Gospels speak of a "high mountain" not far from Lake Gennesaret (Sea of Tiberias, Sea of Galilee); this was later identified as Mount Tabor, near Nain

The Time
About a week after the Multiplication of the Loaves and Fishes

The Figures
Jesus; the apostles Peter, James, and John; the prophets Moses and Elijah

The Sources
The synoptic Gospels

Diffusion of the Image
Not terribly common, but well distributed over the centuries and of notable emotional impact

▶ Fra Angelico, *The Transfiguration*, ca. 1440–46. Florence, Convent of San Marco

Moses hovers in the air holding the Tablets of the Law.

Christ, clothed in light, spreads his arms in a gesture that recalls the Crucifixion. At the same time, however, he hangs in midair as at the Resurrection.

Elijah holds the books of his prophecies.

The apostles James, Peter, and John are atop Mount Tabor, but Peter is the only one to look at the Transfiguration directly. In the Acts of the Apostles (which were written by Luke), Peter is the one who describes it to the faithful.

A possessed child rolls his eyes unnaturally, as his relatives and the apostles writhe in hopes for a miracle.

The nine apostles who have remained at the foot of the mountain—only Peter, James, and John have gone up with Jesus—are unable to heal the possessed boy.

The possessed boy's mother calls the attention of the apostles to yet another of the boy's fits. Jesus will heal him right after the Transfiguration.

▲ Raphael, *The Transfiguration*, ca. 1520. Vatican City, Pinacoteca Vaticana

MIRACLES
AND PARABLES

◀ Jan van Amstel, *The Parable of the Marriage Feast* (detail), 1544. Brunswick, Herzog Anton Ulrich-Museum

▶ Duccio di Buoninsegna, *Jesus Opens the Eyes of a Man Born Blind* (detail), from the *Maestà* altarpiece, 1308–11. London, National Gallery

This is one of the most festive themes in sacred art, featuring a wedding reception, a fine wine that is unexpectedly served to the guests, a pleased master of ceremonies, and infectious cheer.

The Marriage at Cana

This was Jesus' first miracle: he turned about forty gallons of water into an excellent wine in order to save a wedding reception from disaster. The Madonna was the first to notice that the wine was running out and told Jesus so. She was simply making an observation, not necessarily asking for a miraculous intervention. Jesus, however, reacted almost sorrowfully, saying, "O woman, what have you to do with me? My hour has not yet come" (John 2:4). His reply must have reopened old wounds in Mary, like the one she received at Jesus' disputation with the doctors. Nevertheless, Mary called for the servants and told them to do whatever Jesus said. Jesus directed six large stone jars to be filled with water and asked the master of ceremonies to taste the liquid. After trying it, he called the groom over and said to him: "Every man serves the good wine first; and when men have drunk freely, then the poor wine; but you have kept the good wine until now" (2:10).

The Place
The village of Cana near Nazareth

The Time
The beginning of Jesus' public life

The Figures
Jesus, Mary, the apostles, and the participants at a wedding reception, including a wine expert

The Sources
The Gospel of John

Diffusion of the Image
Very widespread, from the Middle Ages to the Baroque period; this is one of the most frequently portrayed Gospel "suppers"

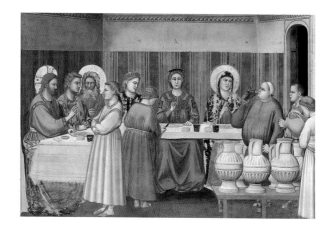

► Giotto, *The Marriage at Cana*, 1304–6. Padua, Scrovegni Chapel

Jesus performs the miracle with his usual gesture of blessing.

In images of the Marriage at Cana, the figure of the master of ceremonies is always something of a caricature. This wine expert is surprised by the quality of the wine brought to the table toward the end of the wedding banquet.

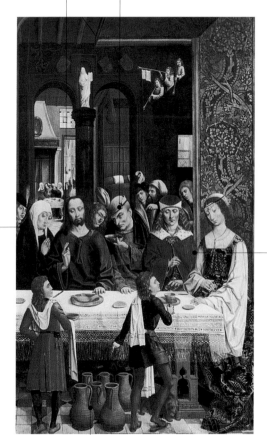

Mary seems saddened by the unexpected coldness of Jesus' reply.

At the end of the table, perhaps in an attempt to mask their embarrassment for not having enough wine, the newlyweds have a dignified air.

The six large jars are used to hold water for ritual ablutions.

▲ Master of the Catholic Kings, *The Marriage at Cana*, ca. 1490. Washington, D.C., National Gallery of Art

The bride and groom are probably seated with their parents. Veronese painted large numbers of figures in his sumptuous supper scenes, which were inspired by the Gospels. When asked, however, he was able to identify the name and function of each participant.

According to an unconfirmed tradition, the musicians here are the portraits of famous contemporary painters. From left to right: Veronese himself, Jacopo Bassano, Jacopo Tintoretto, and Titian.

▲ Paolo Veronese, *The Marriage at Cana*, 1562–63. Paris, Musée du Louvre

The Madonna is seated to Jesus' right. By pressing for a miracle, she is assuming her role as mediator between God and humanity for the first time.

Veronese mixes figures dressed in iconographically traditional costumes—perhaps the apostles—with others wearing the fashions of his time, some of whom are portraits of actual people.

Jesus is seated exactly at the middle of the table. If his features, clothes, and reassuring gesture were not enough, he is also identifiable by the shining halo around his head.

The servants are pouring wine from the heavy containers used to hold the lustral water.

Two Gospel episodes—similar in their events, characters, and outcome—are distinguishable by their setting, which allows this image in art to be correctly identified.

The Healing of the Paralytics

The Place
Capernaum, or the healing pool of Bethesda in Jerusalem

The Time
During Jesus' public life

The Figures
Jesus, a paralytic, and a flock of bystanders

The Sources
For the paralytic of Capernaum, the synoptic Gospels; for the paralytic by the pool, the Gospel of John

Variants
The Healing Pool

Diffusion of the Image
Significant, beginning in the Counter-Reformation; the spectacular chapel of Sacro Monte in Varallo, Italy, is dedicated to the miracle at Capernaum; in the United States, the name Bethesda is often given to hospitals and nursing homes

A large crowd had gathered in the house at Capernaum where Jesus was. A paralyzed man, carried on his bed by four men, was lowered through the roof above Jesus, who said to him, "My son, your sins are forgiven" (Mark 2:5). The words sounded like blasphemy to the scribes who were present. Divining their contempt, Jesus asked, "Which is easier, to say to the paralytic, 'Your sins are forgiven,' or to say, 'Rise, take up your pallet and walk?'" (2:9). He then ordered the paralytic to rise; healed, the man took up his bed and left.

John set a similar scene by the Pool of Bethesda. Shortly after the miracle, the healed paralytic was stopped by observant Jews. It was the Sabbath, and even carrying his pallet was considered a violation of the day of rest. At this, the ex-paralytic talked of his mysterious healer, who declared that he had acted in the name of the Father. The healed man only exacerbated a growing rancor: not only had Jesus broken the Sabbath law, he had also blasphemed, by describing himself as the son of God.

► Jan van Hemessen, *The Healed Paralytic with His Bed*, ca. 1555. Washington, D.C., National Gallery of Art

Saint Peter watches the scene closely. One of his first miracles, which is recounted at the beginning of the Acts of the Apostles, is his healing of a crippled beggar.

Jesus' gesture explicitly invites the paralytic to rise.

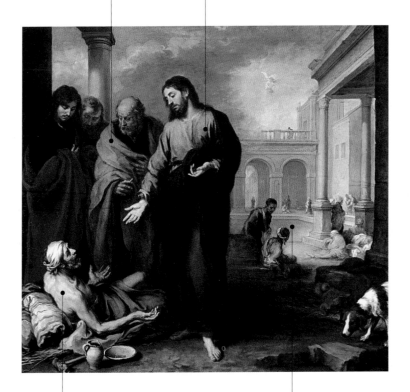

The paralytic, lying on his pallet on the ground, has never found anyone to help him. He turns to Jesus to ask him to carry him to the edge of the pool.

The waters of the Pool of Bethesda had miraculous thera- peutic effects only when they were stirred by the light wind caused by an angel's wings.

▲ Bartolomé Esteban Murillo, *Christ Healing the Paralytic at the Pool of Bethesda*, 1671–73. London, National Gallery

Jesus performed this miracle just a short distance from his native Nazareth, whose inhabitants are disinclined to follow the teachings of the carpenter's son who had grown up among them.

The Widow's Son

The resurrection of a dead person is undoubtedly the most astonishing of all miracles, but in the history of art it is almost always the story of Lazarus—by far the most famous—that has been illustrated. In the synoptic Gospels, Jesus also raised two other people—two children—with his almost ritual invitation to rise: the widow's son at Nain and the twelve-year-old daughter of the priest Jairus. These scenes—like the miraculous resurrections performed by saints—are unusual in art, though renderings of the miracle in the village of Nain are somewhat more common.

Seeing a funeral procession for a widow's only son, Jesus took pity on her and, to the amazement of everyone, ordered the young man to get up from his bier and rejoin his mother. We should add that, in contrast with today's social trends, for centuries, good deeds to children or crimes against them were less important than to adults.

▶ Domenico Fiasella, *Christ Raises the Son of the Widow of Nain*, ca. 1615. Sarasota, John and Mable Ringling Museum of Art

The young man brought back to life during the funeral is at the edge of the painting. Veronese focused on the dialogue between Jesus and the young man's mother.

Jesus turns toward the woman and seems to be pushing aside a length of his cloak. His gesture recalls the episode of the hemorrhaging woman who is healed as soon as she manages to touch Jesus' garments.

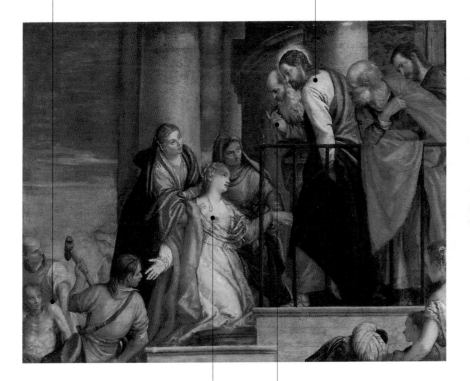

The boy's young mother, a widow from the city of Nain, implores Jesus to work a miracle. Her appearance and clothing, however, display nothing of a widow's usual sobriety. For this reason, this painting was long thought to depict the meeting between Jesus and the hemorrhaging woman.

Jesus' gesture with his right hand is directed at the young man, and is the customary invitation to rise that Jesus used for other miraculous resurrections in the Gospels.

▲ Paolo Veronese, *The Resurrection of the Widow's Son*, 1565–70. Vienna, Kunsthistorisches Museum

Relating to biblical prophecies and spiritual "sight," the healing of the blind is one of the most popular kinds of miracles and a widespread theme in art.

Christ Healing a Blind Man

The entire ninth chapter of the Gospel of John is dedicated to the healing of a man, blind since birth, that Jesus performed in Jerusalem. It is a miracle that includes an uncommon "physical" component: Jesus spat on the ground, used his saliva to make mud, which he spread on the blind man's eyes, then sent him to wash at the Pool of Siloam. Nevertheless, the predominant aspect of John's long account is the importance of faith, which makes the distinction between physical and moral blindness possible.

The synoptic Gospels are simpler, although in Matthew the miracle doubles, or actually quadruples, since it is narrated twice, with two blind men involved in each instance. In Mark, the blind beggar is called Bartimaeus.

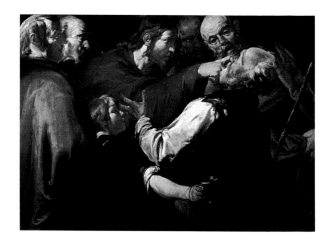

▶ Gioacchino Assereto,
Christ Healing a Blind Man,
ca. 1640. Pittsburgh,
Carnegie Museum of Art

The apostles form a compact group behind Jesus. This dense and heartfelt presence appears in many panels of the narrative side of a Maestà.

Blind Bartimaeus leans on his cane and does not seem to realize what is happening. It is really very unusual for medieval religious painting to pay such realistic and poignant attention to the fragile figure of the blind beggar.

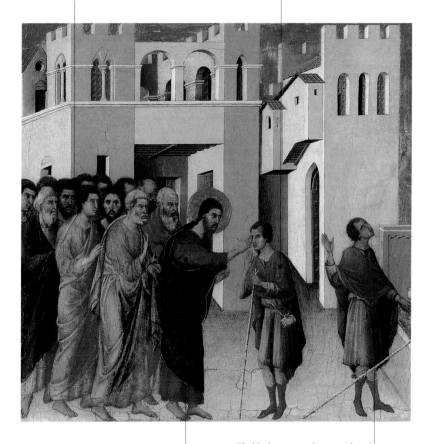

Jesus touches the eyes of the blind man. Here again, his gesture of miraculous healing resembles a gesture of blessing.

The blind man opens his eyes wide and throws away his now useless cane. It is likely that Duccio intended to illustrate the sequence of the two stages of the miracle as it appears in Mark's and Luke's Gospels, and not Matthew's version, which tells how two blind men's sight was restored.

▲ Duccio di Buoninsegna, *The Healing of a Blind Man*, a panel from the predella of the *Maestà* altarpiece, 1308–11. London, National Gallery

"Jesus wept" (John 11:35). John injected a powerfully emotional and moving note into his descriptions of miracles. Artists, however, have tended to overlook this aspect in order to focus on the miracle itself.

The Raising of Lazarus

The Place
Bethany, a village at the gates of Jerusalem

The Time
The last and greatest of the seven miracles described by John; his narrative of this "miracle of miracles" takes up some fifty verses of chapter 11

The Figures
Jesus; Lazarus, his sisters, Martha and Mary; and sometimes bystanders

The Sources
The Gospel of John

Variants
The Resurrection of Lazarus

Diffusion of the Image
This is probably the miracle most often portrayed in art.

▶ Herman de Limbourg,
The Raising of Lazarus, a
miniature from the *Très
Riches Heures du Duc de
Berry*, ca. 1413–16.
Chantilly, Musée Condé

The declining health of Jesus' friend Lazarus of Bethany runs through the first part of John's narrative, together with the apostles' fear of returning to Judea, whence they had fled after Jesus was almost stoned. All the same, Jesus announced his plans to return to Bethany to visit Lazarus. By the time he arrived, however, his friend had already been buried for four days. Jesus' meeting with Martha and Mary brings intense emotion to the episode. The drama reached its height when Jesus was taken to Lazarus's tomb. "Deeply moved again" (11:38), Jesus had the stone removed from the tomb and, after praying to God, commanded Lazarus to come out. Still bound with bandages, Lazarus emerged from the tomb.

In John's text and even more in the apocryphal tradition, Lazarus, who has returned to life from the world of the dead, is the most inconvenient and dangerous of the witnesses to Jesus' powers.

Focused and tense, Jesus resurrects Lazarus with a gesture of benediction.

Giotto followed the Gospels scrupulously to create a very powerful image: Lazarus is tightly bound with funerary bandages, and his face shows the first signs of decomposition.

The figures who cover their faces and who frequently appear in scenes of Lazarus's resurrection relate to Martha's exclamation, "By this time there will be an odor, for he has been dead four days" (John 11:39).

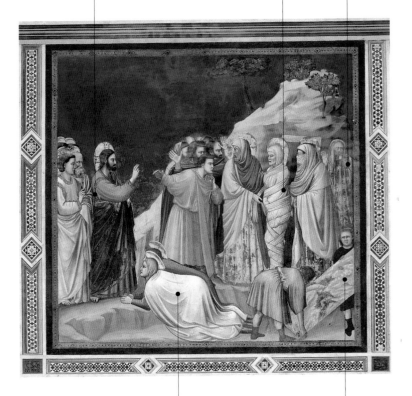

Martha and Mary, who at other times represent two opposite ways of receiving Jesus, here both throw themselves at his feet.

Two attendants laboriously remove the stone cover of the tomb.

▲ Giotto, *The Raising of Lazarus*, 1304–6. Padua, Scrovegni Chapel

Lazarus's sister Mary kneels, while Martha stands and discusses. Once again, the sisters' attitudes represent the contemplative and active lives.

The scene is set in a church. This should come as no surprise: Jesus asked to be brought to where his friend was buried, and in the fifteenth century, tombs were often dug under church floors.

The spirited Peter links the two opposed groups of believers and nonbelievers.

Those who hold their noses because of the odor are scribes and Pharisees, Jesus' adversaries. They are recognizable as such by their negatively charged attire and features.

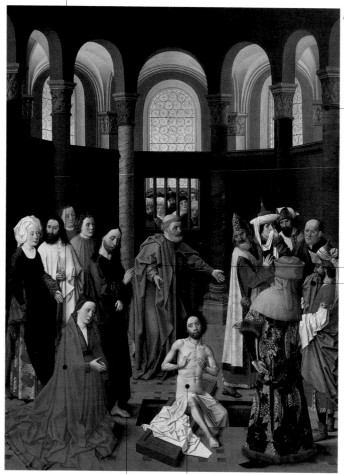

The gesture that Christ makes with his right hand is the invitation to rise that he uses in all the resurrections recounted in the Gospels.

Lazarus emerges from the tomb with a gesture of profound wonder and removes his shroud.

▲ Albert van Ouwater, *The Raising of Lazarus*, ca. 1455–60. Berlin, Gemäldegalerie

In this interpretation, Jesus assumes an energetic and determined pose, inspiring a wave of fear among those present.

In this painting, too, we find figures who cover their noses and entire faces because of the stench.

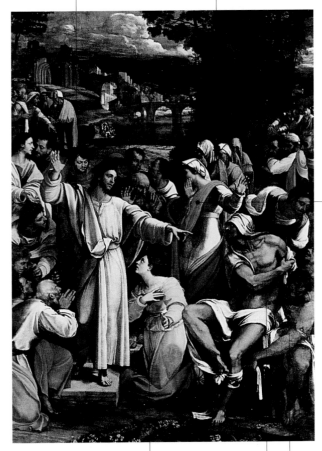

Martha, standing, animatedly reacts to Christ's gesture, which is typical of her practical and impulsive character.

Lazarus's sister Mary kneels before Jesus, in an attitude that expresses adoration and rapture.

Lazarus emerges from the tomb partially wrapped in funerary bandages and linens, but muscular, like a work by Michelangelo.

Attendants are busy around Lazarus's tomb.

▲ Sebastiano del Piombo, *The Raising of Lazarus*, 1517–19. London, National Gallery

The reason for this parable's iconographic success lies in its narrative movement and country setting, so much so that it has served as a pretext for wide open landscapes.

The Good Samaritan

This is one of the best-known and most commented on of the parables, even if, as with almost all the parables, its iconographic success is nowhere near its renown. Artists' imaginations have been stimulated by two different scenes: when the Samaritan first aids the unlucky traveler, and the episode following, when he brings the poor man to an inn and entrusts him to the innkeeper's care.

The story starts with the question "Who is my neighbor?" (Luke 10:29) that a scholar of the law asks Christ. Jesus describes the setting of the road between Jerusalem and Jericho: a traveler was attacked by thieves, who stripped and beat him, and left him bleeding on the side of the road. A priest and a Levite passed by, but did not help him. A native of Samaria, a region hostile to Judea, arrived on the scene and,

The Place
Told by Jesus as he travels to Jerusalem; the story is set on the same road.

The Time
During Jesus' journey to Jerusalem

The Figures
A robbed and beaten traveler, the Samaritan who aids him, and sometimes the priest and the Levite who ignore him

The Sources
The Gospel of Luke

Variants
A number of scenes may be distinguished within the episode.

Diffusion of the Image
Quite widespread, beginning during the Counter-Reformation

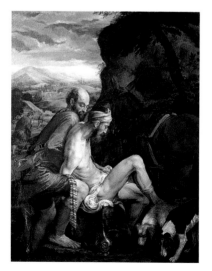

▶ Jacopo Bassano, *The Good Samaritan*, ca. 1550–70. London, National Gallery

seeing the injured man, stopped, dressed his wounds, set the man on his own packhorse, and brought him to an inn, where he watched over him all night. The next day the Samaritan entrusted him to the innkeeper with two denarii against expenses.

In a slight but intelligent deviation from the Gospel text, Elsheimer inserts an extra figure, thereby combining the immediate first aid with the wounded man's later recovery at the inn.

The German painter included in the distance the two indifferent passersby who ignored the wounded man.

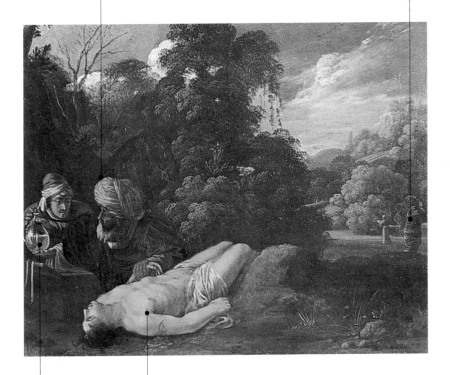

According to the Gospel narrative, the Good Samaritan washes and disinfects the traveler's wounds with oil and wine.

Lying on the ground, bloody, unconscious, and stripped of everything, the assaulted wayfarer appears completely defenseless.

▲ Adam Elsheimer, *The Good Samaritan*, ca. 1605. Paris, Musée du Louvre

The painting appears off-balance, with an empty space on the left. Flinck based this work on an engraving by his teacher, Rembrandt, who placed a defecating dog in this section. It was wisely eliminated in the painted version.

At the entrance to the tavern, the Good Samaritan gives the innkeeper money for the wounded man's lodging and care. He also promises to return on his way back and cover any extra expenses.

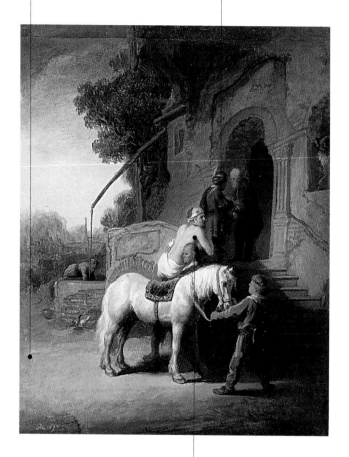

Still extremely weak, the wounded man is brought down from the horse by a robust servant while a young groom holds the bridle.

▲ Govaert Flinck (from an engraving by Rembrandt), *The Good Samaritan*, 1640. London, Wallace Collection

This rare image is an example of how some Gospel episodes served in Baroque art merely as narrative starting points for works of humble realism.

The Lost Coin

"Or what woman, having ten silver coins, if she loses one coin, does not light a lamp and sweep the house and seek diligently until she finds it? And when she has found it, she calls together her friends and neighbors, saying, 'Rejoice with me, for I have found the coin which I had lost.' Just so, I tell you, there is joy before the angels of God over one sinner who repents" (Luke 15:8–10).

Luke's image lies between two even better-known parables, which also relate to God's mercy and the joy of "finding" what seemed lost forever. Yet while the parable of the Prodigal Son implies other characters and that of the Lost Sheep evokes open, bucolic images, this nocturnal search by a solitary woman for a coin lost in the house seems claustrophobic, and opens up with relief at the moment of the coin's longed-for recovery.

The few pictorial interpretations are easily confused with genre scenes, especially in the case of Dutch paintings of the 1600s, in which housecleaning by housewives takes on the tone and importance of a religious practice, practically a divine service.

The Place
Not specified: Jesus is going from city to city

The Time
This is one of a "triptych" of parables that includes the Lost Sheep and the Prodigal Son.

The Figures
A lone woman

The Sources
The Gospel of Luke

Diffusion of the Image
Limited; primarily used as a pretext for genre scenes

Domenico Fetti, ◄
The Parable of the Lost Coin,
1618–22. Dresden,
Gemäldegalerie

For its analysis of feelings and actions, this longest and most detailed of the parables narrated by Luke is a universal masterpiece of poetry and psychological insight.

The Prodigal Son

Because of its remarkable narrative development and dynamic interplay between the various characters (the dissolute son, the father, and the "model" son), this is the only parable to have consistently inspired artists. The first part of the parable—in which the younger son of a rich man asked his father for his share of the property and departed for a faraway country, where he squandered his entire inheritance—is hardly ever depicted. Other than a brief mention of prostitutes, Luke did not explain how the young man spent his money, while artists have fantasized about fabulous delicacies and concubines. Reduced to misery, the young man found humble employment as a swineherd. Just as he was about to die of hunger, he repented and decided to return home. Here the point of view of the story changes. From this moment on, the father becomes the central character, providing the more frequent subject for artists. He saw his son from afar, ran to meet him, embraced him, and kissed him tenderly. All but ignoring his son's apologies, he ordered his servants to dress him and serve a great feast for him, complete with music, songs, and a fatted calf as the main course. There follows the section featuring the first-born brother, who protested the apparent injustice, and the father's calm reply. This section of the parable, however, has left hardly any traces in art.

The Place
Not specified

The Time
This is the third of the "triptych" of parables on mercy that includes the Lost Sheep and the Lost Coin.

The Figures
A dissolute youth who then repents; sometimes his father, envious older brother, and other minor characters

The Sources
The Gospel of Luke

Variants
A number of moments may be isolated: the prodigal son at the inn (or at a brothel); tending the pigs; his remorse and return.

Diffusion of the Image
Widespread, including in north-central European art and as genre paintings

▶ *The Prodigal Son*, painted window, ca. 1520. London, Victoria and Albert Museum

The young woman on the man's knee is a portrait of Saskia, Rembrandt's wife. Both figures turn to look at the viewer, almost as if asking for a moral judgment of the scene.

The outsize glass signifies excesses and squandering.

The main dish of the evening is a peacock pie, a spectacular course, worthy of a king's table. It is unquestionably excessive for the occasion.

The Prodigal Son is a self-portrait by Rembrandt, who openly displays a satisfied laugh of pleasure.

▲ Rembrandt, *The Happy Couple*, ca. 1635. Dresden, Gemäldegalerie

The farm's neglected and dilapidated outbuildings create the impression of a squalid environment.

The realistic, somewhat monstrous figures of the pigs increase the contrast between the young man's miserable condition and his affluent origins.

Dürer chose the moment of the young man's repentance. Utterly abject, he decides to return to his father.

The presence of the piglets eating near their parents emphasizes the young man's misery: having left his father's house, he is reduced to coveting the pigs' acorns.

▲ Albrecht Dürer, *The Prodigal Son*, engraving, ca. 1496. Massachusetts, Mead Art Museum at Amherst College

Murillo liked being didactic; the painting already shows the fatted calf, which the father decides to have slaughtered and cooked for the celebration of his son's return.

Despite the many details and characters, the heart of the scene is still the touching embrace between the kneeling son and his father, who bends to him.

Threading through the group on the right, which includes a servant bringing clean and elegant clothes, seems to be a certain tension due to the father's apparent favoring of his wild son over the elder son, who remained in his father's home.

This puppy is a delightful note; it, too, celebrates its young master's return.

▲ Bartolomé Esteban Murillo, *The Return of the Prodigal Son*, ca. 1670–74. Washington, D.C., National Gallery of Art

Welcomed by his father, the young man takes off the ragged clothes of a swineherd and receives clean clothes from a servant. Although the scene is informed by a straight-forward realism, it also recalls how the blessed are dressed by angels at the entrance to Heaven.

Guercino made the analogy between the busy father of the parable and God obvious: the figure's appearance reflects the traditional features attributed to God the Father.

A servant holds out clean clothes to the young man. As the hands cross, we see at lower right the father's hand, as he seems to test the shirt's softness.

▲ Guercino, *The Return of the Prodigal Son*, 1619. Vienna, Kunsthistorisches Museum

The emotion with which the elderly father embraces his recovered son is entirely interior. The old man bends forward, as if to take his son into an enveloping embrace.

The figures in the middle ground amplify the jealousy of the elder brother, who wonders whether it is fair to rejoice so much for a dissolute son. Between the embrace of the two main characters and the perplexity of the minor characters, Rembrandt hollowed out an abyss of darkness and incomprehension.

The father's large hands rest on his kneeling son's shoulders with a feeling of protection and tenderness.

The Prodigal Son is ragged, filthy, missing a shoe, and shaven because of head lice—brutalized but alive. Rembrandt painted this work while he was suffering the agony of the death of his beloved son, Titus. He projected his own fatherly feelings onto this scene.

▲ Rembrandt, *The Return of the Prodigal Son*, 1668–69. Saint Petersburg, Hermitage

More than a parable, this is actually a stunning metaphor and an example of how even brief Gospel passages were quickly conveyed into works of art.

The Parable of the Blind

This metaphor takes up only one verse in the Gospels of Luke and Matthew. "Can a blind man lead a blind man? Will they not both fall into a pit?" (Luke 6:39). Luke's verse comes toward the end of the Sermon on the Mount, as one of a series of metaphors about the necessity of recognizing one's own sins before judging those of others. These metaphors use a variety of famous images, including the beam in one's eye and the house built on rock.

The brief quote above was so effective that it has left its mark on the history of art, like other biblical subjects connected to eyes and sight. In order to understand exactly what it means to lose our sight—a nightmarish prospect—all we have to do is close our eyes or simply wait for nightfall. In medieval, Renaissance, and Baroque Europe, it was common to go blind because of heredity, illness, or accident, so there were many blind beggars.

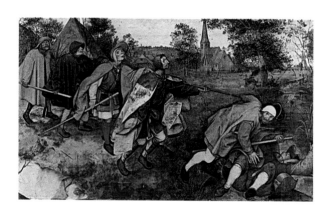

▶ Pieter Bruegel the Elder,
The Parable of the Blind,
1568. Naples, Galleria di
Capodimonte

This rare but excellent episode, in which Jesus accurately explains the world of the farmer, gave rise to images of rustic realism.

The Parable of the Sower

Matthew, Mark, and Luke gave particular importance to this parable, whose symbols Jesus explained to the apostles. He traced the results of the seeds that a farmer sows on a variety of terrains; each is an allusion to a way of receiving the word of God. Because of the complexity of the symbolism that Jesus used (even though it referred to a material reality that was perfectly suited to an agricultural society), the disciples asked him why he spoke in parables and similes. Jesus replied in detail, emphasizing the necessity that he be understood with the heart, as he taught about higher realities through commonplace things. We should add that a reading of the text of this parable and of the explanations provided by Jesus will suggest even further meanings.

The Place
Told by Jesus in a boat near the shores of Lake Gennesaret (also known as the Sea of Tiberias or Sea of Galilee)

The Time
The first part of Jesus' public life

The Figures
One or more peasants

The Sources
The synoptic Gospels

Diffusion of the Image
Limited to the sixteenth and seventeenth centuries. Despite its importance, the parable is little shown in art, partly because of the complexity of portraying the four different types of earth on which the seeds are thrown in a single, figuratively plausible painting.

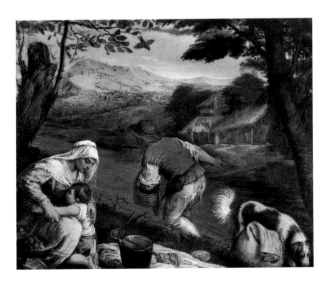

Jacopo Bassano, ◀
The Parable of the Sower,
ca. 1568. Budapest,
Szépmüvészeti Múzeum

Recounted by Jesus just before Holy Week, this parable, with its cautionary ending—"Watch, therefore, for you know neither the day nor the hour" (Matt. 25:13)— refers to the Last Judgment.

The Wise and Foolish Virgins

The Place
Narrated near the temple of Jerusalem

The Time
Just before the Passion

The Figures
Ten young women—five with their lamps full of oil, five with theirs empty—and the arriving bridegroom

The Sources
The Gospel of Matthew

Diffusion of the Image
Because of its symmetrical structure of opposing groups, the parable lends itself to the decoration of pairs of medieval church doors with statues or bas-reliefs. Sometimes, especially in the German Gothic style, the "wise" virgins smile with satisfaction while the "foolish" ones weep.

The parable, which features ten young women dressed for a wedding celebration, has inspired a delightful series of images of bridesmaids holding lamps to welcome the bridegroom in the middle of the night. The story, however, does not have a happy ending: the five more farsighted girls, who brought extra containers of oil for their lamps, were admitted into the celebration, while the others, the "foolish" virgins, who had gone to buy oil, remained outside. Their pleas to their companions to share their oil and finally to the bridegroom himself proved futile.

As often occurs in Gospel parables, a deeper reading raises questions: the strangeness of a bridegroom arriving at midnight, the selfishness of the "wise" virgins, and so on.

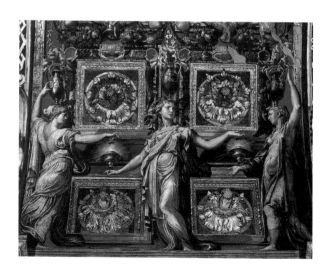

► Parmigianino, *Three Wise Virgins*, 1530–39. Parma, Church of Santa Maria della Steccata

Although this parable parallels that of the Sower, only Matthew includes it (13:24–30), thus confirming him as the evangelist most sensitive to the presence of the devil.

Weeds among the Wheat

The few images that depict this parable are nevertheless significant because they teach us to observe details. The background is identical to the one in the parable of the sower: a farmer sows seeds in a plowed field, while a friend, exhausted from working, sleeps. But pay attention to the first farmer: certain details, such as the cloven hooves that make him limp and the tiny horns that sometimes peek out from his hair, reveal his demonic character. This "enemy" of the good farmer casts seeds of weeds (darnel) into his neighbor's field.

The second and more important part of the parable, in which different fates of the grain (the children of God) and the weeds (the children of evil) are clarified, has not been commonly featured in art. Seeing the weeds spring up, the servants offered to pull them out, but the good farmer did not want to risk uprooting the grain as well, so he ordered them to wait until the harvest. Only then would the grain and the weeds be separated, the grain to be gathered into the barn, while the weeds would be bound in bundles and burned.

The Place
Told by Jesus on a boat, by the shores of Lake Gennesaret (also known as the Sea of Tiberias or Sea of Galilee)

The Time
The early period of Jesus' public life

The Figures
A sleeping farmer and the devil in disguise, who sows weeds in the farmer's field

The Sources
The Gospel of Matthew

Diffusion of the Image
Rare, partly because it is easily confused with the parable of the Sower

Domenico Fetti, ◄
The Sower of Weeds,
1618–22. Prague,
Národní Galerie

This parable speaks of the contrast between worldly goods and heavenly riches. Divided into two parts, the narrative has been rendered in art in a variety of ways.

The Rich Man and Lazarus

The Place
Undetermined

The Time
During Jesus' journey to Jerusalem for the Passion

The Figures
A rich man and a poor beggar; the patriarch Abraham

The Sources
The Gospel of Luke

Variants
In the Bosom of Abraham

Diffusion of the Image
This image slowly spread from the late fifteenth century and during the entire Counter-Reformation; the Italian word "lazzaretto," meaning a place where victims of the plague and other infectious diseases were brought and, if possible, cured, comes from "Lazarus," the name of the poor man covered with sores.

The Gospel of Luke is often rich with narrative details that evoke visual images. Artists have found two starting points in this parable of the rich man.

The first, which is both concrete and earthly, is provided by the episode's opening scene: a rich man in fine garments seated at a splendidly arrayed table, and Lazarus, a beggar (not to be confused with Martha and Mary's brother, whom Jesus raised), who hoped for a few crumbs fallen from the rich man's table.

The second figurative subject of this parable is the otherworldly scene of an "impossible" conversation between the rich man and Abraham. When Lazarus died, angels carried his soul to the "bosom of Abraham," the place of peace for the just. The rich man also died, but he ended up in the fires of Hell, from where he could see Lazarus in the embrace of Abraham. The rich man asked the patriarch to allow Lazarus

to "dip the end of his finger in water and cool my tongue" (Luke 16:24), but Abraham answered that Lazarus had had his share of torments during his lifetime and now was consoled, and that there was an abyss between them.

▶ Friedrich Pacher, *The Bosom of Abraham* (detail), ca. 1490. Novacella, Abbey Cloister

Poor Lazarus, lying on the ground, is portrayed here as a beggar covered with sores.

Seated at his table, the rich man occupies the corner of the picture across from the corner where Lazarus is: a diagonal formed by their gazes connects the figures.

This detail of the dogs that lick Lazarus's sores is from the Gospel.

Bassano does not dwell upon the parable's description of the rich man's sumptuous banquet; in fact, the scene seems quite spare. Only the detail of the lute alludes to the musical entertainment at the rich man's feast.

The empty platter gives the impression that a lavish feast has been consumed. Lazarus was hoping for at least the crumbs fallen from the table.

▲ Jacopo Bassano, *Lazarus and the Rich Man*, 1554. The Cleveland Museum of Art

THE PASSION

◄ Fra Angelico, *Christ Crowned with Thorns*, 1450. Livorno, Museo Fattori

► Matthias Grünewald, *The Crucifixion* (detail), from the Isenheim Altar, 1515. Colmar, Musée d'Unterlinden

The sequence of episodes that extends from the Entry into Jerusalem through the Resurrection comprises the largest repertory of religious subjects, but is also a general theme in itself.

The Passion Cycle

The late medieval catechesis, especially during the fifteenth century, suggested that the faithful personalize the situations narrated in the Gospels and make them current by translating them into the reality and contexts of everyday life, in a manner similar to the popular theatrical reenactments of biblical scenes. The Passion provides perfect narrative material, with its abundance of scenic details and strong characterizations, and setting the episodes in familiar places became a useful mnemonic exercise.

General images of the Passion present a sort of Aristotelian simultaneity of place, time, and action. The Passion cycles can be essentially of two kinds: either a sequence of isolated and juxtaposed scenes—as is the norm in fresco cycles—or, in a much rarer, but also much more evocative approach, a cityscape. The latter was understood to depict Jerusalem, but in reality closely resembled the urban settings of the period.

The Place
Jerusalem

The Time
From Palm Sunday through Easter Monday

The Figures
All those featured in the story of the Passion

The Sources
The canonical Gospels, with additions from the apocryphal gospels and later medieval interpretations

Variants
Stories of the Passion; the Passion of Christ

Diffusion of the Image
Besides the cycles, which are universally widespread, there are single scenes combining several events, usually relating to fifteenth-century devotion.

► Late Gothic Master, *The Passion*, 1415. The Chur Castle Chapel

Jesus is shown already dead in a perfectly frontal perspective. Smaller subjects depicting the last moments of the Passion surround the clearly prominent main theme.

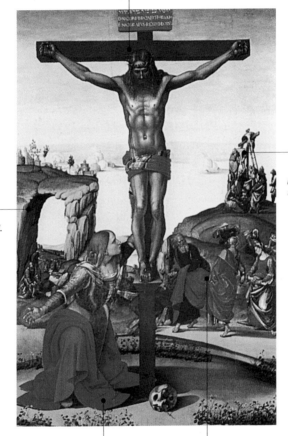

The Deposition. In this case, distance becomes an element that articulates time more than space.

Christ's tomb is in the left background.

Mary Magdalene despairs at the foot of the cross.

Peter and the three Marys set off for the tomb. This scene should occur, not at the Crucifixion (Good Friday), but on Easter Monday.

▲ Luca Signorelli, *Crucifixion with Mary Magdalene*, ca. 1500. Florence, Galleria degli Uffizi

The Entry into
Jerusalem

The Cleansing
of the Temple

The Flagellation

Judas's
conspiracy and
betrayal

Christ
before
Caiaphas

The Last Supper

The Agony in the
Garden

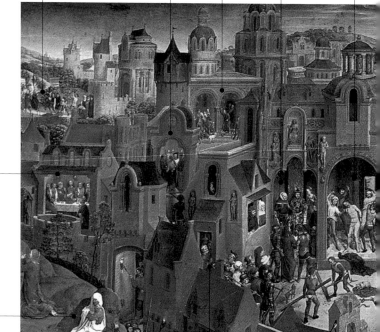

The Kiss of Judas
(Christ is arrested)

Peter's Repentance

 Hans Memling, *The Passion of Christ*, 1470–71. Turin, Galleria Sabauda

The Crowning of
Thorns

The Deposition

The
Entombment

The Crucifixion

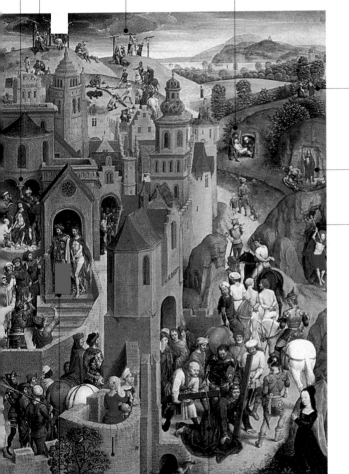

Noli me tangere

The Resurrection

Christ in Limbo

The Road to Calvary
(Christ falls under the
cross)

Ecce Homo

The Gospel accounts of the Passion include a generous share of poignant and compelling passages. Nevertheless, a long devotional tradition has added other emotional motifs, such as this episode.

Christ Taking Leave of His Mother

After Jesus' childhood, the Gospels mention the Madonna very little. The continuous and widespread popular devotion toward the Virgin has largely filled this void; it draws on apocryphal texts from Christianity's first centuries, and in part on medieval treatises, the visions of mystics, and pious traditions. But an extremely important component has been the simple projection of shared, common, and very human feelings onto the figures of the Gospels. This makes it natural to think that Jesus, as the Passion approached, wished to say farewell to his mother.

The subject is unusual in art, and is sometimes confused with the appearance of the risen Christ to the Madonna. Distinguishing between the two, however, is easy, since at the

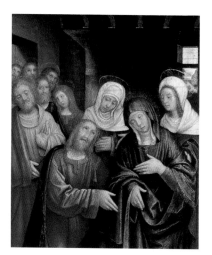

"farewell" before the Passion, Jesus obviously does not present the physical signs of the wounds he received at the Flagellation and the Crucifixion nor the iconographic attribute of the standard of the Resurrection.

The Place
Nazareth or Bethany

The Time
Just before the Entry into Jerusalem

The Figures
Jesus, Mary, and sometimes the apostles

The Sources
This episode is based on medieval tradition; it does not appear in the Gospels.

Variants
This image is easily confused with Christ's appearance to Mary after the Resurrection; an alternate title is Christ's Farewell to His Mother

Diffusion of the Image
Rare but charged with emotional intensity

▶ Defendente Ferrari, *Christ's Farewell to His Mother*, 1520. Florence, Fondazione Longhi

The enclosed garden is one of the Madonna's best-known symbolic attributes.

Mary's perfectly neat room recalls scenes of the Annunciation.

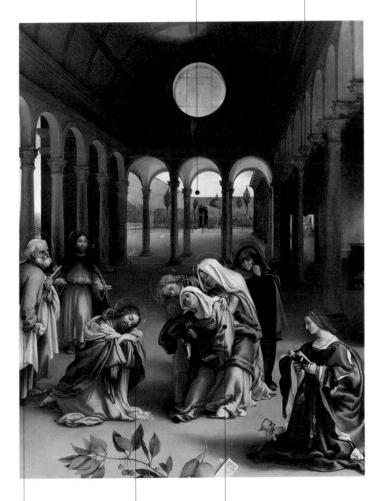

Peter already holds the keys. Lotto followed the Gospel of Matthew, according to which Jesus gives Peter the keys before the Transfiguration.

Jesus kneels devotedly before his mother.

The Madonna faints from sorrow and is supported by John and Mary Magdalene. The scene prefigures widespread iconography of Mary fainting at the moment of the Crucifixion.

▲ Lorenzo Lotto, *Christ Takes Leave of His Mother*, 1521. Berlin, Gemäldegalerie

Amidst a crowd of pilgrims who had come to Jerusalem for Passover, Jesus rode a donkey and was welcomed with palm and olive branches. The disciples laid their cloaks on the ground before him.

The Entry into Jerusalem

The Place
Near a gate in the walls of Jerusalem

The Time
Palm Sunday (the Sunday before Easter)

The Figures
Jesus riding a donkey, a joyful crowd, and some-times the apostles

The Sources
The canonical Gospels

Diffusion of the Image
Widespread, usually as part of Passion cycles

Many years after the Nativity and the Flight into Egypt, another donkey returns upon the scene. Jesus told his disciples to bring him this animal, which he would use for his entry into Jerusalem.

The crowd gathered around the city walls and gates for the Passover holidays was swept by popular enthusiasm, and Jesus entered in triumph into the city, greeted by the songs and hymns that the liturgy includes in every Mass: "Hosanna in the highest! Blessed is he who comes in the name of the Lord."

The Entry into Jerusalem parallels the Road to Calvary. In less than a week, Jesus' situation reversed, and artists have sometimes been able to capture this comparison. The same crowd that welcomed him with honors befitting a king, spreading their cloaks on the ground before him and waving palm and olive branches, would sneer and shout when the Nazarene was sentenced. As the sign on the cross explaining his sentence indicates, he was punished with crucifixion for declaring himself "Jesus the Nazarene, king of the Jews."

▶ *The Entry of Christ into Jerusalem* (detail), from the sarcophagus of Junius Bassus, ca. 359. Vatican City, Grotte Vaticane

The children climb up into the trees to gather olive branches.

The donkey is further evidence of Giotto's close attention to the visual connections between the scenes in the Scrovegni Chapel: the Jerusalem gate that Jesus is heading toward is the same one he will come out of, carrying the cross up to Calvary.

Jesus is portrayed making his customary blessing gesture.

The donkey that Jesus rides is practically identical to the one Giotto painted on the opposite wall for the Flight into Egypt.

At Jesus' arrival, a number of people lay their cloaks down on the ground in homage and to make the road smoother.

▲ Giotto, *The Entry of Christ into Jerusalem*, 1304–6. Padua, Scrovegni Chapel

Jesus' arrival is greeted with the waving of palm fronds, a sign of glory that also became a symbol of martyrdom.

The children climbing the trees recall the charming episode of Zacchaeus, a short man who climbed a tree in order to see Jesus in Jericho.

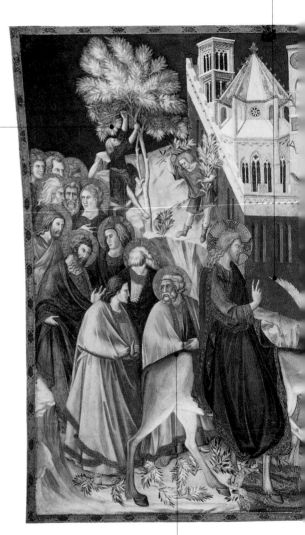

Peter follows Jesus closely.

▲ Pietro Lorenzetti, *The Entry of Christ into Jerusalem*, 1335–36. Assisi, Lower Basilica of Saint Francis

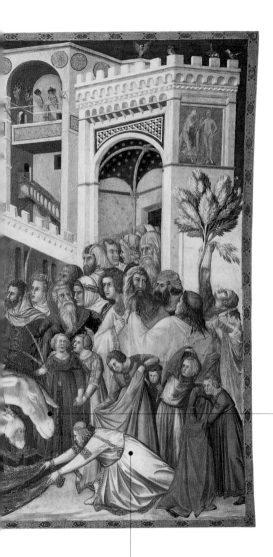

Only Matthew's Gospel specifies that Jesus mounted a she-donkey accompanied by a colt, referring to Zechariah's prophecy: "Tell the daughter of Zion, Behold, your king is coming to you, humble, and mounted on an ass, and on a colt, the foal of an ass" (Matt. 21:5).

Those who lay down their garments before Jesus are essential elements of the scene.

No other Gospel episode has provided artists with such vigorous and angry images of Jesus, who even used a whip to expel those who were profaning the temple.

The Cleansing of the Temple

The Place
The porch of the temple of Jerusalem

The Time
Between Palm Sunday and Holy Thursday

The Figures
Jesus and numerous merchants and money changers

The Sources
The canonical Gospels

Variants
Christ Driving the Merchants from the Temple

Diffusion of the Image
Quite generally widespread as a single scene as well, in fact, it is not always included in Passion cycles.

▶ *Jesus Driving the Merchants from the Temple,* twelfth-century mosaic. Monreale, Duomo

This scene, too, should ideally be seen in connection with the vast throngs of pilgrims pouring into Jerusalem to celebrate Passover festivities, as well as with Jesus' increasing anguish as the Passion approaches.

A lively market had sprung up in the porch of the temple in Jerusalem and was especially active during the holy days, with its money changers' counters (which were indispensable for pilgrims from other areas) and sales of animals such as doves and lambs for sacrificial offerings. Merchants and porters used the temple itself as a shortcut. Disgusted at the profanation of a sacred place, now reduced to a "den of robbers" (Matt. 21:13), Jesus tied together some ropes and used them as a whip, overturning counters and chairs and chasing away the sellers. The incident resounded strongly with the people and attracted even more attention to Jesus—the high priests and the scribes felt that the need to dispose of this dangerous public agitator was becoming increasingly pressing.

This follower of Caravaggio very accurately set the scene in the portico of the temple of Jerusalem's outside courtyard.

There are animals for sale visible in the middle ground. The exterior courtyard of the temple had been turned into a cattle market; the animals were not just for breeding, but especially for sacrificial offerings during Passover.

Christ lashes out with a handful of braided rope.

The money changer's board rests upon a pagan altar.

The figure fallen on the ground who attempts to gather up scattered coins symbolizes human greed.

▲ Cecco del Caravaggio, *The Cleansing of the Temple*, 1610–15. Berlin, Gemäldegalerie

The subject of Judas Iscariot's betrayal is one of Christianity's most controversial, to the point that it symbolizes the entire debate over predestination and God's prescience.

The Betrayal of Judas

As far as Judas is concerned, artists are certain: the man whose very name has come to stand for treachery became an emissary of Satan. The supper in Bethany, where Mary Magdalene washed and anointed Jesus' head and feet with an especially expensive ointment, proved to be the straw that broke the camel's back of Judas's irritation. For some time, the high priests had been looking for an opportune moment to arrest Jesus without causing public tumult. A tip-off from an informer inside the very closed circle of the Twelve Apostles would have been worth something, although it cannot be said that the priests of the Synedrion offered a particularly high figure: the thirty silver shekels they agreed upon with Judas for the betrayal corresponded to the average price for a slave. When Judas returned the money after Christ's arrest, the money went to buy a plot of land.

The Synedrion included about seventy members and was composed of representatives from twenty-four priestly families and a number of scribes.

The Place
The Synedrion, or meeting place of the Council of Elders in Jerusalem

The Time
Six days before Easter

The Figures
Judas (sometimes accompanied by a demon) and the Synedrion

The Sources
The Gospels of Matthew and Mark

Variants
Judas Receives the Thirty Pieces of Silver

Diffusion of the Image
Quite widespread in medieval Passion cycles; the subject became less frequent from the fifteenth century on

▶ Duccio di Buoninsegna, *The Pact with Judas*, back of the *Maestà* altarpiece, 1308–11. Siena, Museo dell'Opera del Duomo

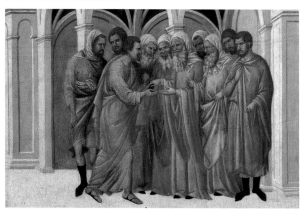

By including a sneering black demon behind Judas, Giotto was illustrating the Gospel phrase "Then Satan entered into Judas" (Luke 22:3).

Caiaphas gives Judas his reward and some suggestions.

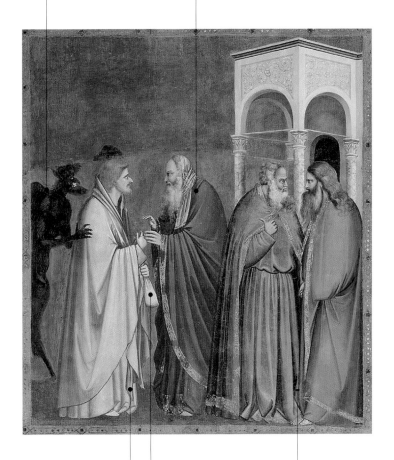

Judas's features resemble the demon's. The yellow of his cloak may signify jealousy, the sentiment that Judas felt toward the other apostles.

This pouch holds the price of Judas's betrayal: thirty silver shekels.

Another two priests discuss the situation with satisfaction.

▲ Giotto, *The Betrayal of Judas*, 1304–6. Padua, Scrovegni Chapel

The tradition of washing the feet on Holy Thursday is still enacted today. As a sign of humility, the pope and bishops celebrate this rite each year, just before the In coena Domini *mass.*

Christ Washing the Feet of the Disciples

The Place
Jerusalem, the room where the Last Supper takes place

The Time
Holy Thursday, just before supper

The Figures
Jesus, Peter, and the other apostles

The Sources
The Gospel of John

Diffusion of the Image
Nearly always included among the scenes of the Passion, it is also quite widespread on its own.

The synoptic Gospels do not include this episode, although John gave it a special solemnity and scrupulously described each stage. Jesus wrapped a towel around his waist, then, after pouring water into a basin, began to wash the feet of the apostles. As often happened, Peter reacted with amazement, an expression of his sincere humanity. Most works of art portray this precise moment, a dynamic scene with Jesus kneeling before Peter, who manifests his incomprehension and some agitation. It is much more difficult to illustrate Jesus' patient logic as he teaches the apostles a true lesson of humility and charity, while at the same time revealing his awareness of his imminent fate. After the ritual, Jesus urged the apostles to fol-

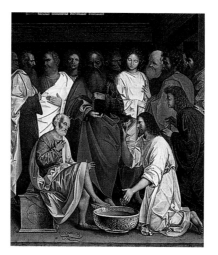

low his example by washing one another's feet in the future: "For I have given you an example, that you also should do as I have done to you" (John 13:15).

▶ Giovanni Agostino da Lodi, *Christ Washing the Feet of the Disciples*, ca. 1520. Venice, Gallerie dell' Accademia

This elegant brass chandelier and the general look of this room became attached to Gospel descriptions of the Last Supper, set in a large furnished room in the upper floor of a building.

The moment after the Washing of the Feet is depicted in the background, when Jesus institutes the Eucharist.

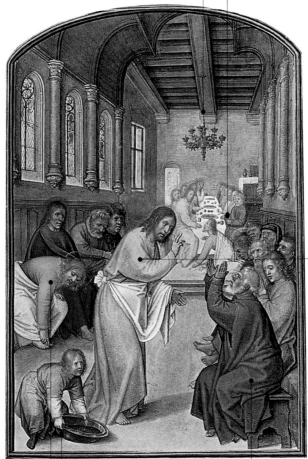

Jesus, who wears a towel around his waist, reassures Peter and explains the symbolic meaning of his washing the apostles' feet: it is a gesture of humility and purification.

The apostles have taken off their sandals and wait their turn.

A boy offers Jesus the basin of water, which seems a bit too heavy for him. Perhaps this is the little boy who, in Mark's Gospel, runs away when Jesus is arrested—possibly Mark himself.

Peter's gestures express his amazement to Jesus.

▲ *Christ Washes the Feet of the Disciples*, a miniature from the Grimani Breviary, late fifteenth century. Venice, Biblioteca Marciana

Beginning with Leonardo's Last Supper, *the subject became so widespread that it seems self-evident. And yet, if we look closely, we will be able to see many differences among the various interpretations.*

The Last Supper

Mark and Luke described the setting of the Last Supper as a refined environment: a large upper room furnished with carpets, couches, and cushions. Based on this description, artists have tended to endow the room in which the Last Supper took place with an elegant, even luxurious look.

If we follow the various versions of the Last Supper in the Gospels, we may identify at least three major themes, and, within these, a number of situations and variants. First is the dynamic and dramatic subject of Jesus announcing his betrayal and the apostles' different reactions. Second is the mystical and solemn institution of the sacrament of the Eucharist—continuously reenacted in Catholic masses—when Jesus offered his body and blood to the apostles in the form of bread and wine. Third is the melancholy subject of Jesus' farewell to the apostles, who, after Judas left to alert the guards and complete his betrayal, numbered only eleven. This last theme is delicately narrated by John: "A little while, and you will see me no more. . . . In the world you have tribulation; but be of good cheer, I have overcome the world" (16:16, 33).

The Place
Jerusalem, the room of the Last Supper

The Time
The evening of Holy Thursday

The Figures
Jesus and the apostles, who are often individualized

The Sources
The canonical Gospels

Variants
Even within the rubric of "the Last Supper," there are different dramatic and doctrinal moments. Scenes depicting the subject of the Eucharist may also be called the Institution of the Eucharist.

Diffusion of the Image
Extremely widespread; frescoes on the rear wall of monastery and convent refectories are common

▶ Heinrich of Constance,
Christ and Saint John, 1330.
Berlin, Skulpturensammlung

Jesus declares, "One of you will betray me" (Mark 14:18). The phrase triggers a rotational movement of surprised gestures among the apostles, here, gathered around an unusual square table.

According to John, "One of his disciples, whom Jesus loved, was lying close to the breast of Jesus" (13:23).

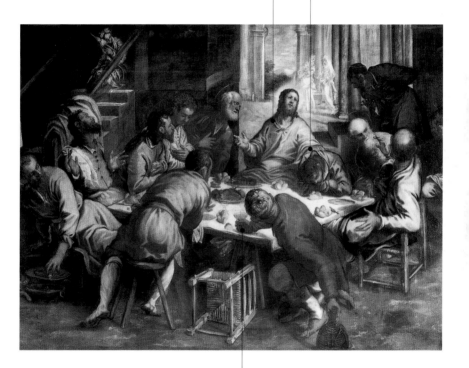

The prominence of the wine glasses and the rolls distributed around the table refers to the institution of the Eucharist.

▲ Jacopo Tintoretto, *The Last Supper* (detail), 1566. Venice, Church of San Trovaso

Jesus announces his
imminent betrayal
calmly and with bitter
resignation.

Most of the apostles
express sadness and
worry.

Valentin followed John's
Gospel to the letter. Peter is
not looking at Jesus, but is
turned to John to encourage
him to ask Jesus who the
traitor is.

John, Jesus' beloved disciple,
leans his head against Jesus'
breast.

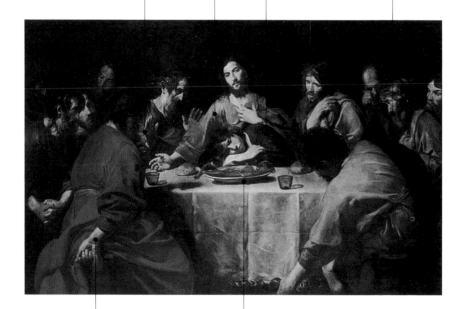

Judas hides the pouch with
the thirty pieces of silver
behind his back.

Roast lamb is the typical Jewish
Passover meal.

▲ Valentin de Boulogne, *The Last Supper*, ca. 1625–26. Rome, Galleria Nazionale d'Arte Antica

Judas is about to leave the group of apostles. Holding his pouch full of coins, he starts toward the door.

The table has become an altar on which the eucharistic hosts and a chalice for the wine have been placed. To make the similarity between the Last Supper and a religious ritual even more obvious, the back of the room looks like the apse of a church.

Jesus is distributing the Eucharist to the apostles. These are true Hosts, not pieces of bread.

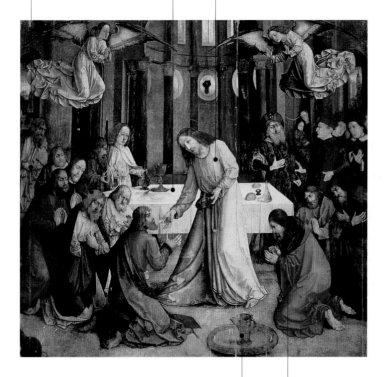

The basin and pitcher refer to the preceding scene of the Washing of the Feet, but are also part of the liturgy: the priest uses them to wash his hands before the Consecration.

The duke of Urbino, Federico da Montefeltro, commissioned this work. Along with several dignitaries, he is present at the scene, and engaged in debate with a skeptical Jewish scholar.

▲ Joos van Gent, *The Communion of the Apostles*, 1460. Urbino, Palazzo Ducale

Judas Iscariot leans forward, holding the moneybag in his right hand. He takes a piece of bread with his left, the very gesture that Jesus expected would identify his betrayer.

As is customary, John is shown meek and sorrowful.

James the Less

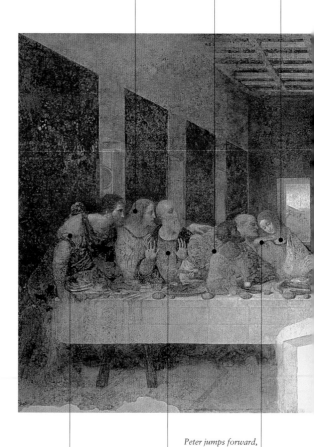

Peter jumps forward, brandishing a knife, and foreshadowing his wounding of Malchus during the tumult surrounding Christ's arrest.

Bartholomew

Andrew

▲ Leonardo da Vinci, *The Last Supper*, 1495–97. Milan, Refectory of the Convent of Santa Maria delle Grazie

Jesus predicts his betrayal, upsetting the apostles. As in John's Gospel, Jesus himself seems deeply troubled. His hands are near the eucharistic bread and wine.

Simon the Zealot

James the Greater

Philip

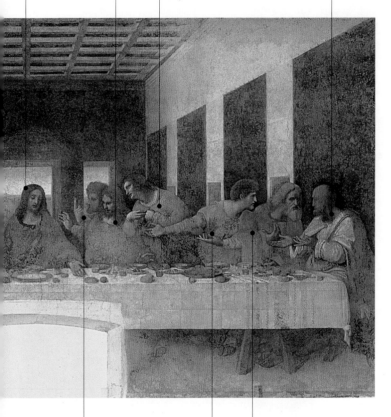

Thomas raises his index finger as if asking a question. This is the finger he will want to place in Jesus' wounds after the Resurrection.

Matthew *Jude (or Thaddeus)*

*A moment of tragic tension, almost fracture, between Jesus'
divine and human natures, the prayer in the garden also pre-
sents the theme of Christ's loneliness.*

The Agony in the Garden

The Place
Jerusalem; the Garden
of Gethsemane is on the
banks of the Cedron
River, on the slopes of
the Mount of Olives (a
suburb of Bethpage)

The Time
Holy Thursday, after
supper

The Figures
Jesus and an angel; the
sleeping Peter, James,
and John

The Sources
The synoptic Gospels

Variants
The Prayer in the
Garden; Christ in the
Garden; Christ and
the Angel

Diffusion of the Image
Very widespread, as an
isolated scene as well;
in Germany, called
"Gethsemane," the
subject is represented
with sculpture groups
on church façades.

In the Gospel of John, too, Jesus prayed to God just before his
arrest, although this version diverges almost completely from
the synoptic Gospels. According to Matthew, Mark, and
Luke, after supper, Jesus set out with Peter, James, and John
(the same three apostles who witnessed the Transfiguration) to
pray on the slopes of the Mount of Olives. Despite Jesus'
affliction—he confided to them, "My soul is very sorrowful,
even to death" (Mark 14:34)—the three disciples, overcome
by sleep, slumbered. Jesus walked farther up by himself (about
a stone's throw away). His prayer took on a truly anguished
intensity: he asked the Father to "remove this cup" (14:36) of
the Passion, but immediately afterward accepted God's will.
Only in Luke, at this point, does there appear a consoling
angel, frequently portrayed in art.

► Sebastiano Ricci, *The
Agony in the Garden*,
ca. 1730. Vienna,
Kunsthistorisches Museum

At the end of Jesus' prayer, an angel descends to comfort him.

Jesus, shaken by deep distress, kneels in prayer at the top of the hill.

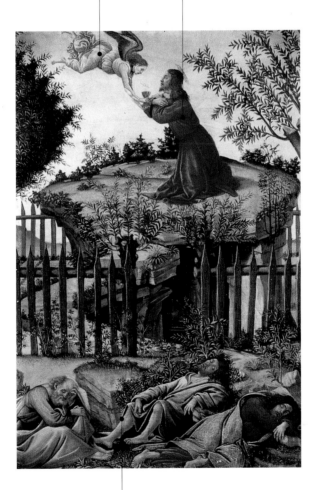

The apostles Peter, James, and John, whom Jesus has asked to follow him into the garden, are sleeping soundly. These were the same three apostles who had kept vigil on the occasion of Jesus' Transfiguration on Mount Tabor.

▲ Sandro Botticelli, *The Agony in the Garden*, 1485–90. Granada, Royal Chapel

Rationally, Judas's kiss was "unnecessary"; in the middle of the Arrest, with its swords, clubs, and torches, Jesus himself said, "Day after day I was with you in the temple teaching, and you did not seize me" (Mark 14:49).

The Arrest of Christ

and you did not seize me" (Mark 14:49).

The Place
Jerusalem, the Garden of Gethsemane

The Time
Late evening on Holy Thursday

The Figures
Jesus, Judas, a crowd of priests and soldiers; sometimes the apostles, including Peter, who severs Malchus's ear

The Sources
The canonical Gospels

Variants
The Judas Kiss; the Betrayal of Christ

Diffusion of the Image
Very widespread, not only in cycles, but as a single scene, usually used as a devotional image. The episode offers the possibility of nocturnal scenes.

This moving episode is deeply rooted in art and in tradition. Upon his return from praying, Jesus woke the sleeping apostles with the words "Rise, let us be going; see, my betrayer is at hand" (Mark 14:42). Judas, at the head of a chaotic mob armed with swords and clubs, approached Jesus, calling him "master," and kissed him. This was the signal that had been agreed upon; the armed men sprang on Jesus and arrested him. In the excitement, the apostles attempted to intervene. Peter severed the ear of Malchus, a servant of the high priest. (The episode is reported in all four Gospels, but only John attributed it to Peter, the only apostle armed with a sword.) This injected into the scene a bloody parenthesis that painters would employ for centuries as a violent and expressive counterpoint to Jesus' calm surrender. According to John, Jesus turned to the soldiers and asked them to let the apostles go, and indeed they all ran away. Only Peter and John followed Jesus—secretly—after his arrest.

► Francisco Salzillo y Alcaraz, *The Betrayal of Christ*, a detail from a wooden processional group, 1752. Murcia, Spain, Museo Salzillo

Torches, spears, and clubs are waving above the heads of the throng of armed men who have come to arrest Jesus.

Judas embraces and kisses Jesus, who glares icily at his betrayer.

A priest carries a scroll on which is written Crucifigatur *(crucify him)*; despite the pretense of a trial, Jesus' fate is sealed.

In an attempt to defend Jesus, Peter wounds Malchus, a servant of the high priest, on the ear.

A soldier grasps Jesus' right arm. Despite his grip, however, Jesus still manages a blessing gesture toward Peter and Malchus, whose wounded ear is instantly healed.

▲ *The Arrest of Christ*, twelfth-century mosaic. Venice, Basilica of San Marco

Judas, at the opposite end of the group from Jesus, looks back as he flees. He still clutches his purse of silver, but his face shows his dramatic remorse.

Peter's action of cutting off Malchus's ear with a cutlass here appears pathetic and completely futile.

The scene occurs at night beneath a starry sky lit with an unnatural glow. This visual reference to the Stille Nacht (silent night) of the Nativity emphasizes humanity's deaf and blind brutality toward Jesus.

As is often the case in northern European painting, Jesus' tormentors have brutish faces and squat, graceless bodies. External ugliness was considered a sign of a base and violent character.

Tightly bound and surrounded by a mob of bestial faces, Jesus is sweating blood.

▲ Master of the Karlsruhe Passion, *The Betrayal of Christ*, 1440. Cologne, Wallraf-Richartz-Muzeum

Terrified, one of the disciples runs away. Judging from his clothing and face, it could be John. However, his Gospel states that he and Peter were the only ones to follow Jesus when he was arrested.

Among the armed temple guards who have come to arrest Jesus, the figure holding the lamp is probably a self-portrait of the thirty-year-old Caravaggio.

Judas is almost smirking as he performs his hateful task, while Jesus receives his treacherous kiss with anguished resignation.

Jesus' hands are clasped in a way that might signify prayer, but also his decision to not resist his arrest.

▲ Caravaggio, *The Betrayal of Christ*, 1602. Dublin, National Gallery of Ireland

The contrast between Jesus and Caiaphas contains delicate implications. Caiaphas, who represents strict Jewish observance, was unable to accept Jesus as the long-awaited Messiah.

Christ before Caiaphas

The Place
The Sanhedrin in
Jerusalem

The Time
The night of Holy
Thursday

The Figures
Jesus, the high priest
Caiaphas, and many
bystanders

The Sources
The canonical Gospels

Variants
The Judgment of
Caiaphas; Christ before
the Sanhedrin (or the
High Priest); Caiaphas
Tears His Garments

Diffusion of the Image
Like all the other "judg-
ments" that Jesus under-
goes, this one is almost
exclusively limited to
Passion cycles.

There was only one high priest in charge of the temple, but all those who had held the position in the past still kept the now honorary title. The Roman procurator Valerius Gratus named Caiaphas to the Sanhedrin in A.D. 26. When Jesus was arrested, Caiaphas held the annual position of high priest.

According to John, the soldiers led Jesus first to Annas (Caiphas's father-in-law and a member of the Sanhedrin) and then to Caiaphas, whose task it was to interrogate him before the entire Sanhedrin. Faced with Jesus' silence, Caiaphas's irritation grew. His last question was "Are you the Christ, the Son of the Blessed?" Jesus replied, "I am" (Mark 14:61–62). Caiaphas tore his garments, as a sign he was denouncing blasphemy. The Sanhedrin's sentence was unanimous: Jesus had offended God and deserved to die—as the priests had already decided some time ago.

▶ Duccio di Buoninsegna,
Christ before Caiaphas, back
of the *Maestà* altarpiece,
1308–11. Siena, Museo
dell'Opera del Duomo

During his interrogation, Caiaphas presses Jesus, raising his index finger. This gesture, unlike Thomas's in Leonardo's Last Supper, does not imply a desire to know, but only accusation of a guilty man.

Jesus listens motionless to Caiaphas's allegations. At all stages of his various interrogations between Thursday and Friday, Jesus will only reply laconically or remain silent.

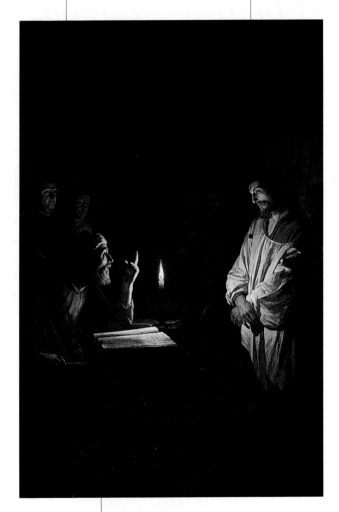

Caiaphas has a copy of the Law of Moses in front of him. Jesus is primarily charged with having been derelict in his religious observance.

▲ Gerrit van Honthorst, *Christ before Caiaphas*, ca. 1618. London, National Gallery

During the turbulent night of Holy Thursday, Peter earned an embarrassing primacy when he denied Jesus three times and then repented. Jesus' prediction was fulfilled within a few hours.

The Denial of Peter

Notice Peter's changeable emotions in the accounts of the night of Christ's Betrayal. During the scene of the Washing of the Feet, he impulsively attempted to withdraw, but then understood the sacred value of Christ's gesture. During the Last Supper, his reaction when the Eucharist was instituted—Peter was the first to receive Christ's body, with a mixture of devotion and emotion—was different from the fury that overtook him when he heard of the Betrayal. The next scene shows the first of Peter's moments of weakness on the night of Holy Thursday, when he falls asleep in the garden with James and John. The Arrest of Christ signaled the dramatic climax of Peter's entire life: in his attempt to stop the soldiers, he unsheathed his sword and severed Malchus's ear.

The Denial of Peter is steeped in a modest but elegaic nocturnal atmosphere, as three times before the cock crowed he declared that he was not a follower of Christ. With tears of repentance, Peter greeted the tragic dawn of the day of the Lord's death.

The Place
Near the Synedrion in Jerusalem

The Time
Late in the night of Holy Thursday

The Figures
There are two versions: Peter alone with a rooster, or Peter with a group of other figures

The Sources
The canonical Gospels

Diffusion of the Image
This episode was remarkably popular during the seventeenth century, especially as a pretext for nocturnal genre scenes.

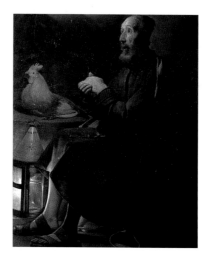

▶ Georges de La Tour, *Saint Peter Repentant*, 1645. Cleveland Museum of Art

In what appears to be a genre scene set at a guard post, where off-duty soldiers relax playing cards, the Flemish painter accurately followed John's Gospel text. The first to think she recognizes Peter is the doorkeeper at the Synedrion.

Once again according to John (who witnessed the scene), an armed servant of the high priest—and a relative of the Malchus whose ear Peter severed—also remembers having seen Peter in the Garden of Olives when Christ was arrested.

Another accuser, at the head of the table, points Peter out to the seated soldiers.

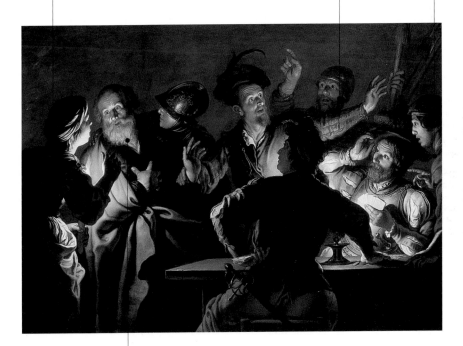

Peter denies knowing Jesus. Seghers gave the apostle an unnatural and forced expression that allows us to see the lie.

▲ Gerard Seghers, *The Denial of Peter*, ca. 1620–25. Raleigh, North Carolina Museum of Art

*Considered for centuries the most despicable of all sinners,
Judas underwent a kind of partial rehabilitation during the
Reformation, because of the doctrine of predestination.*

The Remorse of Judas

According to
Dante, Judas
is eternally
torn to pieces by Satan's jaws. This represented the height of
this traitor's medieval condemnation, a judgment underscored
by terrible images of his suicide by hanging, which was consid-
ered to compound his guilt, rather than an act of repentance.

According to Matthew, once Judas understood the tragic
outcome of Jesus' arrest, he was seized by remorse and ran to
the priests. Brushed off with a few words, he threw away the
bag with the thirty silver shekels, his reward for his treachery,
then went and hanged himself from a fig tree. The priests later
used the thirty pieces of silver to buy a field, called the Field of
Blood, which served as a cemetery (Matt. 27:3–10). Luke
referred to the episode in the first chapter of the Acts of the
Apostles, where he also reported the grisly detail of Judas's
body splitting open and releasing his entrails (1:16–20).

The Place
Jerusalem, first at the
Synedrion and then in a
garden under a fig tree

The Time
The dawn of Good
Friday

The Figures
Judas, the high priest,
and sometimes other
members of the
Sanhedrin

The Sources
The Gospel of Matthew
and the Acts of the
Apostles

Variants
The Hanging of Judas

Diffusion of the Image
A not uncommon scene
in medieval art that
becomes much rarer later

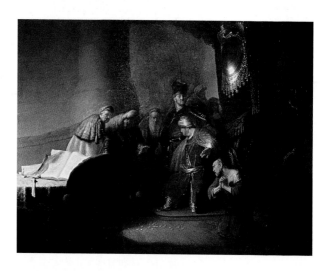

▶ Rembrandt, *Judas
Returns the Thirty Pieces*,
1629. Great Britain, private
collection

The hanged man's wild, grimacing expression gives the impression that Judas is still alive, and thus seeing his own damnation with horror.

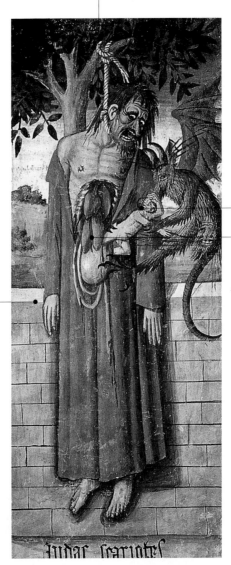

Judas's soul is immediately seized by the devil and brought to Hell.

The gruesome detail of Judas's belly ripping open, allowing his entrails to fall out, is from the Acts of the Apostles. The artist wanted to make this even ghastlier by doubling the betrayer's internal organs in order to illustrate his duplicity.

Judas's suicide occurs against a wall that encloses a field. The field, bought with the thirty pieces of silver of the betrayal, which Judas threw away, was later called the Field of Blood.

▲ Giacomo Canavesio, *The Disembowelment of Judas*. Col di Tenda, Church of Notre-Dame des Fontaines

Pontius Pilate pronounced the sentence that condemned Jesus to death. The Roman procurator, however, hesitated a while and played his cards of eloquence and provocation before giving in.

Christ before Pilate

The figure of Pilate is one of the most controversial in the Gospels. The act of washing his hands, with which, according to Matthew, Pilate declared his innocence, has become synonymous with moral sloth. John instead emphasized the procurator's doubts. Pilate, disbelieving the witnesses, turned directly to Jesus, asking him at one point, "What is truth?" (John 18:38), although he received no answer. Jesus himself defended Pilate when he tells him that "he who delivered me to you has the greater sin" (19:11). When he later wrote the reason for the sentence, Pilate chose "Jesus of Nazareth, the King of the Jews," rather than the high priests' formula. Pilate's guilt lay in his inability to resist public pressure.

In general, the Gospels show respect for the Romans. For example, Jesus said to the centurion at Capernaum who had asked him to heal his servant, "I tell you, not even in Israel have I found such faith" (Luke 7:9).

The Place
The governor's residence in Jerusalem

The Time
Early morning on Good Friday

The Figures
Jesus; Pontius Pilate, the governor of Judea (who held the office from A.D. 26 to A.D. 36); various bystanders

The Sources
The canonical Gospels

Variants
It is not always clear in art which part of the long, dramatic public debate between Christ and Pilate is being rendered, and the scene is associated with the later one of Pilate washing his hands.

Diffusion of the Image
As a whole, the confrontation with Pilate is the most commonly represented "judgment" that Jesus undergoes during the Passion.

▶ Jan Lievens, *Pilate Washes His Hands*, ca. 1625. Leiden, Stedelijk Museum de Lakenhal

Caiaphas pushes Jesus forward and addresses Pilate, asking him to condemn the prisoner to death.

Jesus' whole attitude is one of sorrowful and silent resignation.

Pontius Pilate hopes to conduct a legitimate interrogation, but he is swayed by the advisors beside him and by the crowd that has gathered around Jesus.

The tall building in which Pilate appears may be meant to evoke one of the towers of Fort Antonia, which Herod the Great built against the walls of the temple of Jerusalem.

▲ Giovanni Baronzio, *Christ before Pilate*, ca. 1325. Berlin, Gemäldegalerie

At the center of the composition, Jesus is tied to a pillar.

Enthroned and attended by two servants, Pilate washes his hands.

This small bas-relief ingeniously joins two sequential Passion scenes. On the left, two floggers carry out the command to flagellate Jesus.

▲ *Christ before Pilate*, late tenth-century ivory plaque made in Milan. Munich, Bayerische Nationalmuseum

Luke was the only evangelist to report on the judgment of Herod Antipas, the puppet king of Galilee, to whom Pilate sent Jesus. The king proved himself a figure embarrassingly devoid of any moral or intellectual qualities.

Christ before Herod

Herod Antipas's presence in Jerusalem for Passover provides a brief "intermission" during Jesus' interrogation. It has left few traces in art, but one detail merits mention. The frivolous Herod, who had hoped to enjoy the performance of a miracle, sent Jesus back to Pilate with a white garment as a sort of amusing gift. Jesus wore it until the next phase, the mocking Crowning with Thorns, when a red cloak was thrown over his shoulders. By observing which garment Christ is wearing, especially in interpretations by those artists who carefully followed the Gospel, such as Duccio di Buoninsegna and Fra Angelico, we can correctly identify the exact Gospel passages that they refer to.

We may also underscore the significant contrast between the fierce Herod the Great and his son Herod Antipas, who, here, as at the feast that ended with the beheading of the Baptist, showed he was only a caricature of a king.

The Place
The royal residence in Jerusalem, where Herod Antipas is staying during Passover

The Time
The morning of Good Friday

The Figures
Jesus and Herod Antipas (not to be confused with his father, Herod Ascalonite, or Herod the Great, the king of Galilee at the time of Jesus' birth who ordered the Massacre of the Innocents)

The Sources
The Gospel of Luke

Variants
The Judgment of Herod

Diffusion of the Image
A minor episode of the Passion and in art

Mattia Preti, ◄
Christ before Herod,
ca. 1660. Treviso,
San Martino parish church

Jesus' torture occurred in several stages. First, before Caiaphas, he was beaten; then, before Pilate, he was flogged and crowned with thorns; and finally, he suffered blows and insults.

The Flagellation

In art, the various moments of Jesus' torture on the morning of Good Friday are usually portrayed without attention to their exact sequence. In many instances, the violent actions against Jesus are carried out simultaneously by a group of tormentors. At the same time, there are several versions for each stage of his torment, from isolated scenes to vast and imposing multipaneled altarpieces.

In the case of the isolated scenes, it is well to identify them precisely. The most common are the Flagellation (which is carried out with whips or bundles of briars) and the Crowning with Thorns, whereas the clubbing, the blows, the spitting, and the insults appear much more rarely as single episodes.

One further distinction can be made in the case of the Crowning with Thorns: when the derisive "royal" symbols of the reed scepter and the crimson cloak are present, this is more accurately described as the "Mocking of Christ."

The Place
The governor's residence in Jerusalem

The Time
The morning of Good Friday

The Figures
Jesus and a number of jail guards, or alone afterward, suffering and bloody

The Sources
The Gospels of Matthew, Mark, and John

Variants
The Crowning of Thorns; the Mocking of Christ

Diffusion of the Image
A very common episode, both within cycles and as an isolated scene

► Diego Rodriguez de Silva y Velázquez, *Christ after the Flagellation*, 1632. London, National Gallery

This scene occurs in a cell. People are peering in through the heavy bars. The situation bitterly echoes the gesture of the shepherds who look in the tiny windows of the stable in Bethlehem to see the Christ child.

A soldier in armor places the crown of thorns on Jesus' head and tightens his lips in a strange smile.

The scene includes a dog that barks at Jesus; this is a way of emphasizing how completely alone he is.

One ruffian places a marsh reed in Jesus' hands as a mock scepter.

Jesus wears a red robe, a taunting parody of the crimson cloaks of emperors.

▲ Anthony van Dyck, *Flagellation*, 1620. Madrid, Museo del Prado

Ecce Homo

The title Ecce Homo *("Behold the man!" [John 19:5]) refers to a specific scene: Pilate proclaimed these words as he showed Jesus to the crowd, whipped and mocked and wearing the crown of thorns and the burlesque regal cloak.*

In fact, the use of this term in the history of art is more widespread and generalized than the precise moment, which is scrupulously reported in the four canonical Gospels.

Ecce Homo, properly understood, is a scene that occurred in public, when Pilate led Jesus, dressed, heartbreakingly, as a caricature of a king (a crown of thorns, a reed in hand as a scepter, and a red cloak over his shoulders), out from the Synedrion. Once again he repeated that he found no crime that would justify a death sentence. At that point, a relentless chant erupts from the priests, the guards, and the crowd: "Crucify him! Crucify him!" (John 19:6). Pilate's presence is thus integral to the scene, but the title *Ecce Homo* may also be applied to works that represent rather the Mocking of Christ or even the Man of Sorrows. In these cases, the title serves to emphasize Jesus' complete human isolation; abandoned by all, he is at the mercy of a terrible fate.

The Place
The governor's residence in Jerusalem, near a pillar at Fort Antonia

The Time
Late morning on Good Friday

The Figures
Jesus, Pilate, and a crowd of people

The Sources
The Gospel of John (but the presentation of Jesus to the screaming crowd is also included in the synoptic Gospels)

Variants
This scene can also include the episode of Pilate washing his hands, which is mentioned only in Matthew.

Diffusion of the Image
Widespread, both within cycles and as an isolated scene

▶ Philippe de Champaigne, *Ecce Homo*, 1654. Port-Royal, Musée national des Granges

The brutality of Christ's Passion is captured in the bestial figures of his tormentors. Massys, who had studied physiognomy, pushed to the limits of caricature but not beyond, helping us to understand that such obtuseness and violence are always possible in the human spirit.

Behind Jesus, a column supports a sculpted capital in a niche. This architectural support implies the presence of a statue, but the niche is empty. The torture of the innocent takes place in complete isolation, in the "silence of God," were that god but a pagan idol.

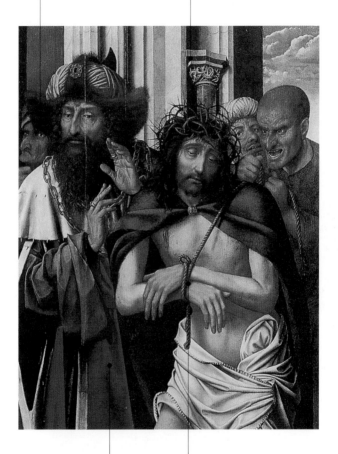

The meaning of Pilate's gesture here is similar to that of washing his hands. He looks away and raises his hands, as if refusing to either see more or intervene further.

Jesus is in the tormented pose of a sacrificial victim. His hands are bound with a rope held by one of his torturers, while his face is lined by the blood flowing from the piercing crown of thorns.

▲ Quentin Massys, *Ecce Homo*, 1526. Venice, Palazzo Ducale

*The great iconographic success of the Road to Calvary is
disproportionate to the Gospels' brief notes, and its episodes
derive largely from extrabiblical traditions.*

The Road to Calvary

Before the
Stations of the
Cross were
formulated—that *Via Crucis* that identifies the last moments
of Jesus' earthly life virtually step by step—the Road to Calvary
(the *Via dolorosa*) was one of the subjects that most stimulated
the imaginations of the faithful and artists alike. The Gospels'
narrative core is extremely poignant yet scarce in detail, except
for the weeping women and the presence of Simon of Cyrene.
However, beginning with the apocryphal Gospel of Nicodemus,
a number of figures and episodes came to be added. The most
famous nonbiblical figure is Veronica, who is supposed to have
wiped Jesus' face with a cloth said to have retained the image—
the *vera icon*. In all likelihood the Madonna was present,

The Place
The Via Dolorosa, a path
leading up to Mount
Calvary (or Golgotha)

The Time
About noon on
Good Friday

The Figures
Jesus, who carries the
cross through a crowd of
people, including the two
thieves, Veronica, the
Madonna, John the
Evangelist, Simon of
Cyrene, and many others

The Sources
The canonical Gospels,
the apocryphal Gospel
of Nicodemus, and
medieval traditions

Variants
Christ Carrying the
Cross. There are also
individual titles for the
various scenes.

Diffusion of the Image
Very widespread, with
significant developments
beginning in the eigh-
teenth century after the
institution of the Stations
of the Cross.

▶ El Greco, *Christ Carrying
the Cross*, 1587–96.
Barcelona, Museo Nacional
de Arte de Cataluña

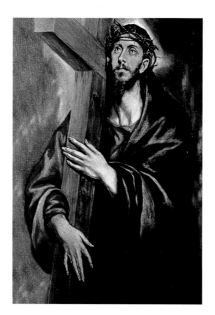

although she is
not mentioned in
the Gospels, and
she is almost
always included in
artistic renderings,
devastated by sor-
row. Jesus' three
falls beneath the
weight of the cross
on his way up the
hill are also not
included in the
Gospels, although
they later became
"stations" of the
Via Crucis.

Disciples and friends follow Jesus
on the Road to Calvary. Mary
Magdalene is dressed in red. Her
long, blond hair is one of her attri-
butes, which relates to the suppers
at Simon's house and in Bethany.

The walls of Jerusalem are solid,
smooth, and without windows or
loopholes. Martini was symbolizing
the city's inhabitants' refusal to pro-
vide Jesus with moral or material aid.

A dramatic detail is the soldier
who threatens Mary with a
club in order to keep her apart
from Jesus.

Jesus wears the red garment that the sol-
diers will later argue over. Jesus' anguished
look is for the soldier who keeps the
Madonna away from him.

▲ Simone Martini, *The Road to Calvary*, ca. 1336–42. Paris, Musée du Louvre

The Roman centurion next to Jesus has a stern look, although he seems more dignified than the violent and brutal plebeian torturers. Besides conveying an effective image of Spain's minor military aristocracy during the Counter-Reformation, the centurion may also be identified with Longinus, who converted at the moment of Jesus' death, exclaiming, "Truly this man was the Son of God!" (Mark 15:39).

El Greco communicates the feeling of an aggressive mob. The scene seems congested, and there are waving spears, pikes, and halberds in the background.

An executioner is preparing the beam of the cross.

The Madonna, Mary Magdalene, and John are recognizable in the lower left-hand corner.

Jesus wears the red cloak that was put on him when he was mocked.

▲ El Greco, *Christ Is Stripped of His Garments*, 1577–79. Toledo, Cathedral

Besides the spears and lance points, we can see at the top of the painting the ladder that was used for the Crucifixion. It became a symbol of the Passion.

Not only does Simon of Cyrene's gesture of supporting the foot of the cross appear to be occurring by chance, but, instead of giving Jesus some relief, it seems to press the wood down on his back.

Jesus advances with tremendous effort beneath the burden of the heavy, T-shaped cross.

Almost all the torturers who whip, drag, and press Jesus have animal faces. The emblem of a frog—the diabolists' symbol of heresy—on a shield is prominent.

The defiance of the face of the bad thief, who is pushed toward Calvary by a group of armed soldiers, thinly veils his terror.

Even though the good thief is bound and held by a jailer, he kneels to make his confession to a friar.

▲ Hieronymus Bosch, *The Road to Calvary*, 1490. Vienna, Kunsthistorisches Museum

The Road to Calvary

The group of guards and gawkers accompanying Jesus, who is burdened by the cross, is at the exact center of the painting, although for perspective's sake it has been set back in the middle ground, so that the viewer does not immediately spot it.

▲ Pieter Bruegel the Elder, *The Road to Calvary*, 1564. Vienna, Kunsthistoriches Museum

The two thieves are brought to Calvary on a wagon.

At upper right, the Road to Calvary's destination is a clearing on a small rise, where a crowd has already gathered in a circle. The people's ferocious curiosity gives the scene a tremendously bitter tone.

Under a gray and dismal sky, the desolate clearing used for executions is littered with instruments of torture, such as a wheel that was used for terrible punishments. A sinister crow perches on it.

The human skull that is frequently depicted in Calvary scenes is replaced here by a horse's skull.

In the foreground, Bruegel portrayed the heart-broken Mary, supported by John and the pious women. They have all turned in order not to look at the scene behind them.

Mary and John are depicted in the background, very far from Jesus.

The theme of Christ's loneliness on the Road to Calvary, and during the Passion in general, is emphasized by the emptiness that forms around him, the stones along his path, and the closed, grim buildings in the background.

Simon of Cyrene, who happened on the Road to Calvary by chance, is forced to help Jesus carry the cross.

Veronica prepares the cloth with which she will wipe the sweat from Jesus' face, the image of which will remain imprinted on the linen.

▲ Juan de Flandes, *The Road to Calvary*, ca. 1510. Palencia, Cathedral

As Jesus falls to his knees, causing a general plunge of tormentors and friends, the Madonna stays standing, enclosed in pain. It is a recurrence of the theme of Mary's sensibility: she has kept many things in her heart ever since the Nativity.

The crown of thorns, the ropes, and the blows of the guards summarize the Flagellation, the Crowning with Thorns, and the Mocking of Christ. Jesus' meek expression alludes to the symbol Agnus Dei *(Lamb of God), the sacrificial victim.*

Veronica kneels and holds out her veil to dry the blood, sweat, and tears on Christ's face.

▲ Jacopo Bassano, *The Way to Calvary*, ca. 1545. London, National Gallery

The Road to Calvary

Here again, Simon of Cyrene's aid is presented by Bosch as more of a hindrance than a help to Jesus in carrying the cross.

Jesus is at the center of a composition that circles around him. His noble face strongly contrasts with the caricatured figures of the surrounding guards.

The good thief half-closes his eyes.

Veronica holds the cloth with the image of Christ's face on it, turns her head, and shuts her eyes. This forms a diagonal, crossing the entire painting from left to right, composed of Veronica, Jesus, and the good thief, Dismus. These "positive" characters close their eyes, as if to separate themselves from the scene.

The bad thief reacts with a bestial grimace to his jeering, equally savage torturers.

▲ Hieronymus Bosch, *The Road to Calvary*, 1515–16. Ghent, Musée des beaux-arts

Domenichino insightfully interpreted the brief Gospel passage concerning Simon of Cyrene, who obviously is no longer able to carry the cross to the place of execution by himself.

The group also includes someone carrying the ladder that will be used during the Crucifixion and then to take Jesus' body down from the cross.

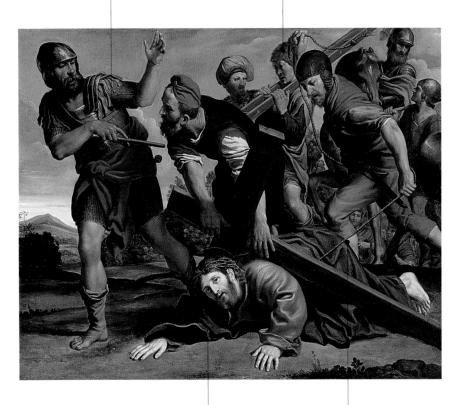

Following the dictates of the Counter-Reformation, Jesus, fallen beneath the cross, turns his poignant gaze directly at the faithful, thus establishing a direct relationship with them.

The cruel lashes that the soldier inflicts upon the suffering Jesus add to the weight of the cross on his back.

▲ Domenichino, *The Way to Calvary*, ca. 1610. Los Angeles, J. Paul Getty Museum

In portraying the life of Christ, art has oscillated between images that concern the physicality of Jesus and spiritual elements. The stages of the execution of his capital punishment belong primarily to the former group.

Christ Being Nailed to the Cross

The Place
Mount Calvary, where capital sentences were executed, just outside the walls of Jerusalem

The Time
About noon on Good Friday

The Figures
Jesus and those carrying out his death sentence

The Sources
The canonical Gospels

Diffusion of the Image
This episode is not very common, although it inspired unusual inter-pretations in the Middle Ages.

Jesus being nailed to the cross, which became one of the stations of the *Via Crucis*, is an image that beginning in the eighteenth century enjoyed a more devotional than artistic success. The image that became codified was of the cross lying on the ground with Jesus upon it having nails driven into his hands and feet. Prior to this, this subject was quite rare, although, especially during the Middle Ages, there were a number of images in which Christ climbs up a stepladder to be nailed to the cross, which is already positioned upright.

A corollary to these preparations for the Crucifixion is when Christ's clothing is removed, which titles of works usually describe as "Christ Stripped of His Garments." The soldiers gambled for Christ's vestments, so dice have come to join the symbols of the Passion. Another interme-diate scene is the raising of the cross, which was done with ropes. This highly dra-matic scene has sometimes been treated in art.

▶ Giovanni Baronzio,
Christ Climbs the Cross,
ca. 1325. Venice, Gallerie
dell'Accademia

The sky is quickly darkening; it will become completely black at the moment of Jesus' death, at three in the afternoon.

Jesus' relatives and disciples watch the scene from a distance, just as Luke's Gospel states.

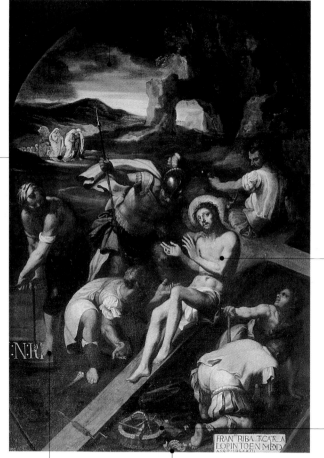

Christ lies down almost horizontally in order to be nailed to the cross.

The nails and hammer—here, in a basket in the foreground—are among the most frequent symbols of the Passion.

The initials INRI stand for Iesus Nazarenus Rex Iudaeorum (*Jesus of Nazareth, king of the Jews*). This was the official reason for his death sentence, that he presumed to be recognized as king.

This jawbone recalls the Hebrew etymology of "Golgotha," which derives from the word for "skull." The jawbone also refers to the symbol of Adam's skull; with his sacrifice, Jesus expiates humanity's sins.

▲ Francisco Ribalta, *Christ Nailed to the Cross*, 1582. Saint Petersburg, Hermitage

Despite the vastness of this theme, we can separate out a few fundamental typologies in both the narrative development and in the way that individual figures are represented.

The Crucifixion

The four evangelists offer different accounts of Christ's suffering and words on the cross. His cross was raised between those of two bandits, one of whom mockingly challenged Jesus to save himself; the other, Dismas, instead asked forgiveness for his sins. Jesus replied, "Today you will be with me in Paradise" (Luke 23:43).

At the foot of the cross, besides the Madonna and John, were the Roman soldiers in charge of the execution, as well as priests, scribes, members of the Sanhedrin, and mere passersby. Somewhat apart was a group of Jesus' friends from Galilee and several women (Mary Magdalene and the Madonna's two half sisters). After entrusting John and the Madonna to each other's care, Jesus asked for something to drink and was given a spongeful of vinegar. After three hours of suffering, he invoked the Father, although those around him misunderstood his words as a delirious prayer to Elijah. In the end, just before dying, Jesus uttered the words "It is finished" (John 19:30), or "Father, into thy hands I commit my spirit!" (Luke 23:46), or simply cried out (Mark 15:37, Matt. 27:50). It was the ninth hour, three in the afternoon. An unnatural darkness fell over the entire world, an earthquake shook Jerusalem, and the curtain of the temple ripped in two.

The Place
Mount Calvary or Golgotha, which means place of the "skull"

The Time
The ninth hour (three in the afternoon) on Good Friday

The Figures
Beginning with the solitary figure of Jesus, the scene can expand to accommodate any number of characters.

The Sources
The canonical Gospels

Diffusion of the Image
The crucifix, as well as a simple cross, has always been the very symbol of Christianity.

▶ *Lindenwood Crucifix,* ca. 1300. Friesach, Dominican Church

The thieves animatedly address Jesus: one aggressively lashes out, while the other asks for forgiveness.

The Madonna, John, and Mary Magdalene stand apart.

Pushed upright by a ladder and other supports, the cross is put in a vertical position. This is an extremely painful stage for Jesus, whose hands and feet are nailed to it. The thieves, on the other hand, have their feet nailed to small platforms, while their hands are tied behind the horizontal beam of their respective crosses.

A large group of Pharisees and priests attend the execution. They are easily identified by their ample and luxurious garments.

As is typical of northern European painting, the faces and expressions of the soldiers charged with the execution are brutish, almost feral.

The city of Jerusalem in the background seems shut up and indifferent, which emphasizes Jesus' isolation on the cross.

▲ Jörg Breu the Elder, *The Raising of the Cross*, 1524. Budapest, Szépmüvészeti Múszeum

In his death agony, the good thief turns toward Jesus.

The centurion Longinus, in charge of the execution, feels remorse as Jesus dies.

As the pious women attempt to support her, Mary faints, collapsing from pain.

▲ Pordenone, *The Crucifixion*, 1521. Cremona, Duomo

This fresco combines details found in the various Gospel passages, particularly in Matthew and John, regarding Jesus' death on the cross.

The bad thief flails about on his cross.

A soldier is striking the thief's legs with a cudgel in order to break them and so shorten the death throes of his crucifixion.

Amidst the animation that shakes the scene, the Pharisees seem calm. Their gestures show that they are debating things amongst themselves.

A soldier points out Jesus, dead on the cross, to the faithful who contemplate the work. His armor and broadsword suggest that he is a lansquenet. At his feet, the earth is opening from the terrible earthquake mentioned in Matthew.

The thieves, blind-folded, their legs broken in several places, are tied to their crosses.

Longinus thrusts his lance into Jesus' side; blood and water gush from the wound. Jesus is already dead, and the lance of the repentant centurion would become a symbol of the Passion and a precious relic, still kept in Saint Peter's Basilica in Rome.

So frequently does the subject of the Madonna fainting appear that it has become a separate episode within many Crucifixion scenes.

The kneeling Mary Magdalene appears to be embracing Jesus' feet. This repeats her gesture of devotion during the suppers in the Pharisee's house and at Bethany.

A soldier uses a pole to raise a vinegar-soaked sponge to Jesus' lips.

▲ Master of Rimini, *The Crucifixion*, ca. 1350. Allentown Art Museum

Mary faints in the arms of the pious women.

Longinus pierces Jesus' side with his lance.

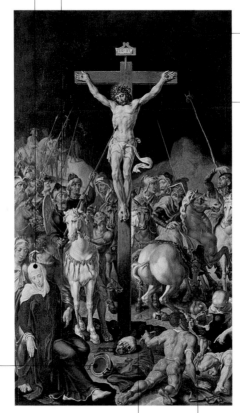

The sky darkens at the moment of Jesus' death.

At the end of a pole, the spongeful of vinegar is raised to Jesus' mouth because he has complained of thirst.

The overturned bucket alludes to the mixture of vinegar and gall that was raised to Jesus' lips when he was on the cross. At the same time, in traditional Flemish imagery, an empty container with its mouth displayed is an obscene reference to the devil.

The skull at the foot of the cross is identified as Adam's, in order to connect original sin to the redemption brought about by Jesus. It characterizes Calvary as a place of capital punishment and refers to the etymology of the name of the hill, Golgotha, which in Hebrew means "skull."

Half prone on the ground, the soldiers throw dice for Jesus' tunic. The presumed relic of the garment, described as inconsutilis, that is, seamless, is preserved in Trier Cathedral.

▲ Maerten van Heemskerck, *Golgotha*, ca. 1540. Saint Petersburg, Hermitage

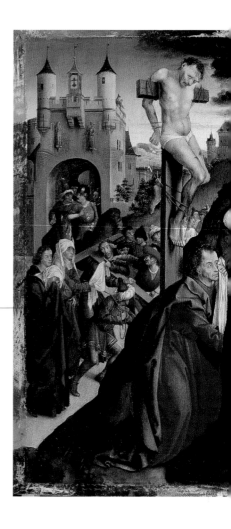

The painting illustrates various moments of the Passion, including unusual iconography. According to an extrabiblical tradition, along the road to Calvary, Mary gave the soldiers a veil with which to cover her son's nakedness on the cross.

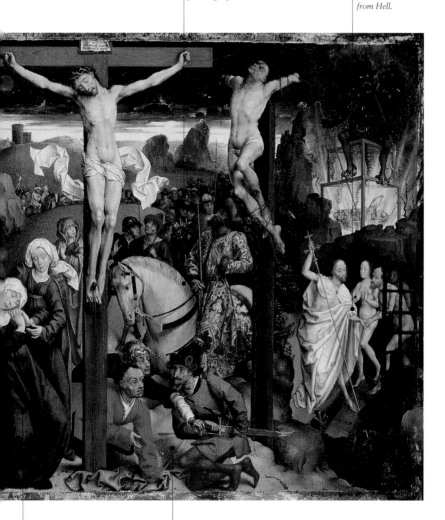

This haughty Pharisee on horseback is watching Jesus' agony.

Descending into Limbo after his death, Jesus frees Adam and Eve from Hell.

Inspired by Flemish tradition, the painter depicts a compact group composed of the fainted Mary; John, who dries his tears with a handkerchief; and Mary Magdalene.

The soldiers throw dice for Christ's tunic.

▲ Master of the Parlement de Paris, *The Crucifixion*, ca. 1490. Los Angeles, J. Paul Getty Museum

Mary Magdalene prays desperately at the foot of the cross. Beside her is the jar of ointment that is her typical iconographic attribute. It refers to the Gospel suppers where she washed and perfumed Jesus' feet, but also to the necessity of preparing Christ's body for burial.

Unusually, Mary wears a white gown, which contrasts strongly with the dark background.

The predella shows the Lamentation over the dead Christ, before the Entombment.

▲ Matthias Grünewald, *The Crucifixion*, a panel from the Isenheim Altar, 1515. Colmar, Musée d'Unterlinden

The roughly hewed horizontal beam of the cross bends under the weight of the dead Christ.

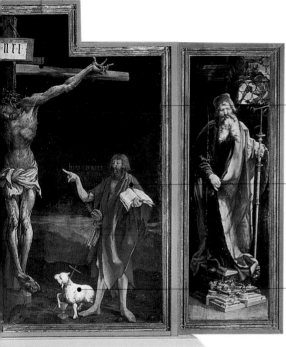

Christ's face bears the traces of the savage violence he has undergone, including the frightful crown of thorns.

An utterly unexpected and anachronistic character, John the Baptist points to Jesus and comments on his death with the phrase, "He must increase, but I must decrease" (John 3:30).

The mystical lamb is a symbol of the Baptist and of the Redeemer's sacrifice.

Jesus' body is supported by John and mourned by Mary and Mary Magdalene, the same figures who appear on the left in the central scene above.

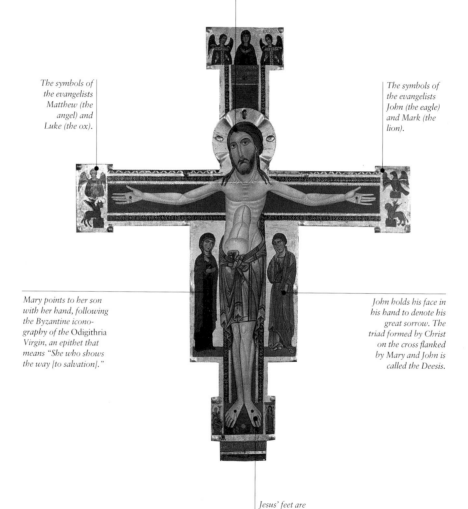

Jesus' eyes are open, his face is relaxed, and his body is calm. This type of medieval iconography, which shows the living Christ victorious over death, is called the Triumphant Christ.

The symbols of the evangelists Matthew (the angel) and Luke (the ox).

The symbols of the evangelists John (the eagle) and Mark (the lion).

Mary points to her son with her hand, following the Byzantine iconography of the Odigithria Virgin, an epithet that means "She who shows the way [to salvation]."

John holds his face in his hand to denote his great sorrow. The triad formed by Christ on the cross flanked by Mary and John is called the Deesis.

Jesus' feet are nailed separately to the small platform.

▲ Berlinghiero, *Painted Cross*, 1210–20. Lucca, Museo di Villa Guinigi

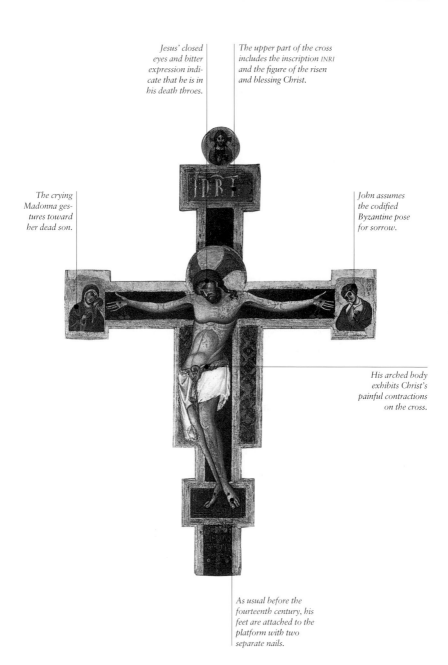

Jesus' closed eyes and bitter expression indicate that he is in his death throes.

The upper part of the cross includes the inscription INRI and the figure of the risen and blessing Christ.

The crying Madonna gestures toward her dead son.

John assumes the codified Byzantine pose for sorrow.

His arched body exhibits Christ's painful contractions on the cross.

As usual before the fourteenth century, his feet are attached to the platform with two separate nails.

▲ Giunta Pisano, *Crucifix of San Ranierino*, 1229–54. Pisa, Museo Nazionale di San Matteo

Blood flows abundantly from Jesus' wounds. This dwelling on his excessive bleeding is characteristic of Spanish devotion and also appears on a popular level in the gruesome sculpted images that are carried in procession during Holy Week.

With scrupulous scholarship, Velázquez included the phrase "Jesus of Nazareth, king of the Jews" in Hebrew, Greek, and Latin.

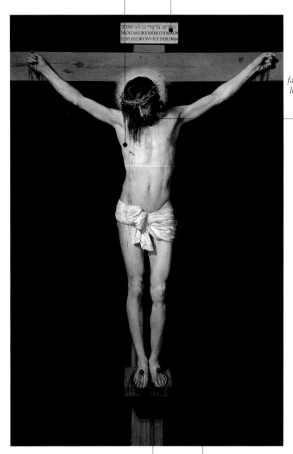

In death, Christ's face relaxes and no longer exhibits the spasms of his death throes.

Velázquez returns to the medieval iconography of the four nails (two for the hands and two for the feet), even though from the fourteenth century on, it was more common to use a single large nail that pierces both feet.

The black background recalls the darkness that fell over the world from the sixth hour to the ninth on Good Friday. However, it is also a way of isolating the crucified Christ and transforming it into a universal image.

▲ Diego Rodriguez de Silva y Velázquez, *Christ on the Cross*, ca. 1632. Madrid, Museo del Prado

A blessing hand sprouts from the right arm of the cross.

The vertical shaft of the cross sprouts a hand with a key, the symbol of the power to open the gates to the Kingdom of Heaven, and the unmistakable attribute of the popes.

Jesus' death is offered as redemption for the sin committed by Adam and Eve.

The hand holding a sword that sprouts from the left arm of the cross symbolizes revenge and punishment.

To Jesus' right are the consequences of the Redemption for Christians; these refer particularly to the birth and activity of the Church. Christ leans benevolently to this side, whereas all the images on his left are negative ones.

The skull with a snake with an apple in its mouth is a symbol of the presence of sin, the cause of spiritual death.

The cross sprouting branches and leaves is an example of the Tree of Life, or lignum vitae.

The allegory to the left of the cross portrays the Jewish faith being superseded by the Messiah's coming. It features a blindfolded Jew, a broken flagpole, and an altar for sacrifices.

The allegory to the right of the cross represents the Christian faith. It features the mystical lamb, the New Testament, and a young woman, who, with her banner and chalice, stands for the Church.

The hammer that is about to shatter a skull symbolizes Jesus' victory over death.

▲ Master of Westphalia, *Allegory of the Crucifixion*, ca. 1400. Madrid, Thyssen-Bornemisza Collection

The material sequence of actions is based on the Gospel texts, which feature Nicodemus and Joseph of Arimathea. The scene has great mystical and symbolic weight.

The Deposition

The execution of Christ and the two thieves on the afternoon of Good Friday took on a feverish pace: the high priests ordered a swift end to the agony of the three, so that the preparations for the upcoming Passover Sabbath would not be ruined.

John included a bloodcurdling detail that is often featured in German painting: the legs of the two thieves were wounded and broken to shorten their death throes. This proved not to be necessary for Jesus, since he was already dead. A centurion (identified elsewhere as Longinus) thrust a lance into his side, and blood and water gushed from the wound. Joseph of Arimathea, a member of the Council of Elders, obtained permission from Pilate to remove Jesus' body. With the help of Nicodemus, a noble Pharisee, the nails were extracted from Jesus' hands and feet, and his body

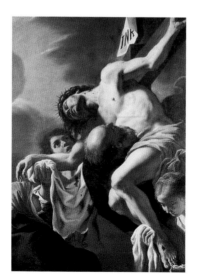

taken down from the cross.

The pincers employed to extract the nails, as well as the nails and the hammer that the executioners used to insert them, came to be among the instruments of the Passion.

The Place
Mount Calvary

The Time
The afternoon of
Good Friday

The Figures
Other than the deceased
Christ, the figures of
Nicodemus, Joseph of
Arimathea, John the
Evangelist, Mary
Magdalene, and the
Madonna are essential.

The Sources
The canonical Gospels,
with details from the
apocryphal Gospel of
Nicodemus and other
traditions, retold in
The Golden Legend

Variants
The Descent from the
Cross; the Deposition
from the Cross should
not be confused with the
Deposition of Christ in
the Tomb, often called
the Entombment

Diffusion of the Image
Widespread and quite
varied; the medieval
wooden sculptural
groups from central
Italy are especially
picturesque.

▶ Mattia Preti, *The Descent
from the Cross*, ca. 1660.
Private collection

The livid body of Jesus is very awkwardly brought down from the cross. Four people atop three stepladders carry on ineffectually, as if performing some macabre ballet.

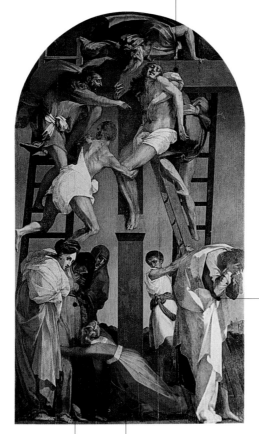

John's statuary figure occupies the right-hand side of the scene. The Mannerist painter effectively developed the Byzantine theme of the evangelist's tears.

The swooning Mary is supported by two women.

Mary Magdalene is sometimes shown embracing the cross. Here, she dramatically lunges to grasp Mary's legs.

▲ Rosso Fiorentino, *The Deposition from the Cross*, 1521. Volterra, Pinacoteca

The Deposition

A personification of the Church Triumphant carries a banner with a cross.

The wood of the cross—the Tree of Life, or lignum vitae—clearly divides the two groups, the good and the bad, on Christ's left and right, respectively.

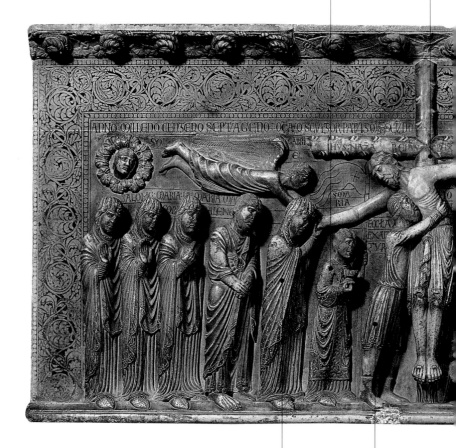

Mary clutches Jesus' hand, which has just been detached from the cross.

Nicodemus supports Jesus' body.

▲ Benedetto Antelami, *The Deposition from the Cross*, 1178. Parma, Duomo

Joseph of Arimathea is about to extract the nail from Jesus' hand.

A personification of Synagogue, defeated, bows her head.

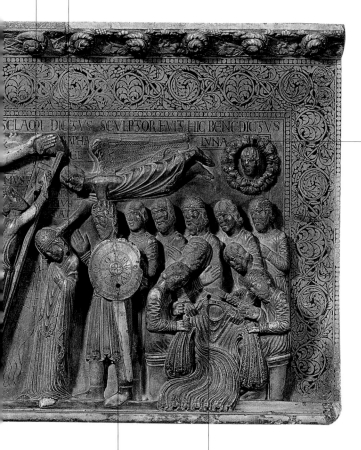

On the ends, the sun and moon watch the Deposition.

The centurion Longinus is about to convert.

The soldiers divide Jesus' garment.

The Deposition

The weeping pious women add a note of very human suffering to the scene.

· The elderly priest Nicodemus supports Christ's body as it is taken down from the cross.

John rushes to catch Mary.

The skull refers to Golgotha and to the redemption of Adam's sin through Jesus' sacrifice.

The Madonna collapses in a faint; her body exactly echoes the curve of Jesus' lifeless form.

▲ Rogier van der Weyden, *The Deposition from the Cross*, 1439–43. Madrid, Museo del Prado

The eminent Joseph of Arimathea, whose clothing underscores his high social class, receives the dead Jesus in the sheet prepared for him.

The despairing Mary Magdalene expresses her sorrow with an unusually awkward pose.

"The Marys, endlessly weeping." This phrase, which a seventeenth-century writer used to describe the Lamentation *sculpted by Niccolò dell'Arca in Bologna, eloquently renders the scene.*

The Lamentation

Taken down from the cross and still bleeding, Christ's body was laid on the sheet brought by Joseph of Arimathea. All the "wicked" had left the place of execution; only Jesus' most intimate relatives and friends remained at the foot of the empty cross. This heartrending scene of despair around the lifeless body of Jesus, the subject of unforgettable works of art, is not described at length in the Gospels. Like the Pietà, this is a very human and sentimental interpretation of the events.

In the strictest version of the theme, seven figures are gathered around Christ's body. The three men are the evangelist John (the only apostle that followed Jesus up to Calvary), Joseph of Arimathea, and Nicodemus. The women are the Madonna, Mary Magdalene, and the Virgin's two half sisters, both named Mary (daughters of Saint Anne and two different fathers, Cleophas and Salome). The number of characters can vary in works of art—often there are only women, but there can also be many more. The title "Lamentation over the Dead Christ" may also be given to works of art that feature only the Madonna and Saint John. Among the figurative pieces on this theme are the *mortori*, powerfully realistic sculpture groups that were widespread in the fifteenth and sixteenth centuries.

The Place
Mount Calvary, at the foot of the cross, or near the tomb

The Time
The afternoon of Good Friday

The Figures
The dead Christ, Nicodemus, Joseph of Arimathea, John the Evangelist, Mary Magdalene, the Madonna, and her two half sisters

The Sources
Briefly mentioned in the canonical Gospels, but mostly devotional tradition

Variants
Also called the Lamentation over the Dead Christ. The term "Pietà" is sometimes incorrectly used. If only angels appear with the fallen Christ, the better title is Christ Supported by the Angels.

Diffusion of the Image
Very widespread in all Christian countries

▼ Hans Holbein the Younger,
The Dead Christ, 1521. Basel,
Kunstmuseum

John supports Jesus' life-less body, as if meditating on the mystery of death.

Livid with sorrow, Mary raises tearful eyes to Heaven. Behind her is Mary Magdalene, also in tears.

The elderly woman who delicately holds up Jesus' hand has been identified as Mary of Cleophas, the Madonna's half sister.

Rubens emphasized the wound in Jesus' side. Diluted blood flows from it: the Flemish painter was referring to the Gospel passage that describes a mixture of blood and water flowing from the opening in Christ's side.

Jesus' body is placed on a smooth stone resembling an altar with a sheaf of wheat on it. This alludes to the mystery of the presence of Christ's body in the bread of the Eucharist, which is upheld by Catholics and denied by Protestants.

▲ Peter Paul Rubens, *The Entombment*, ca. 1612. Los Angeles, J. Paul Getty Museum

The foot of the cross is recognizable at the edge of the painting, marked by the iconographic presence of the skull.

Following iconographic custom, Nicodemus carries Christ's legs in scenes of the Lamentation and the Entombment, while Joseph of Arimathea supports Jesus' shoulders.

Mary Magdalene turns away as if to avoid looking at Jesus' wounded body. On the ground, a jar of ointment—her usual iconographic attribute—rests beside the nails, hammer, and pincers.

▲ Petrus Christus, *The Lamentation*, ca. 1450. Brussels, Musées royaux des beaux-arts

John, with the help of a woman, supports Mary, who has fainted.

The white linen sheet, long enough to be folded over Jesus' body, is the Shroud of Turin, a relic that is kept at the cathedral of that Italian city.

Joseph of Arimathea helps lay the body of Jesus onto the long sheet that will be used as a shroud.

On the left, parts of the faces of Mary, John, and Mary Magdalene emerge into the space of the picture. They appear furrowed with wrinkles, their features almost resembling the tragic masks from antiquity.

The jar of embalming ointment is on the edge of the marble slab.

The scene is set inside a morgue. Christ is laid out on a marble slab, known in fourteenth-century devotions as the Anointing Stone.

By choosing this perspective for the body, Mantegna emphasized the holes in Christ's feet. The wounds have been washed and dried: the body is already partly prepared for burial.

▲ Andrea Mantegna, *The Dead Christ*, ca. 1500. Milan, Pinacoteca di Brera

High atop Mount Calvary, the three fatal crosses are still standing.

Christ's body is laid out on a marble table to be prepared for burial. All around the desolate cemetery landscape are broken tombstones and macabre surfacings of human remains.

A mysterious elderly man—the patriarch Job? Saint Jerome?—meditates on Jesus' death, leaning against a tree that is partly withered and partly green. The tree symbolizes the Jewish faith, which has run its course, and the new life brought by Christianity to the stock of the ancient religion.

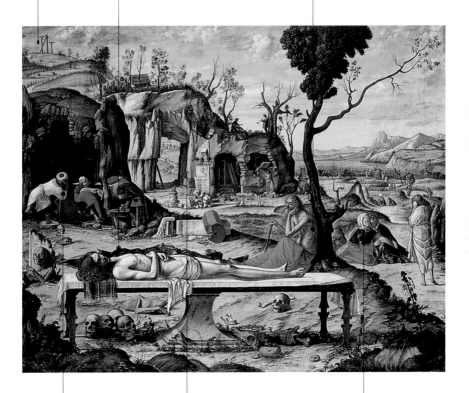

Joseph of Arimathea, Nicodemus, and a third figure prepare Jesus' burial. Two of them move the stone for the tomb while the third carries the tray of embalming ointments.

At the center of this composition, on a cliff riddled with tombs, are two shepherds with their flock. They symbolize life, which continues, but also the period of Jesus' birth.

Mary Magdalene, the fainted Mary, and the weeping John appear in the middle ground.

▲ Vittore Carpaccio, *Preparation for the Entombment*, 1510. Berlin, Gemäldegalerie

This scene is set in a non-place, as if suspended in the clouds.

The large crown of thorns is typical of northern European painting.

This painting combines the icono-graphy of the Man of Sorrows with that of the Mater Dolorosa (Grieving Mary), both of which were very widespread in Germany just before the Reformation.

The angels desperately clutching Jesus' arms and legs emphasize the tragic nature of the scene. They represent a noteworthy variation on a theme that is unusual in northern European painting but commonly found in Italian works.

▲ Hans Baldung Grien, *Christus Patiens*, 1513. Freiberg, Augustinermuseum

The subject of the fallen Christ being supported by angels was hugely popular in Venetian painting of the early Renaissance. Although the image borrows various iconographic elements, it is not exactly a Lamentation, a Deposition, a Man of Sorrows, or even a Resurrection, but rather a theme that is essentially unique.

An angel rests its cheek on Jesus' pierced hand. The angels' attitude is partly inspired by popular devotion to Jesus' wounds.

Jesus is seated on the cover of the tomb.

The corner of the sarcophagus comes out at the viewer with painful obtrusiveness.

▲ Antonello da Messina, *Pietà with Three Angels*, 1474. Venice, Museo Correr

Unusually, an angel holds the cross and nails. This exceptional sculpture group combines themes from popular devotion and a distinguished formal classicism.

Mary Magdalene piously kisses Jesus' feet, repeating the gesture of devotion, homage, and humility that she performed several times during Christ's life.

Nicodemus supports Jesus' legs. The tomb can be seen in the background, behind the group.

▲ Ligier Richier, *The Lamentation*, 1540. Saint-Mihiel, Church of Saint-Étienne

Tormented by sorrow,
Mary once again seems to
be fainting, supported by
the pious women.

Joseph of
Arimathea
supports
Christ's
shoulders.

Careful not to prick herself, a
woman uses a handkerchief
to carry away the crown
of thorns.

The Pietà as a subject takes its name from a series of marbles—sculpted by Michelangelo over more than sixty years—that reveals a clear iconographic evolution of the subject.

The Pietà

In some iconographic interpretations of the Deposition and Lamentation, Mary loses consciousness and faints. Her heartbreaking awareness of her son's death, however, occurs a short time later, when the collective sorrow of the group of friends who gathered for the Lamentation gives way, in the case of the Pietà, to Mary's private, solitary, and inconsolable despair. Here she holds her dead son in her lap for the last time before handing the body over to Joseph of Arimathea and Nicodemus for burial. The subject refers neither to any Gospel passage, nor to the apocryphal gospels, but to human experience alone. Freed from any specific reference to a text, the theme has been repeatedly interpreted by artists of every age with unusual emotional intensity.

Because it centers attention on the figure of Mary, the Pietà may be considered the figurative version of sacred music's *Stabat Mater*, while a profoundly moving literary parallel may be found in poems of the thirteenth-century Franciscan Jacopone da Todi.

The Place
Mount Calvary, at the foot of the cross

The Time
Late afternoon on Good Friday

The Figures
Only two: the Madonna and the dead Christ

The Sources
Devotional traditions

Variants
None. The Italian word "pietà" is also used to describe this scene in other languages.

Diffusion of the Image
Extremely widespread; in Germany it often appears as a wooden sculpture group called *Vesperbild*

▶ Master of Salzburg,
Pietà, ca. 1490. Munich,
Bayerisches Museum

A tree with a few fruits refers to the new life brought about by Jesus' sacrifice.

In the background, the impossibly high crosses loom like a nightmare over the Madonna's head.

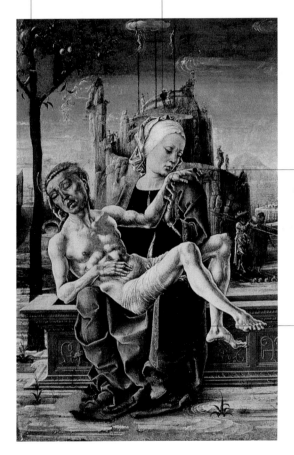

Mary holds up and kisses Jesus' hand, the typical gesture of adoration of Christ's wounds that was customary in fourteenth-century devotional art.

The Madonna is seated on the elaborately sculpted sarcophagus in which Jesus will be laid.

▲ Cosmé Tura, *Pietà*, ca. 1468. Venice, Museo Correr

Christ's limpness, as he lies on the Madonna's lap, is a development of a traditional German sculptural model.

Mary has a very young face. Michelangelo, a careful reader of Dante, may have intended to illustrate the verse from the Divine Comedy *that begins,* "Virgin mother, daughter of your Son" *(*Paradiso, 33*).*

Michelangelo engraved his name on the sash that runs across Mary's chest. This is the only sculpture the master ever signed.

A detail sometimes overlooked: Michelangelo gave the group's base the rough surface of Mount Calvary.

▲ Michelangelo, *Pietà*, 1498–99. Vatican City, Saint Peter's Basilica

A tiny angel picks up the jar of ointment, Mary Magdalene's typical iconographical attribute.

In anguish, Mary Magdalene howls out her sorrow.

Titian, who painted this Pietà for his own tomb, portrayed himself in the figure of Nicodemus, who kneels before Christ.

An angel bears a bundle of candles. There are also small, smoking lamps along the gable of the arch.

At each end, the statues of Moses and the Sibyl of the Hellespont, respectively, recall the Old Testament prophecies of the Passion.

In the center, the Madonna holds Christ on her lap. Despite the presence of other figures, this main group, derived from the customary iconography, justifies titling this work a Pietà.

The small votive image that leans against the base of the statue probably refers to the plague that was raging through Venice at the time this painting was made.

▲ Titian, *Pietà*, 1570–76. Venice, Gallerie dell'Accademia

The distinction between the Lamentation and the Entombment is subtle. While the Lamentation is a static, emotional situation, the Entombment presupposes dynamic action—a story.

The Entombment

Joseph of Arimathea and Nicodemus took charge of burying Christ.

Nicodemus brought a mixture of myrrh and aloe with which to purify and embalm Jesus' body. Artists have sometimes evoked the subject by including small jars of ointment, and the term "the Anointing Stone" is also used for this scene. Nicodemus and Joseph also used perfumed bandages, according to Jewish tradition. They then took the body to an empty tomb that had never been used, carved from the living rock near a garden by Calvary, and belonging to Joseph. Joseph carried the body by the shoulders; Nicodemus, by the feet. Finally, the tomb was sealed with a stone.

The iconographic tradition more or less ignores the processes of embalming and wrapping Christ's body. The body of Christ is usually transported and placed in the tomb wrapped in a white sheet, a shroud, also provided by Joseph of Arimathea. Popular devotion identifies the "sacred linen" that received the body of the dead Christ with the Shroud of Turin.

Raphael interpreted the Gospel subject freely—it would be difficult to identify the two figures carrying the body of Christ as Nicodemus and Joseph of Arimathea, while the apostles Peter and John do appear.

At the center of the composition, Mary Magdalene gazes at Jesus with sorrowful tenderness.

Mount Calvary is in the background, with the crosses still standing.

Christ's still-bleeding wounds add a poignant element to the dramatic scene.

The Madonna faints. This painting's emphasis on the group that includes the fainted Madonna is related to the work's patron, a gentlewoman of Perugia driven to desperation when her son was killed.

▲ Raphael, *The Deposition of Christ*, 1507. Rome, Galleria Borghese

The man helping to lower Christ into the tomb is not Joseph of Arimathea, but the apostle John.

Caravaggio was innovative in the feelings being expressed: Mary Magdalene weeps silently, whereas in the usual iconography she is touching Jesus' hands or feet.

The woman with hands and eyes raised to Heaven closes the group, which is designed as a single block, almost like a sculpture group.

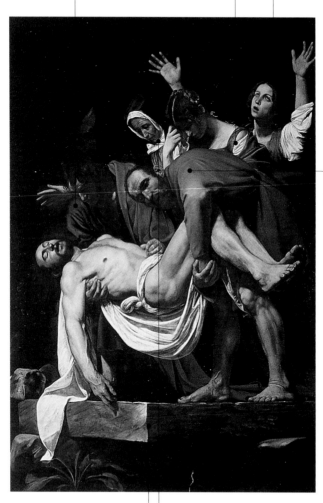

A realistic Nicodemus holds up Jesus' legs and turns toward the viewer, thus establishing a direct engagement.

The sharp corner of the sepulchre stone points out at the viewer, emphasizing the fact that Christ's death is no ancient news item, but a matter of here and now.

Closed within her sorrow, the Madonna opens her arms wide.

▲ Caravaggio, *Deposition in the Sepulchre*, 1602–4. Vatican City, Pinacoteca Vaticana

Nicodemus spreads
ointment and
embalming fluids on
Christ's body.

An assistant finishes
bandaging Jesus' legs.

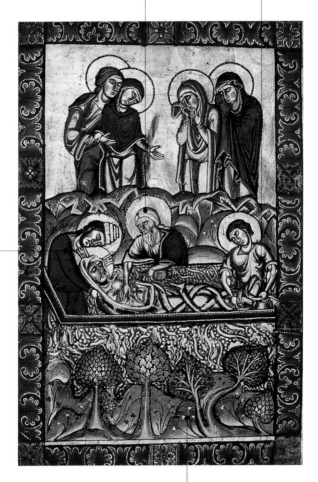

Joseph of
Arimathea,
whose headgear
shows him to be
a member of the
Sanhedrin,
arranges Christ's
shoulders in the
tomb.

This miniature is clearly divided
in two parts. In the top part, the
mourners are in an arid, barren
landscape; in the bottom part
there is a lush green garden.

▲ *Preparations for the Entombment*, a miniature from an Evangelary, ca. 1200. Brandenburg, Cathedral Archives

This image derives from accounts of the Passion in the canonical Gospels, and, in fact, may be considered a visual summary that might have had a didactic and mnemonic function.

The Man of Sorrows

The poignant figure of the wounded Christ is the visual equivalent of medieval prayers in which Jesus enumerates all the torments he underwent and the wounds he received. In art, the subject features a few important variations. First of all, it should not be confused with the *Ecce Homo*, where Christ also appears by himself with his tortured body and expression of suffering but does not bear the marks of the nails of the cross. Instead, the crown of thorns, red cloak, and reed scepter are prominent. In the Man of Sorrows, we see the wounds in his hands, feet, and side. In some cases (especially in Italian art), Christ is depicted standing in the tomb with his eyes closed, sometimes with the Madonna and

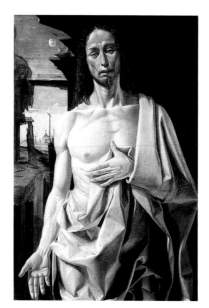

John beside him, as if this were a version of the Lamentation. In German art, Christ is generally shown with a melancholy expression, as if accusing those who abandoned him. In contrast, other northern European works show the dead Christ in a variation of the "Throne of Grace."

The Place
Undefined, or one of the locations of the Passion

The Time
Undefined: it may be linked to a Passion scene, such as the Flagellation, or "projected" out of time

The Figures
The suffering Christ

The Sources
This is mainly an iconographic interpretation that does not relate specifically to any text.

Variants
Christus Patiens (the suffering Christ), *Arma Christi* (Christ with the instruments of the Passion)

Diffusion of the Image
This subject was extremely widespread, especially during the fifteenth century, when it was connected with *Imitation of Christ*, the devotional book attributed to Thomas à Kempis.

▶ Bramantino, *Christus Patiens*, 1495. Madrid, Thyssen-Bornemisza Collection

Among the Arma Christi, or instruments of the Passion, in this work are many allusions to figures and scenes from the Passion. These are busts of Peter and the woman who states that she has seen him.

The pelican, which, according to a medieval belief, tore its own breast open to feed its young, is a symbol of Christ's sacrifice.

The kiss of Judas

The pitcher and basin with which Pilate is washing his hands; beside it, Longinus's lance

The torch used on the night of the arrest

The pillar and whips used for the Flagellation

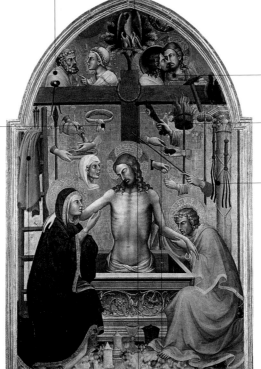

The red cloak and the ladder used for the Deposition from the Cross

The cross and the crown of thorns

The many hands here symbolize the Flagellation, the payment of thirty pieces of silver to Judas, the mocking of Christ, giving him the reed as a mock scepter, and other episodes.

▲ Lorenzo Monaco, *Christ with Mourners and Symbols of the Passion*, 1402. Florence, Galleria degli Uffizi

The three nails from the
cross, the hammer used
to pound them in, and
the pincers used to
extract them

The pole with the
vinegar-soaked
sponge, leaning
against the stepladder;
below, the emblem of
the Flagellation

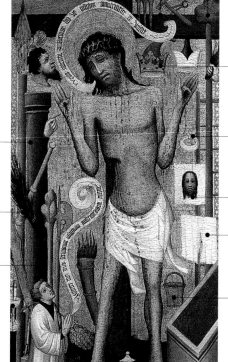

Caiaphas's and
Pilate's hats

The pillar from the
Flagellation, against which
Longinus's lance leans;
above, Judas's profile

The blindfold placed over
Christ's eyes during the
Flagellation

The bundled scourge
used for the Flagellation

Veronica's veil

The club and pike,
specific references to
the arrest

The temple curtain,
which ripped in two at
the instant of Christ's
death

The bucket of vinegar
next to the tomb

The chalice used to
collect the blood from
Christ's wounds

The jars of oint-
ment of the three
pious women

The red cloak and the
dice the soldiers used to
divide it

▲ Master of the Middle Rhine, *Christ as the Man of Sorrows*, ca. 1420. Kreuzlingen, Kisters Collection

This blessing gesture signifies forgiveness for the world.

Jesus' face expresses neither agony nor sorrow, but rather a sort of meditative melancholy.

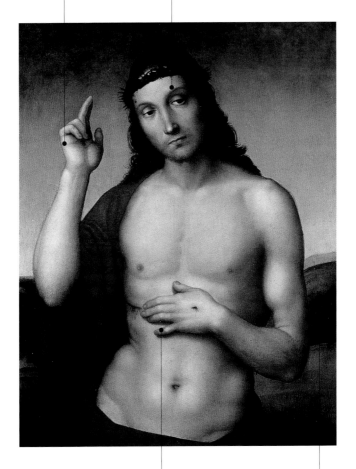

With his left hand, Jesus shows the still-bleeding wound in his side. Although this may refer to the Incredulity of Thomas, because of the size of the image, which is quite forward with respect to the viewer's visual plane, it takes on a universal quality.

A gentle hilly landscape provides the background for this peaceful, serene image, which is quite different from earlier moving, often dramatic interpretations.

▲ Raphael, *The Blessing Christ*, 1506. Brescia, Pinacoteca Tosio Martinengo

This type of image highlights the doctrinal trinitarian composition. Beginning in the mid-fifteenth century, the rising popularity of the Coronation of the Virgin added a fourth element.

Imago Trinitatis

A striking expressive quality characterizes the relatively numerous images of the Trinity that are predicated on the dead Christ. The subject must have been more common than is generally believed, including in objects of private devotion. Certain Flemish paintings, for example, show small sculpture groups of this subject set within the most ordinary domestic environments. The theme is very mystical: God the Father, together with the Holy Spirit in the form of a white dove, gathers up the body of Christ and raises it Heavenward. This completes the cycle of Jesus' earthly existence, and his divine glory begins. It is not by chance that the most correct title for the scene is the "Throne of Grace" (a translation of the German *Gnadestuhl*), indicating the royal rank that Christ now assumes. An eloquent example is the imposing celebration that Albrecht Dürer orchestrated in the Pala di Ognissanti.

There can be two variations: God the Father either supports Christ, who is still nailed to the cross, or simply holds up the lifeless body.

The Place
Undefined or in Heaven

The Time
Essentially undefined, although it may take place during Holy Saturday

The Figures
The dead Christ (either descended from the cross or still nailed to it) held up by God the Father in the presence of the dove that symbolizes the Holy Spirit

The Sources
A late-medieval iconographic interpretation of the theme of the Trinity

Variants
The Trinity

Diffusion of the Image
Significant, especially in the German world of the fifteenth century

▶ Jean Malouel, *Holy Trinity and Lamentation*, 1400–1410. Paris, Musée du Louvre

The dove, symbol of the Holy Spirit, perches on Jesus' shoulder.

Christ still wears the crown of thorns, symbol of the torments he suffered during the Passion. In addition, his left hand indicates the wound in his side.

The monochrome painting imitates the effect of a marble sculpture group in a niche. God the Father, with a gaze of powerful intensity, supports his dead Son.

Christ's legs, heavy and limp, seem to extend beyond the sculpture's edge. By using monochrome and simulating marble, the Flemish painter expressed the idea of the single substance of the three persons of the Trinity.

▲ Robert Campin, *The Trinity*, ca. 1410. Frankfurt, Städelsches Kunstinstitut

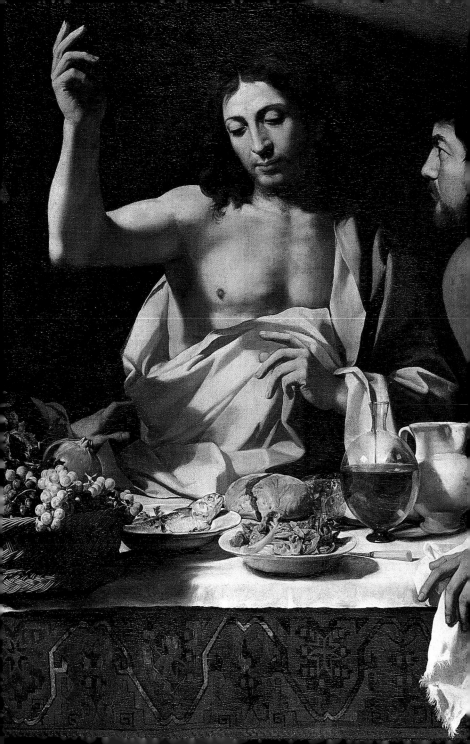

AFTER THE RESURRECTION

◄ Follower of Caravaggio,
The Supper at Emmaus,
ca. 1600. Los Angeles,
J. Paul Getty Museum

► Caravaggio, *The
Incredulity of Saint Thomas*
(detail), ca. 1600–1601.
Potsdam, Neues Palais

In the case of the Resurrection, the lack of specific descriptions in the Scriptures has given free rein to the creative interpretations of artists and the requests of their patrons.

The Resurrection

The Resurrection of Jesus, true man and true God, is the central mystery of Christianity, the determining factor that distinguishes this faith from other religions, which may esteem and appreciate the historical figure and human activity of the Nazarene, but reject the Resurrection.

The scene and the various surrounding elements are formulated in either of two ways in the history of art. The most frequent shows Jesus rising out of the tomb and hovering in the sky, as if carried there by a release of energy, almost anticipating the Ascension. In the other type, Christ emerges from the tomb still characterized by an earthly, fleshly physicality.

Typically, the risen Christ holds a standard with a cross on it; what often changes is the number and attitudes of the soldiers charged with guarding the tomb to prevent any attempt to steal Jesus' body. In art, there are usually four soldiers, and they are asleep. There are, however, many examples where they are very animated or else stunned.

The Place
The Holy Sepulchre

The Time
Easter Sunday

The Figures
The risen Christ and sometimes the soldiers guarding the tomb

The Sources
None of the Gospels recounts this episode; the images in art are extrapolated from later exegeses.

Variants
Despite the various figurative interpretations, the title remains the same.

Diffusion of the Image
Extremely widespread, since this is one of the fundamental and distinctive dogmas of Christianity

▶ Giovanni Bellini, *The Resurrection of Christ*, 1475–79. Berlin, Gemäldegalerie

Jesus bears the banner with
a red cross on a white back-
ground that symbolizes the
Resurrection.

Piero chose the static, silent, and solitary
version of the scene, with no celestial
beings. Jesus is portrayed frontally and
motionless. The Resurrection is the
fixed point in human history; it divides
two epochs.

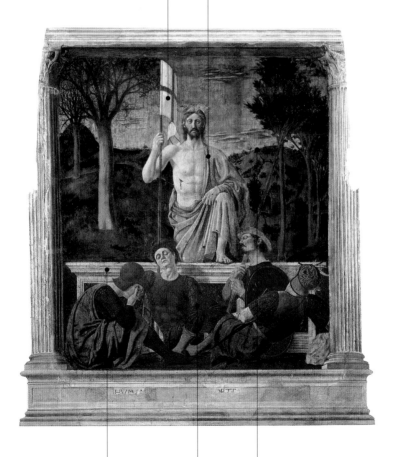

The sarcophagus is emphasized
because Piero painted this fresco for
his native town, Sansepolcro, which
has the sepulchre of Jesus in its
name and in its coat of arms.

The four soldiers
are sound asleep.

The half-barren and half-green land-
scape alludes to the redemption of sin
and to the new life that Jesus' death and
resurrection brought to the world.

▲ Piero della Francesca, *The Resurrection of Christ*, 1463. Sansepolcro, Pinacoteca Comunale

The brightness of Jesus' radiant face is so intense that it almost erases his features.

An extraordinary halo of light and color surrounds Jesus. It recalls not only the Transfiguration but also the rainbow that symbolizes the covenant between God and humanity.

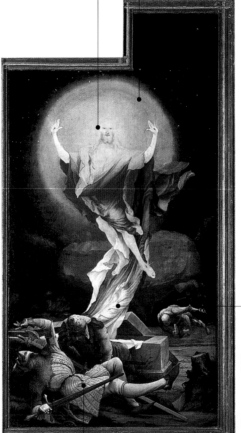

Grünewald adopted a very dynamic and mystical version of the theme. Jesus rises from the sepulchre as if propelled by a vortex of power, while the gesture of his hands, marked by the stigmata, transforms the pose of the Crucifixion into a magnificent salutation of peace.

The soldiers are not asleep, but appear thrown by the explosion of power caused by Jesus' emergence from the tomb.

▲ Matthias Grünewald, *The Resurrection of Christ*, from the Isenheim Altar, 1515. Colmar, Musée d'Unterlinden

An extremely attentive reader of the Scriptures, Rembrandt interpreted Matthew's text: an angel, whose "appearance was like lightning, and his raiment white as snow" (28:3), easily lifts the heavy stone that covers the tomb.

Unlike what generally occurs in representations of the Resurrection, Christ has an almost marginal role. Still wrapped in funerary bandages, he begins to emerge from the sepulchre that the angel has opened.

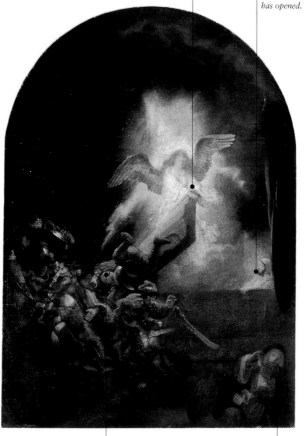

The many soldiers are bowled over by the opening of the sepulchre, as mighty as an earthquake. One of them even tumbles off the cover.

Following Matthew's Gospel (28:1), Rembrandt also includes Mary Magdalene and "the other Mary" going to the tomb.

▲ Rembrandt, *The Resurrection of Christ*, 1639. Munich, Alte Pinakothek

Christ hovers in the sky, enveloped in a halo of light, his gaze directed upward. His open-armed gesture recalls his position on the cross, but Veronese also occasionally used it in images of the Baptism.

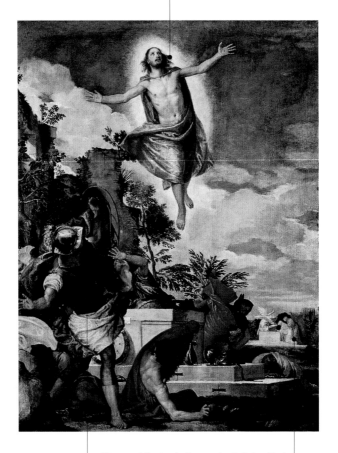

The soldiers draw back, fearful and powerless.

The scene following the Resurrection is depicted in the background. The angel greets the women who have come to the tomb, announcing, "He is not here . . . he has risen from the dead, and behold, he is going before you to Galilee" (Matt. 28:6–7).

▲ Paolo Veronese, *The Resurrection of Christ*, 1572–76. Dresden, Gemäldegalerie

This episode is based on controversial passages from the Scriptures. In contrast with these marked exegetical uncertainties, a precise and powerfully evocative iconographic tradition has taken shape.

Christ in Limbo

The Golden Legend, written by the Dominican Jacobus de Voragine in the late thirteenth century, is the reference text for the success of an image that has been as popular as it has been controversial. The theory that Jesus descended into the netherworld after the Crucifixion is only hinted at in the apostolic letters of Peter and Paul. It is, however, described in the apocryphal gospel attributed to Nicodemus, the same esteemed member of the Council of Elders who played an important role at the Deposition and the Entombment. According to this account, Jesus descended into Hell—shattering its bronze-barred doors—in order to free from Limbo the patriarchs, prophets, and other Old Testament figures, such as Adam and his son Seth, Moses, David, and Isaiah, but also figures from the Gospels, such as the good thief Dismus, the elderly priest Simeon, and even John the Baptist.

In art, the demons of the shadows are defeated by the power and light that emanates from Jesus, and they are often shown squashed under the unhinged gates of Hell.

The Place
At the Gates of Hell

The Time
Presumably Holy Saturday

The Figures
Jesus, defeated demons, and the patriarchs of the Old Testament freed from Hell

The Sources
The apocryphal Gospel of Nicodemus, retold in *The Golden Legend*

Variants
There are no variations in the basic subject, although the figures involved may vary.

Diffusion of the Image
A not terribly unusual episode, either within narrative cycles or as an isolated image

Albrecht Dürer, ◄
The Descent into Limbo,
an engraving from the
Great Passion series, 1510

Jesus' announcement of his Resurrection directly to the Madonna is not in the Scriptures but is based rather on loving filial consideration, as The Golden Legend *reports.*

Christ Appearing to His Mother

This episode is closely linked to the Descent of Christ into Limbo, which sometimes appears in the background. In some works of art, the biblical figures that Jesus brought out from Limbo follow him to the room where Mary had withdrawn in order to weep in solitude. These unusual images are interesting because of the somewhat intrusive presence of a small crowd of patriarchs and prophets that clashes with the intimate emotion of the encounter between mother and son.

The Place
A room in Jerusalem

The Time
Presumably Holy Saturday

The Figures
Jesus, the Madonna, and sometimes patriarchs that are freed from Limbo

The Sources
A tradition recounted in *The Golden Legend*

Diffusion of the Image
Somewhat widespread in the fifteenth century; it should not be confused with Christ's Farewell to Mary (before Holy Week), or with rare images of Christ's visit to the Virgin Mary to announce her imminent death

More widespread, and more elevated in terms of the stylistic effect, is the choice to focus the action only on the two characters, with ardently intense results. The Madonna is almost always seated, brokenhearted, with only the comfort of her

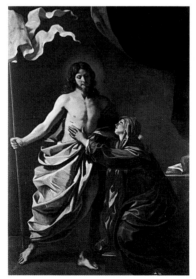

▶ Guercino, *The Risen Christ Appears to the Virgin Mary*, 1629. Cento, Pinacoteca Comunale

prayer book. Jesus appears in flesh and blood, frankly displaying the physicality of his wounds. The standard of the Resurrection—in addition to the wounds and the absence of the apostles—distinguishes the scene from Christ's Farewell to Mary before the Passion.

An angel holds a crown
and a scroll bearing a
passage from the Book
of Revelation.

A number of the
mysteries of the
Virgin, such as the
Annunciation, the
Dormition, the
Coronation, the
Assumption, and
Pentecost, are rep-
resented as if
in bas-relief along
the arch.

Preceding events appear
in the background: Jesus
rises from the tomb with
the angel's help, and, in
the distance, the pious
women are making their
way to the tomb.

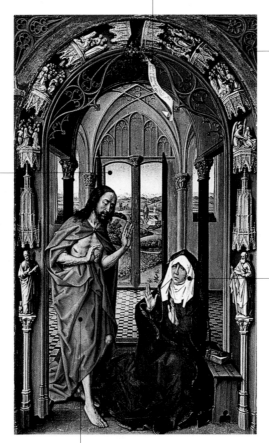

Closed within
dark, habit-like
garments, the
Madonna is
depicted as the
Mater Dolorosa,
her face stricken
and lined with
tears.

Jesus delicately comes
toward her, displaying
his wounds.

▲ Copy after Rogier van der Weyden, possibly by Juan de Flandes, *Christ Appearing
to His Mother*, ca. 1496. New York, The Metropolitan Museum of Art

In the eventful morning hours of Easter Monday, the meeting between Christ and Mary Magdalene is a grounding event. It was narrated by John and has greatly stimulated the imagination of artists.

Noli me tangere

Writing of the Resurrection, John recounted his personal experience. It was he who, together with Peter, was awakened that morning by Mary Magdalene's announcement that she had found Jesus' tomb empty. Peter and John rushed to the tomb, observed the linen cloth bandages lying on the ground, and "saw and believed" (20:8). The two apostles then returned home.

Mary Magdalene, however, "stood weeping outside the tomb" (20:11). Two angels appeared to her, and when she suddenly turned, she saw a man. Mistaking him for a gardener, she asked him if he was the one who had removed Jesus' body. Jesus then called her by name, whereupon Mary recognized the risen Savior, fell to her knees, and embraced his feet, saying "Rabboni!" (Teacher!). Jesus, however, stepped aside, saying, *"Noli me tangere"* (Do not touch me [20:17]), then asked her to spread the news about his coming Ascension.

The Place
Near the Holy Sepulcher

The Time
Easter Monday

The Figures
Christ and Mary Magdalene

The Sources
The Gospel of John

Variants
Christ and Mary Magdalene; Christ the Gardener

Diffusion of the Image
Significant, especially during the Renaissance, because of the growing popularity of Mary Magdalene

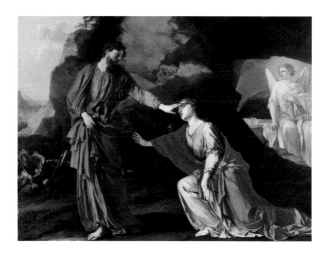

► Laurent de La Hyre, *Christ Appearing to Mary Magdalene*, 1656. Grenoble, Musée des beaux-arts

This scene takes place in a burial ground that the Resurrection of Jesus has transformed into a sort of Garden of Eden. Fra Angelico emphasized the similarity between the red of the bloody wounds on Christ's feet and the color of the tiny flowers; Jesus' sacrifice becomes a new creation of the world, making "all things new" (Rev. 21:5).

The shovel on Jesus' shoulder refers to Mary Magdalene's mistaking him for one of the cemetery gardeners.

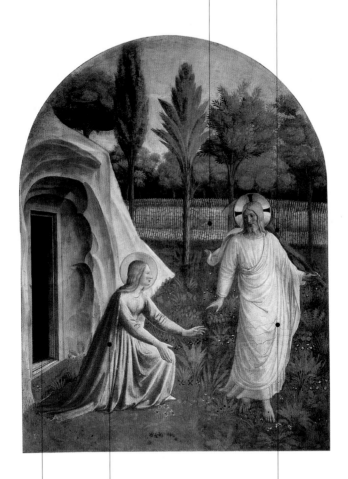

The empty tomb is evoked by the darkened opening carved into the living rock.

Mary Magdalene bends to embrace Jesus' knees.

Jesus is enveloped in resplendent white garments. With a light step, he keeps his distance from Mary Magdalene.

▲ Fra Angelico, *Noli me tangere*, ca. 1440. Florence, Convent of San Marco

The Gospels narrate the first revelation of the Resurrection to Christ's friends and followers in a confused way. Art resolved the contradictions by varying the figures involved.

The Three Marys at the Tomb

The situation at Jesus' empty tomb on the morning of Easter Monday must have been tense. According to Matthew, the armed guards that Pilate had sent to prevent the body's disappearance were paid off by the Pharisees and the members of the Sanhedrin to falsely declare that a group of disciples had stolen the corpse. The Resurrection of Jesus, or, at least at first, the discovery of the disappearance of his remains, occurred under miraculous circumstances. According to the synoptic Gospels, an angel (there are two in Luke) told the women who had come to pray and perform the rituals that Jesus "is not here" (Mark 16:6). With mixed feelings of astonishment, joy, and fear, the Marys spread the news.

The Place
The Holy Sepulchre

The Time
Easter Monday

The Figures
A few women and the angel, and sometimes the apostles Peter and John

The Sources
The synoptic Gospels

Variants
The titles change depending on the characters involved.

Diffusion of the Image
Quite widespread and varied, but less so than *Noli me tangere*

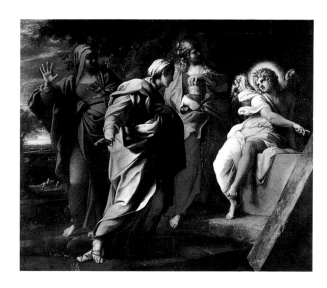

▶ Annibale Carracci, *The Three Marys at the Tomb*, ca. 1590. Saint Petersburg, Hermitage

The three Marys (Mary Magdalene
and two of the Madonna's half sisters,
Mary of Cleophas and Mary of
Salome) fearfully draw back when they
see the angel. Each of them carries a jar
of ointment, and the three containers
are often included among the Arma
Christi, *the symbols of the Passion.*

The angel holds the gate-
keeper's staff that identifies
him as an attendant at the
divine ceremonies. In medieval
iconography, this is the object
that the archangel Gabriel
holds at the Annunciation.

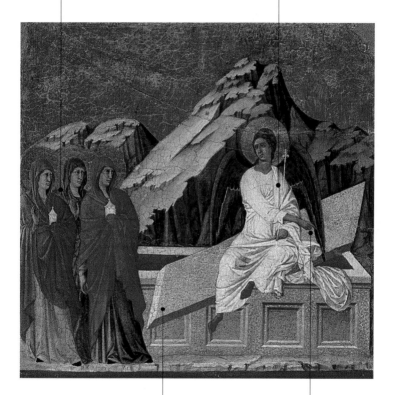

The white-robed angel points
toward Galilee, both the
geographical region and a place
symbolizing another reality,
where the risen Christ awaits
his disciples.

The cover of the tomb
has been moved and
placed across the
empty sepulchre.

▲ Duccio di Buoninsegna, *The Three Marys at the Tomb,* back of the *Maestà* altarpiece, 1308–11.
Siena, Museo dell'Opera del Duomo

Seated on the sepulchre, the white angel gestures with both hands to explain what has happened. He shows them the empty tomb and points upward to where the disciples will be able to see Jesus again.

This scene with the Marys at the tomb is associated with the Resurrection: Jesus bears the standard and the palm branch, a symbol of martyrdom and glory.

The result of a careful interpretation of the Scriptures, this fresco includes a number of iconographic singularities. The three Marys who come to the tomb are the three daughters of Saint Anne: the Madonna, Mary of Cleophas, and Mary of Salome. Mary Magdalene remains apart from this group.

Mary Magdalene inspects the empty tomb.

▲ Fra Angelico, *The Risen Christ* or *The Message of the Angel*, ca. 1440. Florence, Convent of San Marco

Only Luke refers to not one but two angels sitting on the tomb. Displaying the empty shroud, the angels ask the Marys, "Why do you seek the living among the dead?" (24:5), throwing the women into consternation.

The shroud that the angels hold up with their fingertips merges with the traditional devotional iconography of Veronica's veil.

The women, frightened by the presence of the angels and upset by the absence of Jesus' body, fall to their knees with gestures more astonished than prayerful.

Here is a detail from the Gospel of Luke: the cover of the sepulchre is not lying across the empty tomb, but has been thrown to the ground.

The little jar on the ground recalls the reason for the women's visit to the tomb: to sprinkle Christ's sepulchre with perfumes.

▲ Simon Vouet and workshop, *The Pious Women at the Tomb*, ca. 1640. Davron, Church of the Sainte-Madeleine

Even in an exclusively secular reading of the Gospel, from a literary point of view this passage from Luke comprises one of his highest moments of poetry and psychological refinement.

The Supper at Emmaus

The Place
Along the road between Jerusalem and Emmaus

The Time
The third day after the Crucifixion

The Figures
Jesus and two disciples

The Sources
The Gospel of Luke

Diffusion of the Image
This episode, which was very widespread from the Middle Ages on, became extraordinarily popular during the seventeenth century, when, after Caravaggio's example, it provided numerous opportunities for genre scenes.

Among the various appearances of the risen Jesus, this was the only one that went outside the small circle of the apostles or Jesus' immediate family. The history of art has focused almost exclusively on the final moment of the event.

Two disciples were walking along the road from Jerusalem to Emmaus. They were sad because Jesus' death had dashed their hopes that they had found Israel's liberator. A third traveler joined them. He was evidently uninformed about what had happened three days earlier, and asked the disciples to tell him every detail. The disciples on the road to Emmaus did so and also voiced their doubts and their wonder that the tomb had been found empty. At this point, Jesus—whom the disciples still did not recognize—begins to give them a catechism lesson. "He interpreted to them in all the scriptures the things concerning himself" (Luke 24:27). Evening fell, and the two disciples, struck and troubled by the traveler's words, invited him to supper. Seated at a table at an inn, Jesus took the bread, blessed it, broke it, and offered it to his disciples. "Their eyes were opened and they recognized him; and he vanished out of their sight" (24:31).

▶ Ivory Plaque Depicting the Pilgrims on the Road to Emmaus, ca. 860–80. New York, The Metropolitan Museum of Art

The innkeeper is not mentioned in the Gospel narrative, but is often included in works of art.

The bread and wine are very prominent on the white tablecloth, together with other food. The table at the inn at Emmaus thus becomes an altar, where a celebration of the sacrifice of the Eucharist is taking place.

The disciple's gesture of amazement may also be read as an imitation of Jesus' posture on the cross, following the idea that the faithful should become one with him.

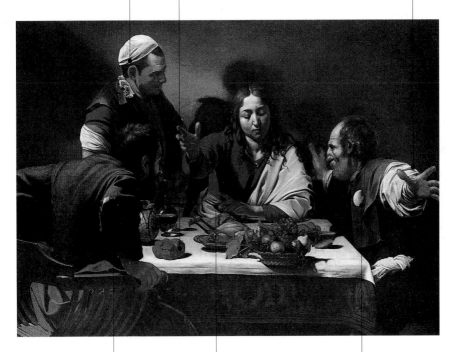

The second disciple starts forward, grabbing the arms of the chair as if to get up. Caravaggio intended to allude to the readiness with which Christ's call must be answered.

The breaking of the bread and his blessing gesture allow the disciples to recognize Jesus.

The shell he wears on his chest identifies the disciple as a pilgrim. Once the symbol of those who completed the pilgrimage to the tomb of Saint James in Santiago de Compostela, Galicia, it has become the emblem of all those who travel to holy places.

▲ Caravaggio, *The Supper at Emmaus*, 1601. London, National Gallery

Although Thomas did not believe the testimony of the other apostles, but wished to literally touch Jesus' wounds, he was the first to call Christ "My Lord and my God!" (John 20:28).

The Incredulity of Thomas

The Place
Jerusalem, possibly in the house of the mother of the evangelist Mark

The Time
A week after Easter Monday

The Figures
Jesus, Thomas, and sometimes the other apostles

The Sources
The Gospel of John

Diffusion of the Image
A widespread image that appeared slightly more often in the sphere of Tuscany influence because of the cult of Saint Thomas there

It is not hard to identify with Thomas and his deeply human need for tangible proof before believing in the wondrous events that were being told to him. In the next-to-last chapter of his Gospel, John returned yet again to his themes of the "life" and "light" that Jesus brought into the world. Thomas's gesture and words symbolize the breaking point between tangible proof and the experience of faith, a mystical leap that took its starting point in an everyday event.

When the risen Jesus first appeared to the gathered apostles, Thomas, who had already expressed doubts and fears on other occasions, was absent. He demanded to see and touch Christ's wounds before he would believe the others' testimony. A week

later, Jesus showed himself again and invited Thomas to touch the wounds in his hands and side, telling him "do not be faithless, but believing" (John 20:27).

Despite what artists have typically represented in their works, the Gospel does not actually say that Thomas put his finger into the wounds.

▶ *The Incredulity of Saint Thomas*, ca. 1125. Silos, Cloister of San Domingo

There is broiled fish on the table. The Greek word ixthùs, *which means "fish," is used in the Christian tradition as an acronym for "Jesus Christ, Son of the Saving God." In addition, following Luke, Jesus is eating broiled fish with the apostles to prove that he has truly risen from the dead and is not a ghost.*

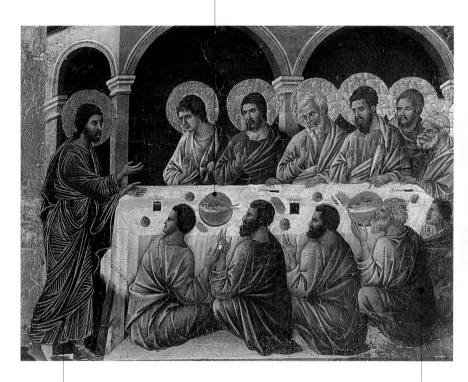

Jesus appears in the hall where the apostles have gathered, saying, "Peace be with you" (John 20:19).

There are eleven apostles, because the scene represents Jesus' first appearance, when Thomas is not present. To be precise, however, there should be ten apostles, since, according to the Acts of the Apostles, Matthias replaced the traitor and suicide Judas Iscariot after the Ascension and before Pentecost.

▲ Duccio di Buoninsegna, *Christ Appears to the Apostles during Supper*, back of the *Maestà* altarpiece, 1308–11. Siena, Museo dell'Opera del Duomo

Saint Magnus, bishop of Oderzo, watches the scene. Together with Saint Thomas, he is the patron saint of the confraternity of Venetian masons who commissioned this work.

Jesus takes Thomas's hand and invites him to put his finger into the wound in his side.

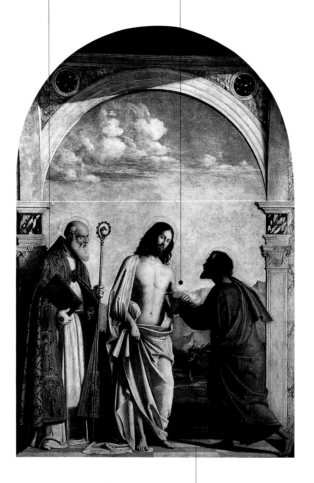

This scene is not set within a closed room with the other apostles, but in a portico that opens onto the peaceful and bright countryside. As is often the case of Venetian painting, the Gospel episode is transposed into a natural environment and presented as a universal event.

▲ Giovanni Battista Cima da Conegliano, *The Incredulity of Saint Thomas*, 1504–5. Venice, Gallerie dell'Accademia

The Apostles look on apprehensively, as if they too may need the same confirmation that Thomas requests.

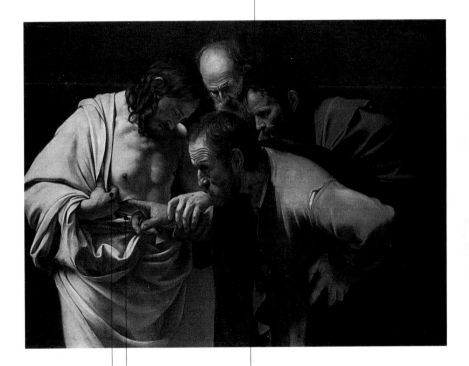

Jesus pulls aside his garment and, with a steady hand, pushes Thomas's right hand forward.

With excessive physicality, Jesus invites Thomas to insert his finger under the skin, deep into the wound in his side.

Thomas's expression is one of confusion and astonishment as he undergoes the shift to which Jesus has called him: to "not be faithless, but believing" (John 20:27).

▲ Caravaggio, *The Incredulity of Saint Thomas*, ca. 1600–1601. Potsdam, Neues Palais

The most specific account of Jesus' leaving the earth and his disappearance from the apostles' sight can be found at the beginning of the Acts of the Apostles, which was written by Luke.

The Ascension

After charging the apostles with the mission of bearing witness "to the end of the earth" (Acts 1:8), Jesus rose into the sky from the summit of the Mount of Olives until a cloud hid him from view. The apostles were still looking up when two men dressed in white—two angels—turned to them, saying, "Men of Galilee, why do you stand looking into heaven?" (1:11). At this the apostles shook themselves and returned to Jerusalem.

Some artists, such as Giotto, have attempted to transfer the arc of the scene into exact images, translating the text of the Acts of the Apostles literally. More often, though, the Ascension is more summarily portrayed, without the final appearance of the two angels. Jesus' footprints often remain visible on the mountaintop, and it is not unusual to see Jesus' body disappearing among the clouds or even outside the frame of the painting, with only his legs still showing.

The Scriptures do not say whether the Madonna was present at the scene, although she is sometimes included because it was so close in time to Pentecost.

The Place
The Mount of Olives, less than a mile outside of Jerusalem

The Time
Forty days after the Resurrection

The Figures
Jesus, who ascends into the sky, and the apostles

The Sources
The Gospels of Matthew and Luke; the Acts of the Apostles

Diffusion of the Image
Widespread, especially during the Middle Ages; sometimes this episode is visually overlaid onto depictions of the Resurrection

▶ Rembrandt, *The Ascension*, 1636. Munich, Alte Pinakothek

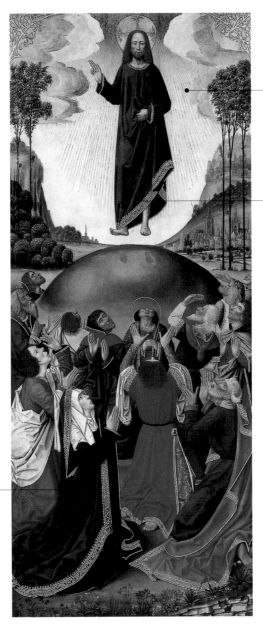

The clouds are about to close Christ off from the apostles' sight forever.

Jesus ascends slowly Heavenward, blessing his disciples. He has left his footprints upon the mountain, the last sign of his earthly existence.

The Madonna wears a rich, blue cloak. As is common in fifteenth-century painting, there is a prayer embroidered in gold along the border; here, it is the Salve Regina (Hail, Holy Queen).

▲ *The Ascension*, a panel from the altar of the Carthusian monastery of Saint-Honoré-de-Thuison, Abbeville, ca. 1485. Art Institute of Chicago

Choirs of angels and biblical patriarchs accompany Jesus at the Ascension.

In the Scrovegni Chapel frescoes, Giotto always followed the text. This cloud, which hides Jesus from the disciples' sight, is mentioned in the Acts of the Apostles.

Christ is leaving the earthly world. Giotto used the ingenious device of cutting off Jesus' hands at the edge of the fresco to convey an impression of dynamism.

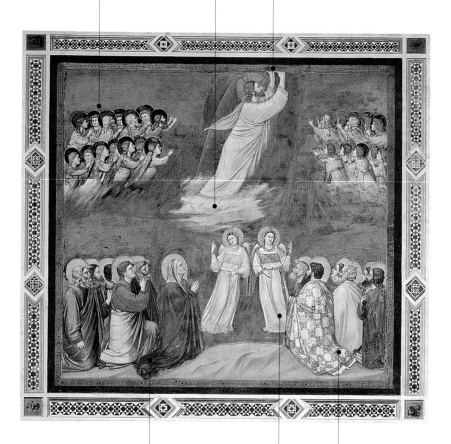

The Madonna observes the scene prayerfully. She is slightly apart from the apostles.

According to the Acts of the Apostles, two angels turn to the disciples with the words, "Men of Galilee, why do you stand looking into heaven?" (Acts 1:11).

The number of apostles— eleven—is correct. Judas's replacement has not yet been chosen.

▲ Giotto, *The Ascension*, 1304–6. Padua, Scrovegni Chapel

The importance of the Christian Pentecost, which was practically the founding moment of the Church, to some degree found its counterpart in art. The old masters often portrayed this subject.

Pentecost

The Gospels speak of an outpouring of the Holy Spirit on Jesus' part whenever he appeared to the apostles after the Resurrection. The Book of Acts, however, describes a specific event that occurred ten days after the Ascension.

Jesus' closest disciples had formed the habit of gathering in a house in Jerusalem, taking precautions to lock all the doors because they feared being arrested or interrogated about the disappearance of the Nazarene's body. One of these meetings coincided with the Jewish feast of Pentecost, seven weeks after Passover. The Madonna and the apostles—once more numbering twelve after Matthias was elected to replace Judas—were all present. With a sound like thunder the rush of a mighty wind filled the room, and tongues of fire appeared and hovered over each of them. As the Holy Spirit descended on the apostles, they became able to express themselves in all the languages of the world. The foreign pilgrims in Jerusalem during this period allowed them to verify immediately and surprisingly the effectiveness of the miracle.

The Place
Jerusalem, perhaps in the house of the mother of the evangelist Mark

The Time
Fifty days after the Resurrection

The Figures
All of the apostles and the Madonna

The Sources
The Acts of the Apostles

Variants
The Descent of the Holy Spirit

Diffusion of the Image
Rather widespread, but mostly within series cycles, until the Counter-Reformation, when it became a separate image

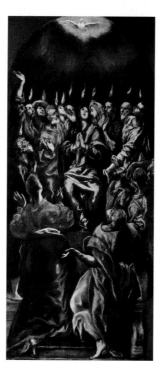

El Greco, ◄
Pentecost, 1604–14.
Madrid, Museo del Prado

The closed room in which the descent of the Holy Spirit is occurring is here depicted as a Gothic pavilion.

The Holy Spirit takes the form of rays of light.

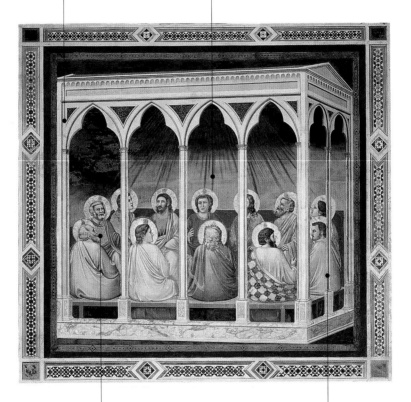

Peter faces the viewer. In this last scene of the Scrovegni Chapel cycle, which shows the beginnings of the Church militant, the faithful in this war are invited to "come into the picture."

The apostles once again number twelve. Shortly before Pentecost, after casting lots for either Joseph the Just or Matthias, the latter was chosen to join the group. The Madonna is missing from Giotto's interpretation, although she frequently appears in other versions.

▲ Giotto, *Pentecost*, 1304–6. Padua, Scrovegni Chapel

The predominantly "masculine" sadness at the Madonna's death counterbalances the almost exclusively "feminine" animation at her birth.

The Death of the Virgin

Many years after Pentecost, when the apostles had already dispersed throughout the world, an angel bearing a palm branch appeared to Mary and announced her imminent death. She said she wanted to see the apostles, who came and gathered around her deathbed. Mary expired ("fell asleep") without pain, as Christ descended from Heaven to take her soul.

Drawn from an apocryphal source, the Death of the Virgin has inspired a long series of works of art. Few subjects permit us to observe so clearly the development of the very concept of a sacred image. Medieval and Byzantine art emphasize Christ's appearance as he descended from Heaven accompanied by angels to gather the Madonna's *animula*. During the fifteenth century, it is the liturgy around the dying Virgin that is highlighted—the candles and aspergillum, and Peter dressed in priestly vestments. After the Counter-Reformation, and especially in Caravaggio's work, the accent is on the deep humanity of the scene.

The Place
Mount Zion near Jerusalem

The Time
Some years after Jesus' Passion

The Figures
The Madonna, the apostles, and often Christ himself, who appears and receives Mary's soul

The Sources
The apocryphal *Transitus Mariae*, retold in *The Golden Legend*

Variants
The Dormition; *Dormitio Virginis*

Diffusion of the Image
Extensive, but with one significant iconographic and doctrinal distinction: according to the Franciscans, Mary did not "die" but "fell asleep," while the Dominican theologians spoke of a true physical death

Andrea Mantegna, ◄ *Death of the Virgin*, 1641. Madrid, Museo del Prado

The angel announces Mary's approaching death with a palm branch, a symbol of entrance into Paradise.

Mary reads a book of prayers in bed. Her expression is peaceful: according to the apocryphal sources, Mary herself had asked to die in order to see her son again.

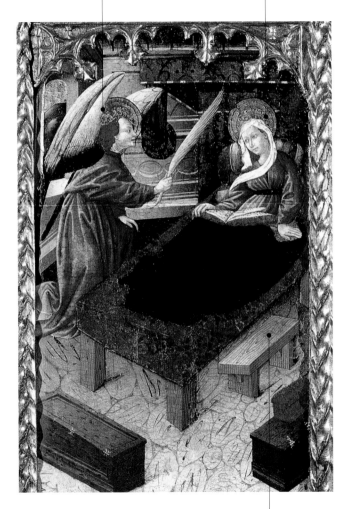

The extreme modesty of the furniture in Mary's room emphasizes her humility.

▲ Master of Riglos, *The Annunciation of the Death and Dormition of the Virgin*, ca. 1460. Barcelona, Museo Nacional de Arte de Cataluña

A private altar bespeaks
Mary's devotion.

John is the apostle who stays
closest to the dying Mary and
hands her a lighted candle. From
the cross, Jesus had asked Mary
and John to consider themselves
mother and son.

Other apostles prepare a thurible
of incense, heightening the
impression of a religious liturgy.

Two weeping
apostles bring a
pail of holy water
for Mary to bless
them with.

The candle, rosary, and
prayer book on the small
table in the foreground
are further signs of
Mary's exemplary
religiousness.

Peter is portrayed as a
priest giving last rites; he
holds a cross and an
aspergillum.

▲ Joos van Cleve, *The Death of Mary*,
1520. Munich, Alte Pinakothek

The Assumption

This subject is in keeping with the Catholic Counter-Reformation. The presence of Baroque churches and artworks dedicated to the Assumption in the primarily Catholic areas of the culturally German world is eloquent.

The Place
The cemetery in the Valley of Josaphat

The Time
Shortly after the Death of the Virgin

The Figures
Mary, who is assumed and welcomed into Heaven by God the Father; the apostles (sometimes without Saint Thomas)

The Sources
The apocryphal *Transitus Mariae*, a fourth-century text attributed either to Melito of Sardis or John the Evangelist himself, retold in *The Golden Legend*

Variants
The Virgin of the Assumption; Mary Is Assumed into Heaven

Diffusion of the Image
This episode is always included in painting cycles dedicated to Mary, but is also common alone in altarpieces.

▶ Egid Quirin Asam, *The Altar of the Assumption of Mary* (detail), 1718–23. Rohr, convent church

The account of the Assumption developed in the same way that the Death of the Virgin did. Its source is the *Transitus Mariae*, which was gradually enriched with additions and interpolations before being narrated once again in *The Golden Legend*. Jacobus de Voragine confirmed that though the source was apocryphal, it was, in the main, trustworthy. This is why the artists who portrayed the events have often left out the minor episodes and attempted to capture the essential elements.

The scene of the Assumption is especially important for the Catholic world. It is set in the Valley of Josaphat, the cemetery where the apostles took Mary's body and, after series of events, placed it in a tomb. At that point, Jesus appeared—in art he more often looks like God the Father—together with a

multitude of angels. The archangel Michael uncovered the tomb, Mary's soul was reunited with her body, and the angels carried her up to Heaven.

A minor theme involves Thomas, who arrived late and missed the Assumption. As proof of the event, Mary gave him her girdle.

Even during her Assumption, Mary's demeanor evokes her pious faith in God's will.

The movement of the clouds has various functions: it emphasizes Mary's rising motion, while the clouds open to indicate the way to Heaven then close up again to finally conceal Mary from human sight.

The angels strew roses on the tomb. The rose is the Marian flower by antonomasia.

The Virgin Mary's now useless shroud is abandoned on her tomb, which is a simple rectangular marble box. Poussin highlights the fact that Mary is assumed bodily into Heaven.

▲ Nicolas Poussin, *The Assumption of the Virgin*, ca. 1626. Washington, D.C., National Gallery of Art

Mary gives Thomas her girdle at the Assumption. The Florentine painter gave the Virgin an enjoyable smile of complicity.

This scene is common in Tuscan art, because the relic called the "Holy Girdle" is kept in Prato.

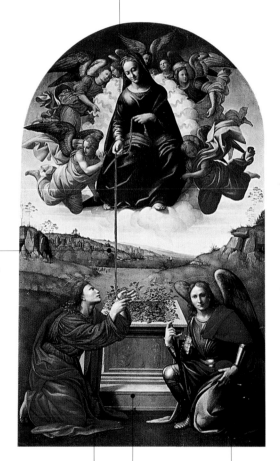

According to extrabiblical tradition, Thomas arrived too late to see the Assumption. The Virgin offers her girdle as tangible proof of her departure to the incredulous apostle.

Roses flower in the Madonna's empty tomb.

On the right, Saint Michael the Archangel is included for devotional reasons.

▲ Francesco Granacci, *The Madonna of the Girdle*, ca. 1515. Florence, Galleria dell'Accademia

Her hands folded in prayer symbolize the Madonna's unfailing piety.

Above the clouds, the Trinity has prepared a place for Mary at the center of the celestial throne. This scene thus joins themes from the Assumption, the Immaculate Conception, and the Coronation of the Virgin.

Even at the Assumption, Mary's hair is long and flowing, a symbol of virginity.

The angels who accompany the Virgin wear rich deacons' vestments, as if they were officiating at a religious ritual.

The moon beneath the Virgin's feet refers to Mary's stability, as opposed to the shifting fortunes and situations of human beings.

▲ Master of the Saint Lucy Legend, *Mary, Queen of Heaven*, 1485. Washington, D.C., National Gallery of Art

Although it is based on an extrabiblical tradition, this theme is exceptionally important in Catholicism, since it reinforces the Virgin Mary's role as Queen of Heaven.

The Coronation of the Virgin

The text of *Transitus Mariae* ends with the image of Mary being assumed into Heaven as the apostles praise Jesus, "who lives and reigns with the Father and the Holy Spirit, in perfect unity, and in one substance of divinity, for ever and ever." This prayer can also apply to Mary, who, according to an interpretation by Saint Jerome, was immediately brought to the throne of God at the Assumption. This is why the Coronation is sometimes portrayed as immediately following that episode.

The Place
In Heaven, sometimes even before the celestial court

The Time
Undefined, or following the Assumption

The Figures
Mary and the Trinity, angels playing music, and sometimes saints

The Sources
Iconographic traditions based on the apocryphal *Transitus Mariae*, by way of *The Golden Legend*

Diffusion of the Image
An episode that is usually part of painting cycles dedicated to Mary, although it is also widespread as an independent, at times spectacular, image

The Coronation of the Virgin is a solemn, celestial ceremony, where God the Father and the Son usually crown Mary in the presence of the Holy Spirit. Images where either Jesus or God the Father crowns the Madonna are less common. Still more rare, but very evocative, are images that show the aftermath of the Coronation, with Mary seated at Jesus' side on the same throne.

▶ Fra Angelico, *The Coronation of the Virgin*, tabernacle, 1433. Florence, Museo di San Marco

The Madonna bows her head, lowers her eyes, and joins her hands in the attitude of submission and prayer that often appears in Annunciations.

The ceremony of the Coronation is only celebrated by Jesus in this example.

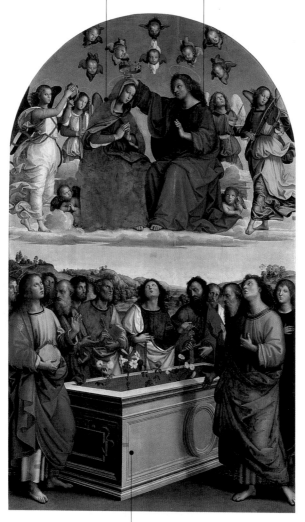

The Madonna's empty tomb fills with lilies and roses. Raphael combines two distinct scenes here: that of the apostles around the empty tomb, and that of the Coronation of the Virgin.

▲ Raphael, *The Coronation of the Virgin (The Oddi Altarpiece)*, 1503. Vatican City, Pinacoteca Vaticana

The elaborate richness of the crown fits right in with the sparkling and sumptuous scene. This painting was originally intended to be carried in processions, which could explain the exceptional splendor of the gold, which was meant to be seen even from a certain distance and in a crowd.

The presence of the dove of the Holy Spirit, but not God the Father, signifies that Jesus' nature is that of both the Father and the Son.

Jesus performs two actions: he places the crown on Mary's head and raises his right hand in blessing.

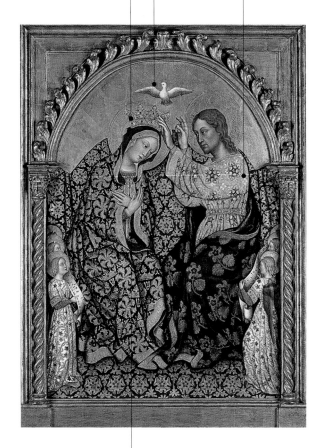

Mary assumes her customary attitude of submission and prayer. This same pose could be used just as well for an Annunciation.

▲ Gentile da Fabriano, *Coronation of the Virgin*, ca. 1420. Los Angeles, J. Paul Getty Museum

Jesus and God the Father share the insignia of universal power and the task of crowning Mary. Christ holds a scepter.

The dove of the Holy Spirit is the painting's most luminous point. The brightest ray of light passes through the symbolic flowered garland (which is entirely different from the goldsmith work featured in medieval art) onto Mary's head.

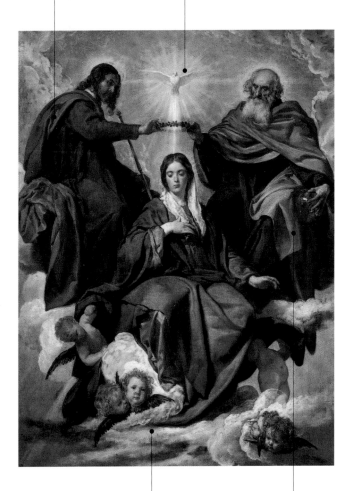

Mary hovers among the clouds just below the Trinity, although this arrangement of figures clearly composes a single, four-part unit.

In his left hand, God the Father holds the orb that symbolizes his empire over the entire world.

▲ Diego Rodriguez de Silva y Velázquez, *The Coronation of the Virgin*, 1641–42. Madrid, Museo del Prado

The Madonna's mantle, edged with ermine as befits a queen, spreads out over the world as a symbol of Mary's protection of all people.

The two cities shown in this lower part are Rome and Jerusalem.

At the Last Judgment, the souls of the blessed are sent Heavenward.

▲ Enguerrand Quarton, *The Coronation of the Virgin*, 1453–54. Villeneuve-lès-Avignon, Musée municipal

The Holy Spirit emanates from the mouths of Christ and God the Father, who are portrayed as identical.

Among the figures of the saints, the blessed, and the angels on either side of the Coronation of the Virgin are the little Innocents, the babies of Bethlehem whom Herod ordered slaughtered by Herod shortly after Jesus' birth.

Christ's empty tomb recalls the Resurrection.

The crucified Christ is at the center of the lower part of the composition, because the Coronation of the Virgin is presented against the background of the story of humanity's redemption.

Demons torture the souls of the damned in Hell.

APPENDIXES

◀ Raphael, *The Vision of Ezekiel*,
1518. Florence, Galleria Palatina di
Palazzo Pitti

Index of Episodes

Index of Names

Jesus, the Madonna, and the four evangelists are not included in this index, since they are constantly mentioned throughout this volume.

The Apocryphal Gospels

During Christianity's first centuries, various communities added their own texts to the four "canonical" Gospels. These additions were later removed from the Scriptures. Some of these apocryphal (meaning "false" or "not original") writings contain heretical tendencies, but also elements, missing from the texts of Matthew, Mark, Luke, and John, that have become fixtures in the Christian tradition, the liturgical calendar, and even the dogmas of the Church, as in the case with the Assumption of the Virgin Mary. The so-called apocryphal gospels were written later than the four canonical Gospels, by authors who were allegedly apostles or other figures from the time of Jesus. Initially the Church tolerated these texts, although they were read less and less. The synod of 397 at Carthage officially removed the writings from the definitive list of the Scriptures, and they were placed on the Index as prohibited books by a decree attributed to Pope Gelasius I (492–96), but actually drawn up in the sixth century.

Today the early Christian apocrypha still exercise a powerful fascination, especially for their abundance of narrative detail (at times credible and poetic, at other times, frankly, crude). These details concern parts of Jesus' life about which the canonical Gospels offer little information.

These writings were thus an extremely rich source of inspiration for medieval art. Jacobus de Voragine made wide use of a collection of apocryphal writings (the medieval Gospel of the Birth of Mary) when he compiled his *Golden Legend*.

When the Council of Trent (1545–63) irrefutably reaffirmed the canonical texts of the New Testament—the four Gospels, the Epistles, the Acts of the Apostles, and Revelation—it also implicitly recognized the popular diffusion of the early Christian apocrypha, at least with regard to certain specific scenes. In this vein, the apocryphal texts constituted a very important source for medieval and Renaissance religious iconography. Many episodes that we are in the habit of considering generic "gospel stories" are, in fact, direct or indirect descendants of these parallel texts. Besides the apocryphal gospels, there are also spurious versions of the Epistles, Acts of the Apostles, and Revelation. What follows is a summary of the main pseudo-gospels or apocryphal texts that have most influenced Western religious art.

The Protevangelium of James

Presented as the work of the apostle James the Less (who according to ancient tradition was the son of Mary of Cleophas, the Virgin Mary's half sister, and therefore Jesus' cousin), this brief text was written around the year 130, which makes it one of the oldest of the apocryphal texts. It takes the form of an extensive prologue to the canonical Gospels, in that it details Mary's life from episodes about Joachim and Anne to the arrival of the Magi. Another, much later part adds information about John the Baptist's father, Zechariah, who was slain in the temple after the Massacre of the Innocents.

The Protevangelium of James is the main source for all episodes relative to Mary's conception, infancy and childhood, presentation in the temple, youth, and marriage—scenes that have been immensely popular in the history of European art. The entire upper register of Giotto's frescoes in the Scrovegni Chapel in Padua, for example, was inspired by this text. Another detail from the Protevangelium that had extraordinary iconographic success was the cave setting for the Nativity of Jesus.

The Gospel of Pseudo-Matthew or "Book of the Childhood of the Blessed Mary and of the Childhood of the Savior"
This is a later elaboration of the Protevangelium, presented as a prologue to the Gospel of Matthew. It pays particular attention to and gives an especially detailed version of the Flight into Egypt and the childhood of Jesus. Although Saint Jerome considered the text false and misleading, it still contains a number of interesting passages that are often illustrated in art. A number of details of the Nativity had particular resonance, such as the star above the grotto at Bethlehem and the presence of the ox and ass. These have all permanently entered into the popular tradition of Nativity scenes.

The Gospel of Nicodemus or "Acts of Pilate"
This is the most important non-canonical text dedicated to the Passion and perhaps the apocryphal work of highest literary and doctrinal quality. According to an unconfirmed theory, it was compiled in order to refute the false testimonies spread by the pagans during the persecutions under the emperor Diocletian.

The text is in two parts. The first tells of the Passion, adding to the canonical Gospel accounts a few curious details, such as depositions at the trial by people whom Jesus had miraculously healed: the paralytic, the man born blind, the hemorrhaging woman, a leper, and a hunchback. The second part, which is much more interesting and dense with iconographic implications, describes in a completely original manner, in the form of a report written by Pontius Pilate to the emperor Claudius, Christ's descent into Limbo, which occurred in the period between the Entombment and the Resurrection.

Transitus Mariae
A number of ancient Armenian and Arab traditions concerning Mary were collected and summarized in versions attributed to Joseph of Arimathea and Pseudo-Melito. These short texts, which spread during the Middle Ages through a number of transcriptions, narrate the episodes of the death, funeral rites, and Assumption of Mary, including the detail of Mary giving Thomas her girdle as she rose up to Heaven. A medieval compilation titled *Transitus Mariae*, or *Book of the Death of the Holiest of Virgins, the Mother of God*, provided the foundation for *The Golden Legend* and the long iconographic tradition of Mary's "dormition" and of the Madonna of the Assumption, both fundamental themes in Christian art.

The popularity of the Madonna of the Assumption, which originated in these Eastern texts, or at least in the traditions they fostered, became Roman Catholic dogma in 1950. It should be noted, however, that Pius XII's bull made no mention of the apocrypha, but only the "Church's belief."

Index of Artists

Photography Credits

Sergio Anelli/Electa, Milan
Archivio Electa, Milan
Archivio Musei Civici, Venice
Archivio Scala Group, Antella (Florence)
Curia Patriarcale di Venezia, Venice
© Photo RMN, Paris

The Ministero per i Beni e le Attività Culturali kindly granted
 permission for images from the following to be reproduced:

Assessorato alla Cultura del Comune di Padova
Soprintendenza per il patrimonio storico artistico e
 demoetnoantropologico di Bologna
Soprintendenza per il patrimonio storico artistico e
 demoetnoantropologico di Mantova
Soprintendenza per il patrimonio storico artistico e
 demoetnoantropologico di Milano, Bergamo,
 Como, Lecco, Lodi, Pavia, Sondrio, Varese
Soprintendenza per il patrimonio storico artistico e
 demoetnoantropologico di Piemonte, Torino
Soprintendenza per il patrimonio storico artistico e
 demoetnoantropologico di Venezia

The publisher would also like to thank the many photographic archives
of museums and the public and private entities that provided photo-
graphic material.